How to Paint Portraits in Pastel

How to Paint Portraits in Pastel

By Joe Singer

WATSON-GUPTILL PUBLICATIONS, NEW YORK
PITMAN PUBLISHING, LONDON

Published 1972 in the U.S.A. and Canada by Watson-Guptill Publications,
a division of Billboard Publications, Inc.,
One Astor Plaza, New York, N.Y. 10036

Published simultaneously in Great Britain by Sir Isaac Pitman & Sons Ltd.,
39 Parker Street, Kingsway, London WC2B 5PB
ISBN 0-273-00041-1

Manufactured in the U.S.A.

First Printing, 1972
Second Printing, 1973
Third Printing, 1974

Library of Congress Cataloging in Publication Data
Singer, Joe, 1923–
 How to paint portraits in pastel.
 1. Pastel drawing. 2. Portrait drawing.
I. Title.
NC880.S5 743'.4 70-190519
ISBN 0-8230-2465-2

For June

Contents

List of Portraits

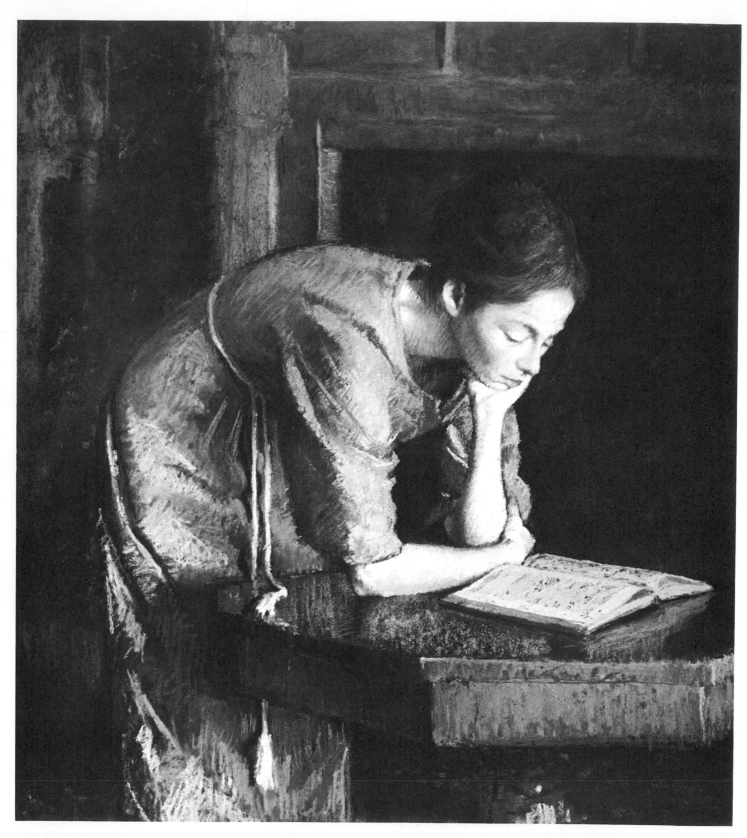

Woman Reading *by Aaron Shikler, pastel on board, 19" x 17". This is a fine example of what can be achieved in portraiture aside from the usual head-on shot. The bathrobe tassel lying on the table is a natural and a very amusing touch. Although the face and arms are smoothly handled, the robe and the table surface contain more rough and lively handling. Although we can't see the subject's eyes, there's no problem* of our recognizing them. Compare this painting with Philipp's Janet Reading *(p. 16),* Greene's Model Resting *(p. 112), and* Handell's Yellow Kerchief *(p. 72). Do you see how each artist has approached a basically similar scene? These paintings should encourage the aspiring portraitist to learn to vary his approaches, not to repeat himself once he thinks that he has a safe formula. (Collection Mr. and Mrs. B. Rionda Braga)*

Why Pastel?

The chapter head poses a good question: Why pastel? The reader might well say: "If I'm going to exert all this effort to do a good portrait, why shouldn't it be in oils like most of the portraits I've seen in museums? Why should I work in pastel—it smears, it probably won't last, and my friends won't think as well of it as they would of an oil painting?"

As in every bone of contention, there's a measure of truth in this statement. However, I'm appointing myself a one-man committee to persuade artists that pastel is equal—if not superior—to oil paints; that it's at least as permanent as oils, and perhaps more so; that it requires every bit as much artistic endeavor and application; that it can produce effects as solid and as forceful; that it's more versatile; that it's less frustrating for the inexperienced artist; that it boasts the advantage of being both a *drawing* and a *painting* medium; and above all—that it's an eminently satisfying and a fun medium to work with.

As we go along, I'm confident that I can prove these allegations and provide the stimulus for you to paint many of your future portraits in pastel.

What Is Pastel?

To understand what pastel is, you must first understand that all painting mediums consist of pigment and a binding agent. Pigment can be a natural or an artificially prepared substance. It can come from the ground as the earth colors do; it can come from vegetables; it can be made from animal matter such as bone; or it can be prepared in the laboratory. But whatever it stems from, it serves one purpose: to provide the color for *all* painting mediums. The same pigment, in powder form, is used for oils, watercolor, pastel, gouache, and acrylics. The only difference is in the binders used for the various mediums.

A binder is the substance that binds, or holds, the raw pigment in such a way that it becomes workable in a painting medium. The purpose of the binder is to effectively weld the pigment granules into some sort of solid form so that our hands or brushes can carry the color to the grounds on which we're working.

In oil paints, the raw pigment is usually combined with a binder of linseed oil to form a fluid paint. In

watercolor, the same pigment is combined with a gum binder. Casein (milk curd), egg yolk, wax, and plastic are some of the other binders used in various painting mediums.

In pastel, the raw pigment is usually combined with a substance called gum tragacanth or with methylcellulose to form the pastel stick or crayon. Since pastel is a dry medium rather than a liquid medium (such as oil, watercolor, tempera, casein) only a *minimum* of binder is used, or just enough to *hold the pigment particles together*. Therefore, pastel is technically the purest art medium since it uses the *least* binder, and the *maximum* pure pigment. And since it is often the binder and not the pigment that is the main cause for the deterioration of paintings—especially oil paintings—pastel can be considered among the most permanent of art mediums. Of course, the grounds upon which the picture is painted, the lightfast qualities of the colors, and the conditions under which the painting is hung are other factors affecting the permanence of a painting. But all considerations being equal, pastel is *as* permanent as any painting medium.

To sum up, therefore, pastel is pure, finely ground pigment (dry color) combined with gum tragacanth or methylcellulose (binder) to hold it together; with precipitated chalk or other white substance added to produce the lighter shades and with black to produce the darker; possibly with talc to improve the working qualities; and perhaps with some sort of preservative added to the binding solution to keep it from spoiling. From this is rolled a stick or crayon which is then ready to be applied to the grounds to produce a pastel painting.

A Very Brief History of Pastel Portraiture

The history of pastel portraiture goes back hundreds of years. If we are to disregard the ancient chalk drawings which can't be rightfully classified as pastel, some of the earliest pastellists practiced their art in the sixteenth century. Rosalba Carriera, a Venetian lady, is generally credited as one of the earliest portrait painters in pastel. Well-known French portrait pastellists included Maurice Quentin de La Tour, Jean-Etienne Liotard, Jean-Baptiste Perronneau, and Jean-

Baptiste-Siméon Chardin. John Russell was an early English master of pastel portraiture. There were others—dozens and dozens of others—in every civilized European country who turned to this versatile medium to execute the equivalent of the society portrait of today—rather slick and mannered paintings of the upper classes, with inordinate care paid to laces, ornaments, powdered wigs, beauty marks, and all the other trivia with which the beautiful people of that era adorned themselves.

While some of these portraits are technically magnificent, most of them pale alongside the powerful oils painted by such contemporary masters as Rembrandt, Velásquez, or Titian.

This unavoidable comparison helped to relegate pastel to the secondary position it has continued to occupy in the art realm, and in the minds of many art critics. I can't really blame anyone who strolls from a Rembrandt to a Carriera and is struck by the depth of the one and the apparent superficiality of the other. But it doesn't have to be this way—*the difference is not inherent in the medium, but in the way it was used!*

Happily, there was a Degas.

From the beginning of the 1800s until much later, pastel lay dormant. Then—impressionism!

When painters like Millet, Manet, Renoir, and Degas picked up a pastel crayon, God smiled down from heaven. Pastel threw off its stays and began to expand and soar. Vivid, powerful portraits of real men and women, executed in bold, innovative style began to emerge from artists in France, England, Belgium, Italy, Holland, Germany, and across the ocean in our own country. No more ivory-skinned contessas in Chantilly lace delicately sniffing camellias; no more angelic children looking as if a good sneeze would carry them off, but real, down-to-earth men and women who were born, worked, got drunk, had babies. Pastel had come into its own.

Mary Cassatt, the American and a friend and disciple of Degas, painted exquisite pastel portraits of women and children in homey, domestic poses. Her infants and toddlers, unlike those in earlier pastel portraits, are flesh-and-blood people who exude life and vigor.

Henry Tonks, the Englishman, and Rik Wouters, the Belgian, among others, added stature and prestige to pastel portraiture.

But what's happened since then? For some inexplicable reason, the twentieth century has experienced the resurgence of the snide and patronizing attitude toward pastel. Why this attitude? Why do professional artists feed this prejudice by charging less fees for their pastel portraits? Rather than polemicize, I'll discuss some of the advantages of this potent medium that deserves a better reputation than it has enjoyed to date.

Advantages of Pastel

To an artist, the medium in which he chooses to express himself can be compared to selecting a car. In both cases, it's a matter of which vehicle will get him to the place where he wants to go in the safest, fastest, and most comfortable fashion.

The experienced artist will make his statement pretty much the same way regardless if he paints in oils, watercolor, acrylics, or pastel. He has found his style and discovered the bridges and short cuts that he uses to travel his artistic road. He, therefore, seeks the easiest technical means through which to attain these goals. If he prefers a fluid medium which allows him more time to get to where he's going, he might choose oils. If he's a faster, more disciplined worker, he might try watercolor. If he prefers not to have to wait to effect changes and corrections, he might possibly work in acrylics. And so on.

Why and when would he select pastel? When his knowledge and experience have taught him that pastel can do nearly all of the things that oils, watercolor, casein, acrylics, etc., can do—and do them better.

Let's compare pastel with oils.

One advantage of using oils is that you can achieve deep, dark tones. So can pastel.

Another advantage is that you can keep working over oil again and again to achieve the effect you want. Pastel too.

Oils can be painted any size you want. So can pastel.

Oils are easily manipulated. So is pastel.

Oils allow you to achieve a wide range of colors. So does pastel.

In oils, you can combine opaque with transparent effects in a single painting. In pastel too.

In oils, you can cover a large portion of the surface very quickly. Pastel is just as quick.

Now, what about some of the disadvantages of oils as compared to pastels?

Oil paintings crack. Pastels don't.

Oils darken and yellow. Pastels don't.

Oil colors change somewhat in value or hue from wet to dry. Pastel doesn't change at all.

You must often wait until the coats dry before repainting in oils; in pastel you can rework immediately in an hour, a day, or twenty years later.

You need mediums such as turpentine, linseed oil, copal or damar varnish to make oil paints more workable. A stick of pastel is ready to use as is.

Oil colors dry out on the palette and must be discarded. Pastel crayons never change or dry out and can be used practically forever.

Oil paintings acquire slick, greasy, or dry surfaces which are difficult to work on and you need retouch varnish or other solvents to restore the working surface. The surface of a pastel painting remains almost always receptive for reworking unless it has been built up so thickly that it can accept no more color. But even this condition can often be corrected.

To paint in oils, you need brushes, knives, a palette, and cups for medium. In pastel, you need only crayons and fingers.

After painting in oils, you must wash and shape brushes, clean the palette, protect colors from drying out, recap tubes. In pastel you simply put away the crayons and you're done.

With oils, canvas is expensive to discard and begin

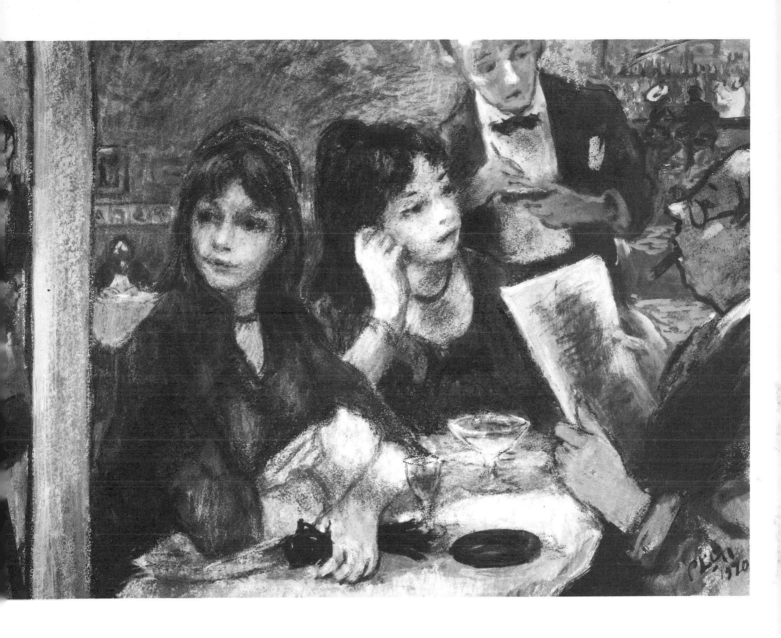

Café *by Robert Philipp, pastel on paper, 24" x 32". Roughly painted in a truly impressionistic technique, the painting fairly jumps with sparkles of vivid, jewel-like color. The faces of the three main figures are merely indicated, yet each is a portrait in itself, a study of a human being thinking, doing, or being something highly specialized and individualistic. The daring technique is one only a very experienced and knowledgeable artist would attempt. Squint your eyes and see how solidly all the elements fall into their proper setting. This masterfully painted group portrait vividly demonstrates the strength and vigor of pastel. (Courtesy ACA Galleries)*

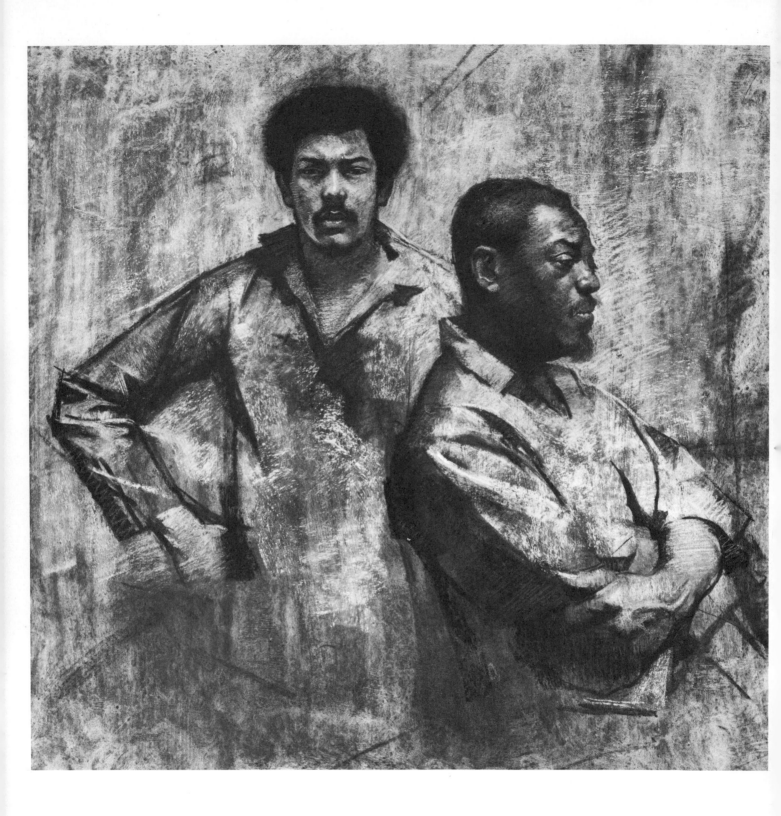

Two Men *by Harvey Dinnerstein, pastel on board, 21" x 22¼".
This is a powerfully rendered presentation of two distinctively
different personalities. The heads are painted with greater
attention to detail; the figures are done in a more sketchy
manner. Note the foreshortening of the left hand of the
bearded subject, which seems unusually large. This device
propels the bearded figure forward and ensures a three-
dimensional effect. The artist used broken strokes of color
throughout and leaves many parts of the painting rough and
unfinished. The overall impression is one of tension, vitality,
and suppressed excitement.*

anew when things become unmanageable. In pastel, you throw away the sheet of comparatively inexpensive paper and do it over.

Oil paintings *must* be varnished when completed. Pastels can be left as they are.

Oils are essentially a *painting* medium; with pastels you can either *paint* or *draw*.

Is it my contention that pastels are a superior medium to oils? Not at all. I merely suggest that pastels are *not inferior* to oils but are equal in the family of artistic mediums. Pastels are certainly as viable a medium for portraiture, which is the concern of this book.

Portraits in watercolor, tempera, casein, and acrylics are certainly possible, but a good deal harder to manage for the less experienced artist.

But what of the disadvantages of pastel?

First, pastel smears on touch. You might as well accept this factor if you're going to work in pastel. Second, unless you spray it with fixative, the finished painting will have to be framed under glass. And third, your cousin who knows all about art will tell you that a pastel painting doesn't have the value and prestige of an oil.

If you can learn to live with these limitations, you can go on to paint pastel portraits.

Why Paint Portraits in Pastel?

For one, because it's *easier* than oil. To paint in oil requires at least a rudimentary knowledge of under-painting, glazing, the *alla prima* technique, the differences between short and long paint, the drying characteristics of paints, the opacity and transparency of colors, and many other things. These things can be learned through reading, from schools, and through experience. I don't mean to imply that painting a pastel portrait requires any less artistic knowledge. *Pastel requires less technical skill, not less artistic skill!*

Pastel painting represents a much simplier technical process. The less you have to remember as your artistic juices are flowing, the easier it is to make your artistic statement. When you're a comparative beginner and feel weighted down by the demands of the

craft, it can be a relief to work in a medium that frees you of some of these burdensome restrictions.

But don't ever slip into the error of thinking that pastel is the medium for children and little old ladies. It may be less complex technically, but it calls for every artistic resource at your command to create an honest and meaningful painting.

However, the fact that it may take you down the road to artistic fulfillment with less bumps along the way is a most important consideration. Oil painting is much like being invited to a formal dinner; your goal is to put the food into your mouth, but you spend the evening worrying which fork to use. Painting in pastel would be more like eating a snack in your own kitchen; you enjoy your meal more and you concentrate on the business of eating, not on the means of getting the food into your mouth.

There's no assurance that you'll paint a better portrait in pastel. But it helps a lot to know that you'll have *less* problems than you might experience with other mediums. Pastel is simple. You can stop and start the work at any time without worrying about colors drying out when you want them to stay wet; *waiting* for colors to dry out when you *want* them to dry; squeezing out colors; scraping palettes; pouring out painting mediums; or selecting brushes, knives, and what have you. You begin whenever you want, and you stop whenever you want. You don't need an excess of *technical* knowledge: basically, it's a process of applying crayon to paper. No need to pre-mix the colors on a palette; it can't be done in pastel, since all the mixing is done on the painting surface. The crayon leaves its mark on the surface, and it will be the same color as that which you hold in your hand. If you don't want to, you don't have to blow fixative on the surface. All you need do is paint. When you get tired or feel yourself going stale, you just stop. The next day when you are fresh again, you resume.

Why paint portraits in pastel? Why *not* paint portraits in pastel?

The one factor you can't avoid will be those who inevitably say: "Why don't you paint in oils? Oil is so much more popular . . ." I can only urge you to respond with as much dignity as you can muster: "Oil is also good to pack sardines in."

tive stroke. They are employed when more distinct or hard-edged effects are desired. Half-hard pastels usually come in smaller assortments than the soft pastels.

Talens (the manufacturers of the Rembrandt line) makes a good semihard pastel called Talens Van Gogh fine pastels.

Hard Pastels

Hard pastels are made in such a way as to produce a stick capable of imparting a thin, clean, uniform line or a strong accent. However, since they're manufactured primarily for commercial artists, they often include colors which fade—so-called fugitive colors which are not acceptable for serious art purposes. Hard pastels are usually square in shape, and are often thinner than the softer pastels.

Eberhard Faber manufactures a line of hard pastels called Nupastel in a wide range of colors. It's advisable to select from this assortment only those colors that carry the names of permanent pigments. But more on that later in the section on "Permanence."

Some other hard pastels available in the U. S. are those manufactured by Eagle, called Prismapastel; by Grumbacher, called Golden Palette; and by Swan, called Carb-Othello.

But again, be wary of hard pastels since they aren't all completely lightfast and may fade on prolonged exposure to light. Later in the book, I'll suggest how to circumvent this problem.

Pastel Pencils

A comparatively recent arrival to the family of pastel products is the pastel pencil—pastel color encased in wood for the ultimate in detail manipulation. These pencils can be sharpened in an ordinary pencil sharpener and would be a most handy addition to the pastel painter's kit of tools except that, like the hard pastels, they include some fugitive colors. Still, if you're careful in your color selection, pastel pencils can be a most valuable instrument for fine detail work.

Conte makes a set of pastel pencils, as does Eagle Primapastel, Swan Carb-Othello, and General Multi-Pastel.

Use them by all means, but exercise care. The same rules that apply to the selection of hard pastels should guide you in the selection of pastel pencils.

Oil Pastels

The standard, modern oil pastel is created by combining raw pigment with an oil binder and an occasional mixture of wax, thus creating a crayon that produces a greasier, more buttery stroke. Since the pigment is encased in an oily substance, the oil pastel is less friable and will not smear unless strong pressure is applied, and even then in a very minimal way. Oil pastels aren't a new medium by any means; however, they have never achieved the popularity of the standard pastel.

Only since about a dozen years ago has there been a slight resurgence in the popularity of oil pastels which, however, are still produced in cheap, vulgar assortments, mostly for children. Due to their greasy character, oil pastels are often mistakenly equated with what are commonly known in our country as wax crayons, rather than pastels.

I like oil pastels, but they leave most professional pastellists cold. Part of the reason, I suppose, is the difficulty in obtaining a decent set. Talens makes a superb product called Panda oil crayons which are not only a delight to handle, but permanent as well! Like many other treasures in our civilized society, they are a problem to locate. I live only minutes away from New York City where everything legal or illegal can be obtained at a moment's notice, yet, months go by without my being able to procure a box of the Panda pastels. Perhaps this lament will touch the hearts of the Talens people and induce them to fill the shelves of the art stores with this superior product.

In any case, oil pastels should be tried by every artist interested in pastel. They can be used as is, dipped in medium such as turpentine or mineral spirits and used "wet," applied to a surface moistened with a medium, *painted from* by lifting the color off the stick with a turpentine-moistened brush, *painted over* with a wet brush on the painted surface, and used in various resist-and-scratch techniques. The possibilities are many. Oil pastels permit most of the manipulations accorded to standard pastels and present a broad area for experimentation for the ambitious and inquisitive artist.

I strongly advise you to buy a set and let yourself go with them.

Besides the Talens Pandas, oil pastels are manufactured by most art supply firms, both in this country and abroad. The better-known brands include the Grumbacher line, and the Sakura Cray-pas which offer a very respectable professional assortment.

Watercolor Pastels

There's a product which can technically be called a watercolor pastel. It's soluble in water and produces effects similar to those performed in conventional watercolor. The method is to paint with the crayons in the usual fashion, then run a wet brush over the painted surface to create liquid effects.

This product comes in crayons and in pencil form.

Conté, Payons, Mephisto, and General are but a few of the water-soluble crayons or pencil brands.

Wax Crayons and Other Types of Crayon

I suppose that crayons (and in this context, I'm referring to the medium not to the pastel stick) don't really belong in a book on pastels, but I feel that the medium is worth a mention here due to the close kinship that exists between crayons and pastels.

Crayons are, basically, pigment mixed with an emulsion of wax, paraffin, or oil—or combinations thereof—then rolled into a convenient stick form. The

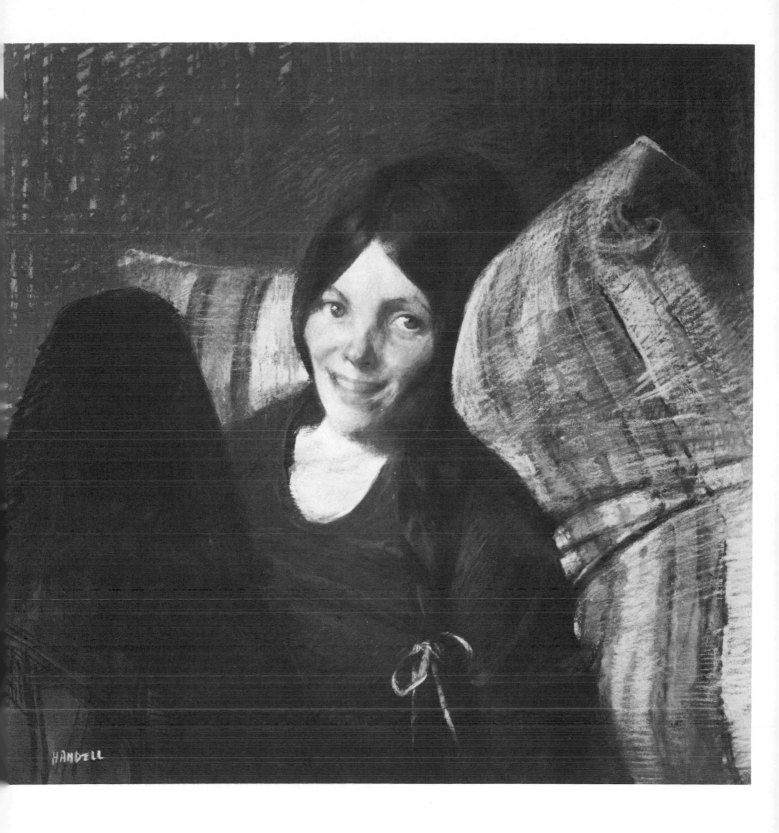

Diane Smiling *by Albert Handell, pastel on board, 18½" x 18½". Gay and carefree, this is a fine example of the informal portrait that for the professional artist is a welcome respite from the usually more circumscribed commissioned portrait. Observe how deftly the artist has handled the sitter's teeth, which a less-experienced painter might be tempted to draw individually and paint a dazzling white. The background is roughly treated and presents a lively contrast to the bright, youthful features. (Courtesy Eileen Kuhlick Gallery)*

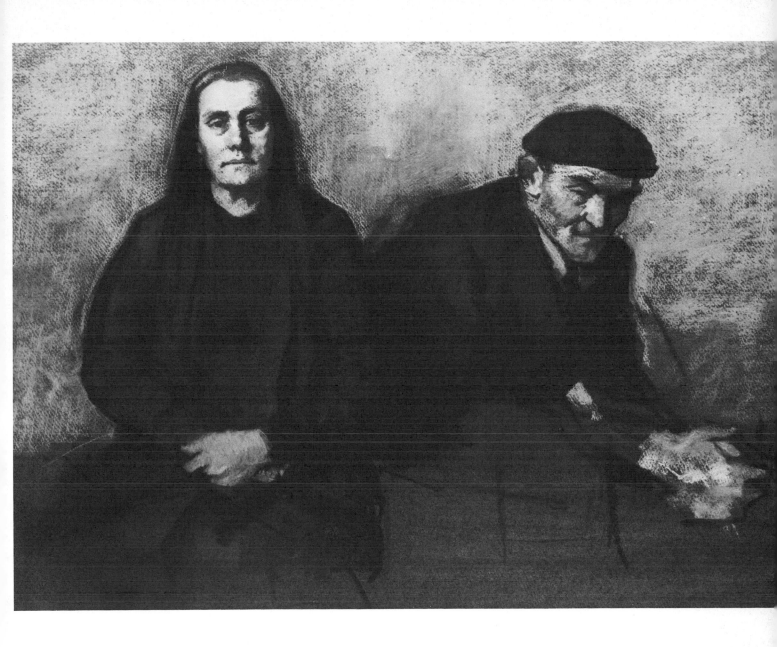

Pietro Valerio *(Left) by Daniel E. Greene, pastel on paper, 29" x 21". In this vignetted profile, the artist outlined the contours of the face in dark crayon in order to bring the head forward toward the viewer and to dramatize the sharp contrasts of light and shadow in the facial planes. The hair is painted almost white against the darker tones of the flesh. The wrinkles and folds of the skin are struck in boldly and incisively. The back of the head is thrown into shadow and softly modeled to concentrate the viewer's eye on the frontal features. The pastel is applied heavily and none of the underlying surface shows through in the painted areas. The artist didn't hesitate to show such minute details as individual hairs in the eyebrows and mustache. (Collection W. D. Conner Foundation, Salmagundi Club)*

Old Couple *(Above) by Harvey Dinnerstein, pastel on paper, 18" x 25". The burdens and resignation of old age are exemplified in the husband—who has already given up all hope—and the wife—who retains traces of a proud defiance against the tyrannies of time. The artist used the black of the costumes to hint at the imminence of death. The woman's face is more intricately rendered and is clearly intended to attract our eyes first. Note how roughly the hands of both subjects are painted—nearly blobs in the case of the man. The entire mood of the painting is strongly dependent upon the way the subjects are sitting—she, erect in dignity, he, bowed in surrender. (Collection Mrs. Leslie Jamison)*

result is usually a transparent, greasy medium which is somewhat similar to oil pastels but which lacks the flexibility, blendability, and versatility of the latter. Wax crayons run the gamut from the rather formidable imported Caran D'Ache colors to the cheapest grades sold in the dime store. They can be used in a great variety of ways—from pure painting to resist techniques, but this is neither the time nor the place for such discussion. For those of you interested in crayon painting, there are several books describing the medium. Two that come to mind are:

Introducing Crayon Techniques by Henry Pluckrose (Watson-Guptill Publications, 1968) and *Painting with Crayons* by Norman Laliberte and Alex Mogelon (Van Nostrand Reinhold Company, 1967).

Actually, you can achieve a high level of professional performance from the humble wax crayon; and in the hands of the skilled artist, it's a perfectly respectable art medium. I have enjoyed working with Talens' Wasco, and with Crayolas and Crayonex crayons.

Conté Crayons and Pencils

A product often employed in conjunction with pastel painting is the well-known Conté line of crayons and pencils. Conté comes from France and is named for Nicolas-Jacques Conté, an inventor and amateur painter who is credited with the development of the graphite pencil in that country. It's a somewhat fatty crayon, a combination of chalk and oil binder, manufactured in white, black, and a number of earth shades, and is available in stick and pencil form. Many important drawings have been produced in Conté, which closely simulates the traditional red, black, and white chalks employed by such masters as Watteau, Michelangelo, and Rembrandt.

Some pastellists employ the Conté crayons and pencils in conjunction with their pastel paintings. Similar results can be achieved with actual pastel. However, there's no technical or artistic objection to the use of Conté with pastel, since it's an excellent and a permanent product.

Conté comes in three degrees of hardness and in six colors: white, black, gray, sepia, bistre, and sanguine.

Chalks

The word *chalk* has several connotations when it pertains to art materials.

For instance, chalk in powdered form is used as an inert material added to the pure pigment in pastel to render a lighter grade crayon. Chalk is also used to extend or add bulk to oil and gouache paints, to make casein solutions, and mixed with glue or other mediums to form grounds for oil and tempera paintings. What is most commonly referred to as chalk, is a cheap, artificial product used on the schoolroom blackboard or to draw a game of hopscotch on the sidewalk.

There is, however, a natural chalk that was used by the masters. This is a mineral substance mined from the earth and cut into the shape of a solid crayon with a knife or other sharp instrument, and used *as is* without the addition of any other substance. These natural chalks came in white, black, and shades of reds, yellows, and browns.

With the advent of such processed materials as pastels, wax crayons, etc., natural chalks ceased largely to be used as an important art medium. The current Conté crayons give essentially the same effect as did the natural chalks.

However, natural chalks are still available in limited quantities, and for those interested in testing this medium, sources are listed in an excellent book called *The Craft of Old Master Drawings* by James Watrous (The University of Wisconsin Press, 1957).

Making Your Own Pastels

Although the variety of pastel crayons available to the artist is staggering, there are good reasons for making your own pastels. The noted German art expert Professor Max Doerner writes in his *The Materials of the Artist and Their Use in Painting* (Harcourt, Brace & Company, 1962): "An artist who works much with pastel would do well to prepare his own crayons . . . one will be astounded to see what power and depth can be obtained with pastel colors of full chromatic strength . . . one would believe that one had an entirely new material with such homemade color crayons, so powerful and luminous are the tones made with them."

Ralph Mayer, the American authority on art materials and techniques, says in his *The Painter's Craft* (Van Nostrand Reinhold Company, Inc., 1966): "Pastels may be listed among the artists' materials which can be homemade to advantage. The artist is rewarded for the time spent . . . by obtaining a supply of good, practical materials at a small fraction of the cost of ready-made crayons."

The process of making your own pastels is relatively simple. Full instructions are provided in Mayer's *The Painter's Craft* and in his *The Artist's Handbook of Materials and Techniques* (Viking Press, 1970).

The reasons for making your own pastels are, as the aforementioned gentlemen suggest, to obtain a more economical product; to obtain sticks of desirable shade and consistency; to assure the permanence of the crayons; and to obtain stronger, richer, more brilliant crayons.

Permanence

Not the least of the reasons people become artists is man's eternal quest for immortality. Most of us are anxious to leave something of ourselves for posterity. That is the reason for so many "juniors," for bequests to universities establishing chairs in the donor's name, for statues, monuments, etc.

This is also the reason artists sign paintings.

But what a blow it would be to our ego to know that only thirty or forty years following our departure, our masterpieces began to fade or change color!

The only solution is: permanent grounds and permanent pigments.

At best, we must learn all that we can about the permanence of pigments, and how to employ only those known to withstand the test of time. At worst, we must put ourselves at the mercy of pastel manufacturers and to trust their honesty and integrity. So the *second* best way to assure permanence in your paintings is to buy from a reputable manufacturer. The *best* way, of course, is to make your own pastels—though few artists do.

The three leading makers of pastels available in the U. S. are Talens (labeled Rembrandt), Grumbacher, and Weber. All list the permanence of their crayons in their catalogs and color charts, which are available for the asking either from your local art supplies store or from the manufacturer. It would be wise to profit from this information in selecting our colors. Most other brands of hard, semihard, soft pastels, and pencils do not supply this information. In such cases, it would pay to consult a book such as Mayer's *The Artist's Handbook* which lists permanent colors, and to choose only those sticks that bear *the names of colors that are permanent.* In other words, select only those sticks marked "burnt umber, raw sienna, Indian red," etc., not names such as "pistachio green, hyacinth violet," and likewise.

There are artists who aren't overly concerned with the permanence of their materials. Norman Rockwell has said: "Let the next generation paint its own pictures." But Mr. Rockwell is an exception. Most of us do care to preserve our paintings. This is particularly important when you do commissioned portraits. When a client orders a portrait, he's symbolically carving a chunk of immortality for himself, and he's entitled to his place in posterity, at least as far as the physical condition of the painting is concerned. The artist is, therefore, honorbound to use only permanent materials in his painting, and he must learn all that he can about colors, grounds, etc.

I've listed ways of assuring the permanence of pastel colors. I'll discuss the permanence of painting surfaces in the subsequent chapter.

How to Keep and Lay Out Your Pastels

As many artists as there are working in pastel, so many ways are there of keeping and laying out the pastel crayons. These vary from a dozen or so sticks scattered helter-skelter on a drawing stand to a carefully balanced selection of hundreds of sticks, each resting in its own slot in the box in which they came. The way you keep your pastels depends largely upon your personality. If you're disciplined, they'll all lie in clean and inviolate order—wiped, sharpened, pristine. If, on the other hand, you're somewhat on the sloppy side, your pastels will lie heaped all over the place—dirty, messy, mixed beyond recognition.

It's very, very important how you keep and lay out your pastels, since this will decisively affect your painting efforts. Oil paints, once squeezed onto a palette, stay reassuringly put. You know where your white is, where your red is, where your yellow is. Not so with pastels. A stick used and put down seems to

acquire a will of its own and invariably disappears when you need it again. Therefore, you must develop some workable system which will provide the means of locating the crayon that you want at the time that you want it. If I could peek into your closet and see the way you keep your clothes, I could tell you with some degree of accuracy how you'll lay out your pastels. Barring this intrusion, I can only suggest a method meant to accommodate both the fusspot and the slob. But here's a most important note:

Before we can get into any discussion of *how* you should lay out your pastels, it's important to state that *you cannot even consider laying out your pastels until you know each and every stick in your possession like the back of your hand.* To know each stick means to recognize it right off without reading its name and to know how it will look when it's stroked on your paper. Please go back and read the first sentence in this paragraph again. It's that important, because the way you'll use your pastels is predicated on the way you'll lay out your pastels, and both these factors are predicated on the way that you *know* your pastels. You can do this by keeping the sticks separated by hues, assigning a number to each color, and laying them out accordingly. Let's say, white is number 1, yellow ochre is number 2, and so on. You would then keep a layout of your pastels in numerical order.

I'm assuming that you'll buy a set of pastels, or that you already own such a set, rather than purchasing individual colors. As you know, pastel sets come in a dazzling array of assortments, including shades and nuances you'll never use for reasons of impermanence, repetitiousness, etc. Eventually, you'll eliminate the colors that you won't need and select a palette of colors that you'll use in the majority of your work. But since in pastel there can be up to twelve shades of a single color, you might still end up with an assortment of some two hundred individual sticks, each one different from the others.

Before you can go on to lay out these sticks so that they'll be most handy to your method of working, you must learn the identity of each one—its name, rank, and serial number, as it were—so that you may be free to call upon it for the specific assignment it's best equipped to fulfill. So, like the good administrator that you are, you'll make an exhaustive study of the palette of colors that you'll ultimately have selected so that you know each stick by name without first consulting the little cellophane paper that lists its pedigree. You'll do this when the colors are still new, because the cellophane paper has an annoying habit of tearing or falling off at the wrong time, and you'll be stumped as to which number you're holding. It's also most important to know and recognize each stick since you'll know how to replace those that are worn down or missing.

We'll get around to what sticks you might want in a subsequent chapter. For now, I'll only point out a practical way I've developed to keep my own selection. I took a flat dresser drawer from a discarded chest and divided it into six partitions. I then separated *all* my colors into six rough color divisions: the reds,

bright pinks, bright oranges, and red violets; the blues and blue-purples; the greens; the whites, grays and blacks; the yellows; the browns, dull pinks, earth and flesh colors.

This is admittedly a very arbitrary method, but *it works for me*. I fling all my pastels—hard, semihard, and soft—into these respective compartments and go on from there. Since I'm an impulsive worker, I manage somehow to deal with this arrangement, but each artist must determine his own way of laying out his crayons. Dan Greene keeps his pastels in their original slots in the trays in which they came. Aaron Shikler keeps them in little cigar boxes, separated by hue and temperature. Burt Silverman's pastels are thrown about fairly casually, yet he knows where to find the one he wants. It's basically a matter of temperament and personality, but each of these artists knows exactly where to get the particular stick he wants when he wants it. They differ only in the way they keep and arrange their painting tools. I advise you to experiment and to devise your own system of keeping and laying out your crayons. If you're the impulsive type, you may not want to replace a stick into its proper niche each time after you've used it. If you're more disciplined, you would be dismayed by the mess you might find in my studio. You might employ cigar boxes to house the various shades and tints, or invent some other method that's best suited to your method of working and to your personality. But whatever you decide, give deep thought to *how* you'll keep and lay out your pastels. It will have a very significant bearing on all your painting efforts and will show in the result of your portrait.

My Father *by Joe Singer, oil pastel on board, 20" x 16". In this portrait of my father, the novelist and playwright I. J. Singer, I tried to show the strength and resoluteness of the subject. It was painted from a photograph, but I used the photo merely as an anatomical guide for my visual memories which remain sharp even after twenty-eight years. I. J. Singer was a highly disciplined, tough-minded man who faced his creative task with total dedication but with not a trace of temperament. I employed the portraitist's prerogative to show him looking rather grim, although he was essentially a pleasant and gregarious person.*

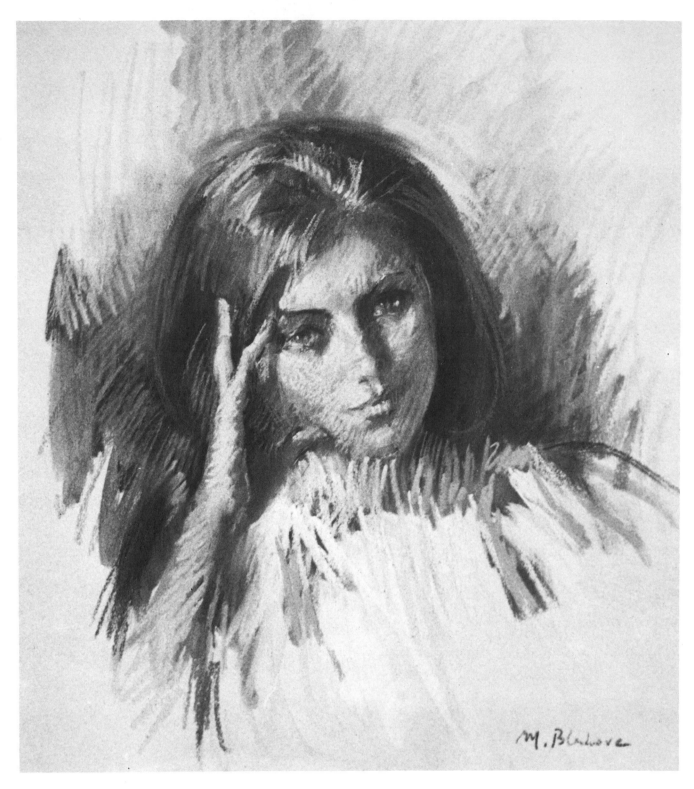

Portrait of a Young Woman *by Marcos Blahove, pastel on paper. Painted in a free, bravura style, the portrait is made up of a number of short, choppy strokes that fall basically into the pointillist technique. The artist doesn't necessarily follow the shape of the forms but works against them in certain areas such as the right cheek, to achieve a lively, animated effect. Note the treatment of the sweater, which is a series of broken, vertical lines without any contours whatsoever. Only the hair on the left side of the subject is painted as a solid mass. The entire impression is one of verve and sparkle, which goes admirably with the subject's pretty, young face.*

Painting Surfaces

Actually, you can paint with pastels on almost anything that has tooth (roughness of surface), from wrapping paper to walls. Prof. Max Doerner writes that Wilhelm Ostwald, the chemist, recommended painting murals in pastel. But the medium is best employed on traditional pastel grounds—paper, boards, and canvas. However, I'll list some alternate possibilities as well.

Paper (Unmounted)

The most commonly used surface for pastel painting is unmounted paper. The pastel portraits that have come down to us from the sixteenth century and are still as fresh today as the day they were done were painted on paper. Paper is the most logical, the most easily obtainable, the least expensive ground for pastel painting.

There are many kinds of papers used for pastel painting; however, it's vital that no matter what type you ultimately select, make sure that it's made up of 100% rag content to help assure permanence in your painting.

There are essentially three types of pastel papers available: the fibrous, the granular, and the cloth-coated. The fibrous is the most common and resembles the usual drawing and watercolor papers. The granular is covered with glue into which pumice stone, sand, or marble dust have been sprinkled. The cloth-coated simulates velvet, felt, or velour. The first two types are both quite good but the third is an abomination. The granules easily dislodge from the latter and the strokes look slick, like paintings on velvet.

You aren't honorbound to use the so-called pastel paper for pastel painting; some artists prefer charcoal paper. However, charcoal paper, besides being rather slight for pastel manipulation, is also crisscrossed with the most annoying grooves running through it, which doesn't make life any easier when you're struggling with all the other annoyances inherent to painting. Why do things the hard way? Use charcoal paper for charcoal and pastel paper for pastel.

One of the best fibrous pastel papers is the French Canson Mi-Teintes line. (It's preferable to buy the bigger size—21″ x 29½″—since for some crazy reason it's a *heavier*, that is, a thicker paper than that made in the smaller size.) There are other fibrous papers probably just as good.

Of the granular papers, Grumbacher, Weber, and Morilla among others, make sand-coated papers.

The wonderful marble dust papers and boards are, unfortunately, no longer available, and their loss is deeply mourned by pastellists who regret the demise of this useful product. Wouldn't it be a blessing if some enterprising manufacturer decided to make available again a marble dust surface for the army of eager pastellists, a gesture that would assure him our eternal gratitude?

For those anxious to try the cloth-coated papers, these too are manufactured by leading art firms and are available in art stores.

In addition to the aforementioned brands, there are many other foreign and domestic papers available to the pastellist, the only requisite being that they be of all-rag content (if intended for serious work) and heavy enough to withstand vigorous pastel manipulation.

Boards

Many pastellists prefer the firmer resistance of a board to the greater resilience of paper. (Boards are papers mounted on to a firm cardboard.) There are a number of boards made especially for pastel, principally, the sand and velour surfaces mentioned in the paper section.

Grumbacher manufactures sanded boards in the same surfaces as its pastel papers, as well as a velour board in three colors. Morilla also manufactures pastel boards, as do other companies. The reason I hesitate to name brands is that so often, products and even companies in the art supply field drop abruptly out of sight. Of the products that *are* manufactured, many are most difficult to track down.

There's no technical reason why an all-rag board—even if marked for illustration or watercolor purposes—can't be used for pastel painting; the only consideration is whether it will accept the pastel crayon successfully. First, the surfaces marked "rough" or "cold pressed" would probably take the pastel better. However, the boards are usually made in white only and most pas-

tellists prefer to work on colored surfaces. (I'll discuss this subject later.) Second, these boards sometimes *do not* offer a sympathetic surface to pastel. Some artists can and do work on them, some can't and won't. My only advice is that you try a few of these boards and see how they work *for you*. Never be a slave to convention. Make your own judgments about all art products. Some of Lautrec's finest works were painted on what appears to be plain cardboard.

There are other boards that can be used for pastel work. The Crescent Company manufactures a colored drawing board in twenty-eight colors and a so-called Charko Board in three colors. Both these products take pastel readily and I've used them with success. However, storekeepers will sell them only in lots of twenty-four sheets. There's no mention as to whether this is an all-rag product or not, however.

There's an excellent board made by Anjac, called the Multimedia board, which comes in six surfaces and which can be used effectively for pastel. This is another product that seems to be very hard to find.

There are other art boards manufactured. Never mind if they're marked for purposes other than pastel. Buy those that strike your fancy. You never know— perhaps one of them will draw forth from you the results that you've been hoping for.

Pads and Rolls

Canson Mi-Teintes and Morilla make pastel paper in pads. There are also pads of watercolor, drawing, and charcoal paper that can be used for pastel purposes. Strathmore, Morilla, and most major paper manufacturers produce such pads, which can be used for sketching, practicing, and other pastel uses.

The Mi-Teintes paper is also available in rolls eleven yards long by fifty-one inches wide. These are handy for pastellists who need an extra large or an oddly shaped sheet.

Canvas

Some pastellists like to work on pastel canvas. The canvas is drawn on to stretchers exactly as in oil painting, and the work proceeds accordingly.

Manet did several striking pastel portraits on canvas. Other major pastels have been painted on canvas as well. Pastel canvas is (or was) manufactured by Grumbacher, by Fredrix and by Weber, in sand and in velour surfaces.

Artist's canvas is woven of flax, hemp, jute, and cotton. The best, for pastel purposes, is the linen woven of flax. Ralph Mayer's *The Artist's Handbook* provides precise instructions on how to stretch canvas on to stretchers.

Panels

The classification *panels* encompasses many products of various origin. There are panels made of wood, of compressed wood, and of plyboard; panels that are sized with glue and left unprimed; panels that are pre-pared with surfaces of gesso (a mixture of chalk, whiting, or plaster of Paris mixed with glue, gelatin, or casein); and panels that are made with oil grounds. There are many combinations and variations thereof, including panels of metal and even of glass.

There are aslo the so-called canvas boards, usually a cardboard to which cloth has been pasted.

Although most of these grounds are intended for oil painting, they *can* be used for pastel painting. Again, I advise the experimenting pastellist to consider only those surfaces that are designated for permanent performance. This can be determined by purchasing from reliable manufacturers who aren't reluctant to state the ingredients and the composition of their products.

Other Surfaces

Technically, as I've already mentioned, you can paint pastels on almost anything. Practically, however, paper (mounted and unmounted) and canvas suffice for most pastel work.

For those who like to experiment, it's possible to paint on muslin, linen, or taffeta which has been roughened with pumice or covered with glue into which some substance such as marble dust, pumice, or silica (in powder form) has been sifted—or on just about any surface that will accept and hold the pastel particles.

Other surfaces mentioned in connection with pastel are roughened vellum and genuine parchment which is made from the dried skins of animals. (I don't know about you, but I wouldn't like to paint on a dead animal.)

Preparing Your Own Surfaces

Many of our prominent pastellists prepare their own surfaces to accommodate their own style of working, or to achieve special effects. The methods of preparing these grounds may vary, but the finished product is usually a pebbly, granular surface with a roughness geared to the particular demands of the artist.

To prepare your own surface, it's best to begin with all-rag paper mounted on a firm board, like the ragfaced illustration board or watercolor board, which you can purchase at any art supply store. You then buy pumice, silica, marble dust, or sand from a dealer who specializes in these products. They're listed in the classified telephone directory and probably in other metropolitan center phonebooks.

Then you either mix the granules (sand, pumice, marble dust, etc.) with a gesso solution and spray or brush the mixture on the board's surface. Or you can paint or spray the gesso on the surface then sprinkle the granules into the wet surface or substitute white casein for the conventional gesso or a coat of acrylic gesso which makes for a most pleasing surface and mixes well with the granular material. Prof. Doerner mentions using starch paste as the basic surface ingredient.

When you prepare your own ground, you control the degree of tooth it will possess, and may possibly

come up with the formula for a surface that will greatly enhance your work. Degas wasn't afraid to paint on unconventional grounds. He did many of his most striking pastels on sheets of monotype (a wet painting printed from metal or glass onto a sheet of paper) and broke many other rules on his way to becoming the world's foremost pastellist.

There's an additional bonus in preparing your own pastel surfaces. It's the sense of history you acquire, the feeling of belonging to an earlier era when artists' apprentices were thoroughly grounded in the craft of their profession and learned, step-by-step, how to prepare their own materials under the tutelage of experienced masters. In this age of waste, obsolescence, synthetics, and shoddy workmanship, it's a heady feeling to commit the time and dedication to the preparation of reliable, durable materials that are produced with loving care and with no concern for the time and energy expended.

It's a practice worth the consideration of every serious artist.

Effects of Surfaces on the Final Painting

In pastel particularly, the underlying surface can play an enormous role in the final painting. Since pastel is a medium that can't be sloshed across the surface as can the so-called liquid mediums such as oils, gouache, watercolor, tempera, and acrylics, surface and tone can be more significant in pastel painting than in the other mediums.

The surface will also determine how the artist will apply his colors, since it's the tooth that files off and holds the particles of pastel which are released with each stroke of the crayon. These particles are forced into the interstices, or depressed areas of the paper, and held there. The rougher the surface, the more particles the surface will accept. Conversely, a completely smooth paper would repel all efforts to apply pastel to it. These factors play a decisive role on the artist's technique. After you have gained a pretty fair knowledge of your *artistic* inclinations, you can determine what surface best suits your style of working or permits the effects you're after. Assuming that you haven't yet arrived at this stage, I suggest that you experiment with the various surfaces so that you can learn the character and potential of them all, even of the repulsive velour surfaces. The more you come to know about your materials, the greater your chances to conquer and dominate your medium rather than the other way around.

Toned or Colored Surfaces

Pastel usually isn't painted on white grounds. Some artists claim that a white surface cuts down on the brilliance of the pastel; others claim that the pastel colors appear darker when painted on a white ground. There are those, of course, who disregard these contentions and use a white surface without hesitation.

Mindful of the idiosyncrasies of artists, the paper manufacturers offer their papers in a wide range of colors, including white.

However, there are occasions when the artist prefers to prepare his own *colored* grounds by *toning* the surface the color that he wants. He may be after a particular effect and will go over a surface color that he doesn't like, or he has prepared his own surface texture and now wants a tinted ground to work on. Since the paper he has prepared was most likely white in its original form, he now must color (tone) it to his specifications.

This can be done in a variety of ways. You can use watercolor, acrylic, or gouache. You can brush on the color, sponge it on, or spray it on. You can lay in one color or several. You can put down wash after wash—it all depends on what you're after.

But all this becomes academic if you don't intend to let the surface color show through in the finished picture. If you intend to work heavily and cover every inch of the surface with a thick pastel impasto—which is a perfectly legitimate practice—it doesn't much matter what surface color lies underneath. If, however, you intend to let the surface color play an important part in the picture, heed the following remarks.

How to Incorporate Surface Color into Your Painting

The surface color can be an actual part of the pastel portrait. It can serve as the middletone so that the artist need only indicate the light and the shadow areas and leave the middletones blank. Depending on the surface color, it can, likewise, be employed as the light tone or the shadow area.

In portraits that are vignetted (which means that only the head—or the head and shoulders—are painted and the rest is left unfinished) the surface color serves as the background and is, therefore, of deep importance to the overall painting.

Pastel, more than any other medium, is often rendered in vignette form, and especially so the pastel portrait. It's, therefore, most important that the surface color be such as to enhance the finished painting.

In the pointillist method that I'll be discussing in later chapters, the surface color also plays a vital role since the dots of color are spaced apart and the surface color becomes one of the actual colors of the painting.

Therefore, unless you determine to paint corner-to-corner, thickly "impastoed" pastel portraits exclusively, you must give much thought to the color of your painting surfaces. It must be pleasing and complementary, not harsh or gaudy such as to clash with and detract from your finished portrait. Olives, grays, dull ochres, and dull browns are preferable to bright colors in your painting surfaces since they're less prone to compete for attention with the stick colors than reds, oranges, bright yellows, or blues. Generally, white and black painting surfaces are also less satisfactory for pastel painting.

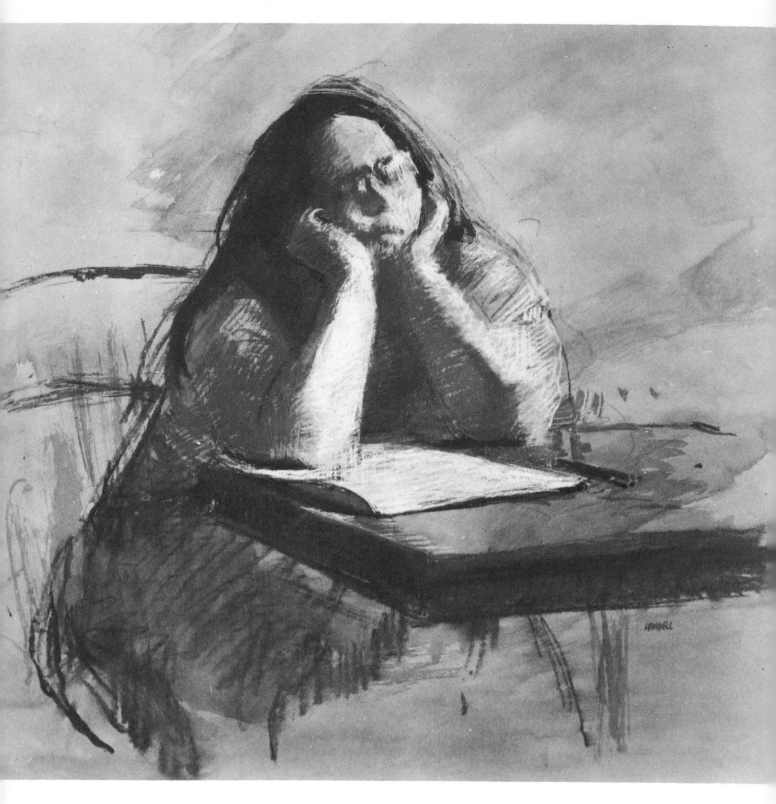

Teresa *by Albert Handell, pastel on board, 18" x 18". Loose and sketchy to an extreme, yet no one could mistake the personality of the subject who so patently is lost in her own thoughts as she looks up from her reading. The total absence of contour lines focuses our attention inside the sitter, and the artist thus cleverly forces us to a deeper, a more analytical visional response. Note how skillfully the features are handled, with a studied "carelessness" that gives proof of the artist's knowledge of portraiture and of his medium. (Collection Mr. and Mrs. Robert Ross)*

Other Equipment

To paint in pastel, you need some other materials besides crayons and grounds. Some of these materials are basic, others superfluous, but I'll list them all and you can decide which of them you can't get along without.

Easels

Easels come in all shapes and sizes from cheap $6 classroom models to $350 jobs with sliding drawers, adjustable thingamabobs, and tilting what-nots. Buy the kind that turns you on, but get something that'll hold your painting firm and in a fixed position. If you can't afford a decent easel—improvise. Surely, if you want to paint badly enough you'll manage to come up with some sort of contraption to hold your painting. Use your lap or the legs of an inverted chair to hold the paper or board, or tack your paper to the wall as Pierre Bonnard did. Or pile books on your kitchen table to make the paper and board tilt toward you. Above all, use your head.

Stools and Chairs

If you're the kind who likes to rest while working, you'll need a place to sit. You'll also need a place for your model to sit. Therefore, get yourself two chairs or stools or benches or whatever.

Art supply stores carry all kinds of folding, tilting, swiveling, and adjustable stools. I use a straight-back kitchen chair—you use whatever stimulates your bottom to the most creative effort.

For the model, on the other hand, you'll need a good comfortable chair, preferably with arms. There's no call to impose a Spartan discipline on a sitter; you're having all the fun while he sits there in a stew wondering if something will come out of all this bother.

Drawing Boards

Because a sheet of paper will buckle, you'll need something solid under it, such as a drawing board. The kind you'll get is, again, a matter of personal choice. Our friends, the art suppliers, offer magnificently sculptured wooden masterpieces complete with

beveled edges, supersmooth varnishes applied by happy gnomes, kiln-dried, golden bodies—the works. Instead, you can take a piece of plywood or Masonite, the back of an old dresser drawer, a sheet of Beaver board or Upson board, Celotex, Homasote, Vehisote, or a piece of cardboard.

Drawing boards (with the paper attached, naturally) are either held on your knees or fitted into the easel. Take your pick.

Work Tables

Work tables, or taborets as they're called when they're sold in art supply stores, are an essential part of your studio equipment. You need a place on which to lay out your pastels, rags, pencils, fixative sprays, paint tubes, coffee cups, cigarets, etc.

Here again, you can buy a table specially designed for studio use—or make do. In this instance, however, a little more care is advisable since the table top must be of a level at which your fingers can easily locate the pastels, etc., without groping, stooping, or bending. I use an adjustable drawing table which can be fixed at any height. It's also advisable to have coasters under this table in case you want to shift positions.

Additional tables and/or cabinets come in handy for storing extra pastels, brushes, pencils, etc.

If you're a well-organized person, you'll soon come up with a sound system for storing your supplies. If you're like me, your materials will be scattered all over your studio, but *you* will know where everything is so long as no one comes in to mess up your mess.

Additional Equipment

In addition to the more-or-less basic items listed above, you may need or want the following materials:

(1) Thumbtacks, push pins, clips, rubber bands, tape. They'll help to keep the paper or board affixed to the drawing board. Dan Greene uses a strip cut from an inner tube to keep the bottom of his sheet flat against the board.

(2) Stretchers. If you use canvas, you'll need wooden stretchers and keys (little wooden wedges) to stretch the canvas on. They're sold in all art supplies stores.

(3) Razor blades. (Single-edge safety razor blades, if you want to keep your fingers). They will help you to cut paper and mats, to make certain corrective manipulations, and to sharpen pastel crayons.

(4) Erasers. The best for pastel is the so-called kneaded eraser.

(5) Charcoal, carbon sticks, and pencils. Some pastel artists use charcoal, carbon sticks, or pencils for preliminary work, for accents, etc. This is a perfectly acceptable, if superfluous practice since pastel will serve as well. However, for those who prefer it, charcoal is sold in various forms (vine, compressed, etc.) and in various degrees of hardness (6B-softest to HB-hardest or 1-softest to 5-hardest). Carbon sticks and pencils also come in various degrees. The difference between charcoal and carbon is too slight to worry about.

(6) Pastel holder. For those who don't want to get their fingers dirty, or who may want to extend the life of a pastel crayon, there's an item called a pastel holder into which you insert the stub of the crayon.

(7) Stumps and tortillons. A stump is a roll of paper shaped into a kind of stick with a sharp point. A tortillon is just about the same thing. Both are used to blend the pastel tones. A fingertip is cheaper, handier, and more easily controlled.

(8) Chamois cloth. A chamois cloth is the skin of a poor goat that has been sacrificed so that fusspots can wipe their pastel paintings. Why encourage the slaughter of animals when an old shirt will do as well?

(9) Sandpaper block. Some people like to sharpen their crayons on charcoal or sandpaper. To accommodate them, manufacturers make a pad of sandpaper glued to a block of wood with a handle.

(10) Acetate sheets (or cellophane). Since pastel paintings smear, a way to keep them pristine until you get them to the framemaker is to preserve them under sheets of acetate.

(11) Tape. Gummed tape is sometimes used to paste the pastel paper to the mat or to hold the pastel paper down if you're combining pastel with water-based paint.

(12) Mat boards and accessories. A mat is the board—with a window cut out—that lies between the pastel painting and the frame. Pastels are almost always framed with mats. The only kind of paper mat that assures permanence for your pastel painting is one made of an all-rag paper, commonly called a museum board. Other mats are made up of impermanent wood pulp paper, cork, felt, or velour, or other fabrics pasted on a rigid cardboard. If you're going to mat, you're going to need something to cut and measure the mats with. There are special mat cutters made for this purpose. You'll also need a ruler.

(13) Pigments, binders, etc. If you're going to prepare your own pastels, you'll need certain materials as enumerated in Ralph Mayer's book: pigments, binders (gum tragacanth or methylcellulose), preservatives (betanaphthol), the precipitated white chalk for the lighter gradations of color, and possibly additional substances such as gilder's whiting or talc.

You'll also need bottles, a mortar and pestle, a spatula, measuring spoons, knives, a slab of glass, a syringe, and other things.

All these items can be purchased from appropriate artist materials and chemical suppliers listed in the classified telephone directory, or in the *Artists' Guide to Art Materials* published by *American Artist* which is printed annually.

(14) Gesso, pumice, marble dust, sand, etc. If you're going to make your own painting surfaces, you'll need casein, glue, sand, gesso, pumice, marble dust, etc. Again, you must turn to *Artists' Guide to Art Materials* or to the classified telephone directory for your sources of supplies.

(15) Surgical mask. If you're concerned about inhaling pastel dust, a gauze surgical mask is a good safety measure when you are wiping, cleaning, or handling your pastels. Such masks are available in drug or surgical supply stores. Personally, I love the smell of pastel dust.

(16) Fixatives and blowers. Whether you spray fixative on your final painting or isolate the intermediary steps, you might find use for a good pastel fixative and a mouth blower or atomizer. There's so much controversy about pastel fixatives that I'll devote a whole section to this question later in the book. For now, I merely mention it as yet another item for possible inclusion in your arsenal of artistic weaponry. Pastel fixatives for blowing or in spray cans are manufactured by many firms. Each makes extravagant claims for its product. We'll look into this question toward the end of the book.

(17) Watercolors, gouache, casein, or acrylics. If you're going to make your own grounds—and even if you're not—you may want to tone your surfaces. For this, you'll need one of the so-called aqueous mediums: watercolor, gouache, casein, or acrylics. I suggest that after you've made a choice of these mediums, that you go out and buy the finest made. Since your painting owes much of its permanence to the surface on which it will be painted, it behooves you to buy the best colors available.

Five or six colors in any line should suffice for your needs. I'd suggest an ochre, an umber, a chromium oxide, a cobalt, an Indian red, and a white. These alone or in mixture should do the job.

(18) All rag illustration boards or Standard Presdwood panels (Masonite manufactures the latter in ⅛" thickness). For preparing your own surfaces or mounting papers.

(19) Brushes, sponges, rags, supports, etc. To apply gesso mixtures or to paint on a tone, you'll need brushes, sponges, rags. My suggestion is that you buy a good wash brush for the toning—one as wide as an inch. Whether you'll be using watercolor, casein, acrylic, or gouache the wash brush will do for all the mediums. To apply the gesso solution, you'll need a good, stiff 2″ cutter bristle brush that you can buy at any hardware or paint store. Or, if you prefer, you can use a sponge or rags. The natural sponges are the best. You'll also need an old plate on which to mix your colors and a jar for water.

(20) Dusting brush. To sweep away dust particles from your painting, your table, and your work clothes.

A final note: Degas sprayed his pastels until they virtually dripped, then worked into them with stiff bristle brushes. If this is something you'd like to try, get yourself some good oil painting brushes—the short-haired bristle kind.

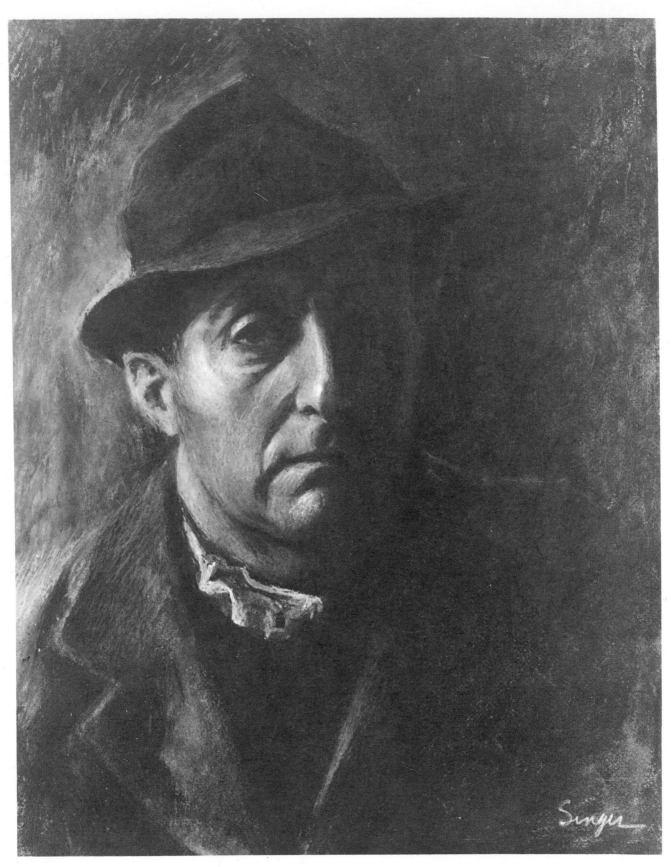

The Man in the Hat by Joe Singer, oil pastel on paper, 16" x 13". This picture is painted in the so-called Rembrandt lighting in which the face seems to float out of and into the background. Details are subjugated and lines are kept soft and subdued. The key is low throughout, the mood—dark and mysterious. I sprayed this painting heavily to see how much abuse a sheet of paper can take. It held up well despite a very heavy coat of oil pastel and repeated coats of fixative. It proves again that pastel (in this instance, oil pastel) can be used in a great variety of ways.

The Palette of Colors

Pastel, not being a liquid medium in which a few colors can be blended into infinite combinations through admixture, requires a separate stick for every tone and hue. The assortment can run as high as four hundred to six hundred crayons in a single line of soft pastels. If you choose pastel as your medium, you owe it to yourself to learn all you can about every crayon available, even though you may end up using only a fraction of the total. This isn't as formidable a task as it may sound if you remember the principle on which soft pastels are graded.

How Pastels Are Graded

To begin with, every pastel manufacturer bases his assortment on a foundation of some sixty or so full-strength colors (pure pigment to which no white or black is added). Beginning with this basic assortment, white or black is added in gradated percentages to form lighter or darker shades of the pure colors. Each color may thus consist of from four to eleven shades, varying in lightness and darkness.

The major pastel manufacturers employ fairly similar systems to designate the various shades in their lines. Grumbacher uses a scheme in which each pure color has seven shades. A pure raw umber, for instance, is labeled No. 27D. Adding 15% black to the pure color gives us stick No. 27C. Adding 40% black to the pure color gives us stick No. 27A. Now going to the lighter side, adding 15% white to the pure color gives us stick No. 27F. Adding 40% white produces stick No. 27H. Adding 60% white produces stick No. 27K; and adding 80% white produces stick No. 27M. Letters B, E, G, I, J, and L are omitted from the Grumbacher line, except for gray which comes in letters E, G, J, L, N, and O. Some colors don't come in letters A and C. Thus, we end up with seven shades of raw umber in various grades of lightest (M) to darkest (A) with D as the pure color shade.

Talens, which manufactures the Rembrandt line of soft pastels, does it another way. Its pure raw umber, which would correspond to Grumbacher's No. 27D, is labeled No. 408, 5. Adding a mixture of 20% black to the pure color gives us stick No. 408, 4. Adding 40% black gives us stick No. 408, 3. Going the other way

again, adding 20% white produces stick No. 408, 6. Adding 40% white makes stick No. 408, 7. Adding 60% white makes stick No. 408, 8. Adding 80% white produces the lightest shade of raw umber in the Rembrandt line, No. 408, 9. Rembrandt doesn't use numbers 1 and 2 in its line. The Rembrandt gray comes in shades of 5 through 14. Basically, it's the same system as Grumbacher's.

Weber's line comes in four shades of each color, of which the number 1 is the full color shade and the subsequent numbers 3, 5, and 7 represent the lighter shades of the pure color. Weber doesn't use numbers 2, 4, and 6 in its line. Thus, the Weber raw umber No. 431 would correspond to Grumbacher's No. 27D and Rembrandt's No. 408, 5. Other pastel manufacturers—Lefranc and Girault in France, Rowney's in England, and Schmincke in Germany—have systems of their own, which are variations of those listed above.

When it comes to semihard pastels, hard pastels, and oil pastels, these are *usually* made one stick to one color, with no or few lighter or darker shades. The same principle generally applies to pastel pencils.

A Suggested List of Pastel Colors

Here's where an author of a book such as mine takes his life in his hands and embarks on a most dangerous path. For who's to say what colors an artist should or shouldn't use in his painting? There can't be any arbitrary rule dictating what tools a craftsman may use to achieve his creation. Would anyone dare stand over Michelangelo's shoulder and tell him with which chisel to carve David's left ear?

In his *History of Color in Painting,* Faber Birren (Van Nostrand Reinhold, 1965) lists the palettes of some famous artists. They range from Delacroix's opulent twenty-three colors to Rembrandt's spare six. Each of these two masters is acknowledged a superb colorist, yet each chose a different path to attain his artistic ends. If you were to use all of Delacroix's twenty-three colors there's no guarantee that your painting would equal his in color virtuosity, nor would you match Rembrandt's skills with his extremely restricted palette.

Still, this *is* a how-to book and I'll try to guide you in

your selection of colors for your portrait painting needs in pastel.

To begin with, you must employ—unless it's unavoidable—only those colors that are designated permanent by their manufacturer. In this, you must rely on the integrity of the maker. Talens, Grumbacher, and Weber all list the permanence of their soft pastel lines in their catalogs and color charts.

It's in the semihard and hard pastel lines (and in pastel pencils) that you enter a blind area where no designation of permanence exists and where you must protect yourself as best you can by *selecting only those colors which bear a legitimate pigment name,* i.e., light ochre, Indian red, ultramarine blue. Keep away from the pistachios, the peacocks, and the salmons. They're liable to be made of cobwebs and fairy dust and may fade at the first glimpse of sunlight.

Ralph Mayer, in *The Artist's Handbook,* supplies a recommended list of pigments for pastel. These include the usual permanent colors and you certainly won't go wrong in following Mayer's recommendations.

Prof. Max Doerner supplies his own list, which also includes known, permanent pigments.

Both authorities warn against the use of such poisonous pigments as lead white, Naples yellow, emerald green, and cobalt violet, which can cause harm if inhaled.

Now that you know which colors you shouldn't select, you might rightfully ask which ones you *should* select. Bear with me.

Fundamentally, any painter's palette should carry the basic primary colors—red, yellow, and blue—with the addition of white and black to lighten or darken these three primaries. To elaborate a bit further, artists separate the primaries into the warm and cool colors. The warm tend toward the yellow and the cool toward the blue. Thus, the palette might be expanded to include six colors—a warm and a cool of each of the three primaries. This might include a warm red, cadmium or vermilion, and a cool red, alizarin; a warm yellow, cadmium medium or deep, and a cool yellow, lemon; a warm blue, cobalt, and a cool blue, ultramarine.

This assortment can ostensibly produce any hue under the sun. Theoretically, this may be so but I don't know of any artist who uses this supposedly all-encompassing palette. Being human—and even more so by the virtue of being artists—painters select palettes that include some of the weirdest colors imaginable. This is their artistic right and that's the way things are.

But in pastel, especially, such a regimented palette leaves much to be desired. Where are those good earths, browns, grays, and greens?

Another road is indicated.

Begin with the aforementioned palette of cadmium red light, alizarin, cadmium yellow deep, lemon yellow, cobalt blue, and ultramarine blue. Since alizarin doesn't seem to appear on the lists of the three major manufacturers, you might try to fill the void of a good, cool red with one of the so-called permanent reds, which appropriately enough happen to be only semipermanent. Or, lacking this, by including a madder lake which is even less permanent than a permanent red.

Anyway, to these six basic colors, I've added the following:

Burnt sienna, caput mortuum, burnt umber, raw umber, yellow ochre, flesh ochre, blue violet, gray blue, viridian, mouse gray, moss green, olive green, in all the shades of every color. These, plus white and black should suffice for your portrait needs.

Please understand that any list of suggested colors is by its very nature arbitrary, and I strongly advise you to ultimately select your own palette out of the wide assortment of permanent colors that are available in soft pastel. Mine is merely what it claims to be—a *suggested* list.

How Colors Feel And Behave

Color plays a vital role in our daily lives. It helps guide us in the selection of our food, clothing, furnishings—even of our mates. It helps us to identify objects. It affects our moods. People speak of looking at the world through rose-colored glasses, of feeling blue, of falling into a brown funk, of feeling black rage or black hopelessness.

In painting, colors have their own code of behavior. The blues and greens *tend* to recede; the reds and yellows *tend* to advance. Yellows, reds, and oranges *seem* to shout: greens, blues, and violets *tend* toward shyness. If two areas of equal size are painted—one white and the other black, the white one will appear larger.

The above are merely little generalities that I've tossed in to demonstrate some of color's more obvious quirks and mannerisms. To describe the full potential of color requires a book on that subject alone. Fortunately, such books by acknowledged color experts are available. Our concern, however, isn't with color itself but with *color pigments,* especially as they apply to pastel painting.

The various pigments employed in making pastel require different strengths in their binder. The more binder a crayon contains, the harder it becomes. Also the more chalk (white) the stick contains, the softer it becomes and the more black, the grittier it becomes. Thus, the lightest shades of a color are—usually, but not always—the softest. A good point to remember, when you consider that as a pastel painting progresses, it becomes easier to work into it with ever softer and softer crayons, which provides another good reason for working in the traditional way, which is from dark to light.

There are small differences of texture among colors in our suggested palette. For instance, black feels hard and gritty, while raw umber feels soft and mushy. The greens feel generally softer than the reds and blues. What you must do is pick up each of the crayons and rub them, stroke them, dot and stipple them against the surface. Get to know the feel of each color; the way it behaves when it's applied directly to the surface, when it's applied over a heavy impasto, etc. I can write on and on about how the different colors feel

and behave, but an hour spent with the crayons and a sheet of paper will do more to enlighten you as to their feel and character than twenty books.

When you're able to pick out the stick you want without consulting the little paper *sleeve* that contains it, you've gone far along the road to learning the behavior of colors. If you were to adopt the palette I've suggested—this would amount to 128 different sticks (seven grades of each of the eighteen colors plus one white and one black). It would be most helpful toward all your future efforts if you came to know each of these 128 sticks as intimately as you do your own toothbrush which you immediately recognize in the family bathroom. Otherwise, you'll spend valuable time groping and fumbling while your artistic flame dims from impatience. The time you'll devote toward this preliminary getting-acquainted period will be repaid a hundred times over throughout your pastel painting career.

Restricted and Extensive Palettes

Much has been written about the pros and cons of a restricted palette. Experts are sharply divided on the subject, but I've yet to read anything pertaining to the psychological aspect of this question.

Actually, what does it matter how few or many colors an artist uses to paint his picture? The only thing that counts is the end result—the painting. But when I was studying art, I spent endless hours tracking down obscure books that listed the palettes of the various masters, and I suspect that many other aspiring artists share this curiosity. Is it that we secretly fantasy that by using Rembrandt's palette we'll attain his artistry? Does the whole question contain the element of sorcery? Is it a quest for secrets that will unravel the mysteries of art?

There are no secret formulas for painting well. It is, and it has always been, a smoothly working combination of brain, eye, and hand functioning in perfect harmony. It's as simple as that. If Rembrandt hadn't had the colors that he had available, he would have improvised with others. He settled on a palette of colors because he found that they served him well. If he had to, he would have painted as well with other colors. He was a genius and genius doesn't depend on this or that tool. Rembrandt would have painted magnificently with housepaints.

I firmly believe that the reason artists adopt restricted palettes has to do with their personalities. There's a kind of sense of smugness and superiority in knowing that you can produce a good work of art out of four or five colors while others can't manage it with thirty. Also, some men are by nature sparing and contemptuous of waste, which is another stimulant for painting with a limited palette. There are niggardly souls and expansive souls. The artist who severely restricts his palette would more likely be found driving a Chevrolet than a Cadillac, even if he could afford the more expensive car. The guy who likes to live it up, however, and be out on the town every night would be more apt to use every color made. Why not, he argues, it's avail-able, why not use it? And even if he doesn't use it, let it lie there on the palette. Who gives a damn, there's more where that came from. . . .

This, I believe is one of the chief driving forces behind the adoption of restricted or expanded palettes.

Books offer contrasting advice to the beginner. Some tell him to buy a few colors at first, then add to them as his experience grows. Others advise him to buy *all* the colors, then gradually eliminate until he is left with only those he likes and finds useful. Which is the correct approach? Of the two, I lean toward the latter, but with qualifications.

My method was to assemble the complete list of all permanent colors available, then to divide the colors into groupings of reds, blues, yellows, greens, browns, violets, and grays. Next, I compared colors within one group—the reds, for instance—and I began to eliminate colors that were close in hue. For example, cadmium red light and vermilion are closely related so I eliminated vermilion. Indian red, English red, flesh ochre, and burnt sienna are close enough so that I felt that two of these would suffice, and I selected flesh ochre and burnt sienna. Because I couldn't find a permanent alizarin red in pastel, I substituted the fairly permanent permanent red (which I'm not sure is at all necessary) and which really isn't a true substitute for the alizarin. This left me with four reds, if you include flesh ochre and burnt sienna which can as easily be classified as browns.

Next, I went to the yellows. I picked a lemon for the cool and a cadmium deep for the warm. The cadmium pale was too close to the lemon yellow and, therefore, was superfluous. The darker shades of cadmium deep were close enough to cadmium orange, so that I wouldn't need the orange. I then chose the yellow ochre instead of the raw sienna for the dull yellow. This gave me three different yellows.

Next, the blues. Cobalt is a good warm blue, and I eliminated cerulean and manganese which are fairly close in hue. For the cool blue, I chose the well-tested ultramarine. I felt that this would negate the need for the Prussian and phthalocyanine blues which are available, but which frankly I didn't consider necessary.

Next came the greens. Viridian is a good, useful, soft color. Olive green and moss green seemed to fulfill my requirements, and I didn't feel tempted to go for the other greens which appeared to me only variations of the three greens I selected.

Among the browns, I felt that the raw and burnt umbers gave me the grayish and the warm browns I like, and I picked caput mortuum for the rich, deep dark I wanted.

Blue violet, mouse gray, and gray blue seemed to satisfy my gray requirements and black and white completed the assortment.

I ended up with a palette of twenty basic colors out of a possible fifty or so designated as permanent. Is mine a limited palette? Who cares? It's a palette that works for me. I could just as well use the whole assortment or cut down to ten basic colors if necessary. It's merely a matter of personality.

I suggest that you spend less time worrying about

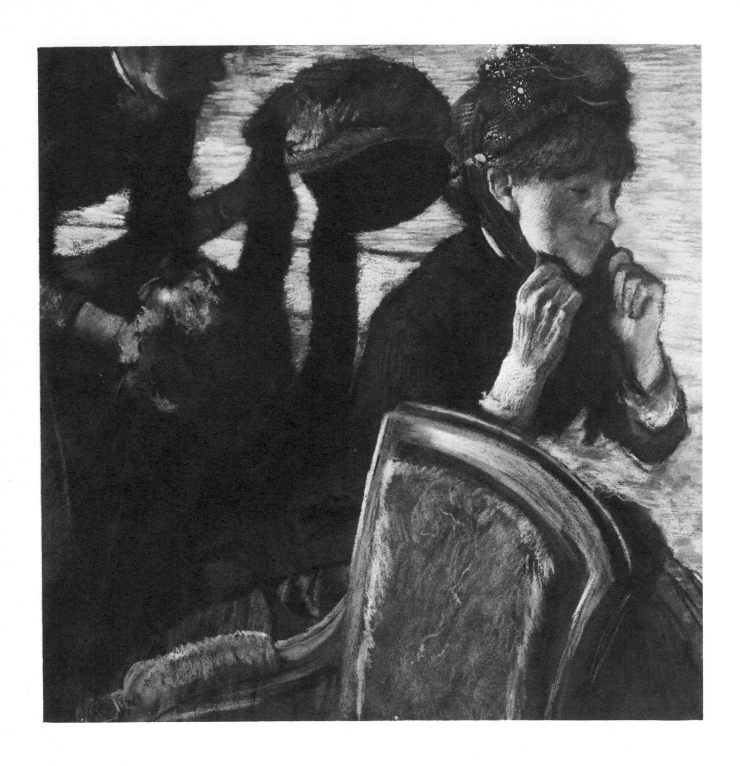

At the Milliner's *(Above) by Hilaire-Germain-Edgar Degas, pastel on paper, 27⅝" x 27¾". This portrait is another splendid example of why Degas is the big daddy of us all. Who else in 1882 would have presented such a daring design? This superb genre of painting breaks every rule of composition—the subject is off to the side with the least "air" and the milliner is nearly out of the frame. Even the top of the customer's hat is partly outside the paper. But the fatal effect is perfectly correct and we can easily convince ourselves that it all wouldn't have worked if the elements had been reshifted, even slightly. (Collection Museum of Modern Art, Gift of Mrs. David M. Levy)*

Six Friends of the Artist *(Right) by Hilaire-Germain-Edgar Degas, pastel on paper, 45¼" x 28". Here is a most remarkable example of the multiple portrait—remarkable in that it consciously transcends every so-called "rule" of portraiture. The six individuals seem completely indifferent to the presence of one another and seem totally lost in their own ruminations, a distinct departure from the usual group portrait which seeks to unify and to establish a cohesive relationship among all the subjects involved. (Collection Museum of Art, Rhode Island School of Design)*

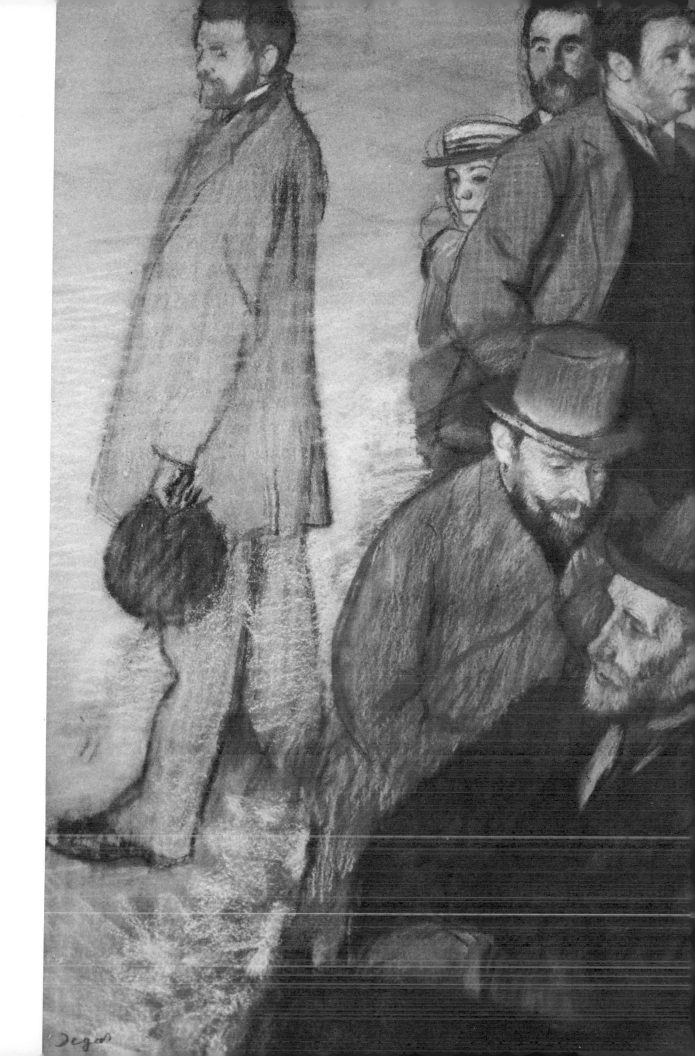

whether you should employ a restricted or an expanded palette, and more time selecting a palette that will work for you, whether it includes seventy-two sticks or three hundred and fifty.

How Many Sticks Do You Actually Need?

No one can honestly estimate how many sticks you'll ultimately need for all your pastel portraits. Even after you've selected a palette that seems all-inclusive, an occasion may develop in which a lady demands that you paint her in her hot pink sweater, and you'll have to run out and get yourself a carmine or a madder lake crayon. Or, you may decide to paint a particularly striking sunset between portraits and you'll discover your palette inadequate for the job.

In any case, I would advise the following procedure: whatever colors you ultimately select, *buy the full complement of shades in that particular color*. This will give you free rein when you're working and not inhibit you in the heat of artistic endeavor. Since Rembrandt and Grumbacher provide seven nuances of each color (Weber clings to a conservative four), the amount of sticks you'll need will be seven times the number of colors you've chosen (except for black and white, which, naturally, come in a single grade).

This will take care of your soft pastel needs. When it comes to the semihard and the hard lines and to pencils, these are made one grade to a color and your selection is thus made much easier.

In any case, I strongly urge you *not* to buy the ready-made assortments prepared by the manufacturers, since they apparently assign the task of selecting the crayons for these assortments to congenital imbeciles who suffer from color blindness besides. I find these assortments top-heavy in ridiculously unnecessary sticks and woefully lacking in basic colors most often needed. The assortments are obviously picked to make the best possible showing when the box is first opened—they simply sparkle with gorgeous pinks, violets, and chartreuses, but their inadequacy quickly becomes apparent after a month or so of steady use. There's a desperate paucity of pure color crayons. One assortment of ninety crayons designated for portraiture didn't contain a single stick of raw umber. It had ten carmines and madders and not a single cadmium red. It had ten violets and only two cadmium yellows. And so on.

Therefore, I advise you to obtain the lists from the leading pastel manufacturers, and after making your selection, to buy the sticks you need either individually or in boxes of six, however your dealer will sell them to you.

Exercise the same selectivity when buying the semihard and hard pastels and pencils, and you'll end up with a good, well-rounded assortment of useful and reliable sticks.

Economy of the Masters

A final word about the economy of colors practiced by the masters. Although there are all kinds of books written on the alleged limitations the masters placed upon their palettes, no one really knows for sure how many colors Rubens and Van Dyck used in their paintings. At best, any definitive statements categorically listing the palettes employed by the masters are pure supposition. Possibly, they employed a certain more-or-less fixed palette for most of their work, but who is to say that they didn't deviate from this palette under special circumstances? Maybe they were out of raw sienna at the time and used a yellow ochre instead? Maybe they were away from their studio on a portrait commission and had to substitute? Would a giant like Leonardo da Vinci hesitate to use a malachite if his terre verte wasn't available? Wouldn't Goya use a fugitive lake for some special effect he was after? Only amateurs and dilettantes commit themselves to hard and fast rules concerning painting and fret about limiting their palettes. The masters were men of breadth, scope, and pragmatism. To them, colors were merely tools with which to achieve their goals and they'd freely use whatever instrument helped them toward that direction.

Tony by Albert Handell, pastel on paper, 24" x 20". A powerfully modeled study of a young man in which the artist used the side of the pastel on the shadows and halftones, in accord with the time-tested practice of thin shadows and opaque highlights. Note how darkly the whites of the eyes have been painted, nearly the same value as the rest of the face. The strokes of the crayon generally follow the shapes of the planes so that there's a definite three-dimensional feeling. The light areas are those that project toward us; the dark ones seem to recede. Note the simple yet effective handling of the hair—as one overall mass. The outer contours of the face are artistically treated, loosely and roughly, not as a sharp line as in a cutout. (Collection Harry Smith)

June *by Joe Singer, oil pastel on paper, 10" x 10". I chose a fairly high key for this portrait of my wife who is a fairskinned, golden blonde and has a sunny disposition. I applied the oil pastels heavily, actually pushing the medium to see how far I could go with it. I used not more than four or five sticks for the painting, and kept one overall color scheme, except for the blouse which is green. I find oil pastels especially good for painting flesh tones. (Collection Mrs. June Singer)*

Exercises and Manipulations

To paint with pastel, you obviously must know how to handle the medium, how to make it do what you want, how to bend it to your will, how to make your craft serve your art, how to make the pastel crayon the instrument of your artistic endeavor. All this may sound like a herculean undertaking, but it really isn't. What it boils down to is knowing what your painting tool—in this case, the pastel stick—will do when you touch it to the surface (for simplicity's sake, I'll call it paper, which you'll understand to apply to all surfaces).

Knowing the Properties of Pastel

Knowledge represents a deep study of a subject. To get to know pastel, you must study its properties, its capabilities, its potential, its limitations. Pastel can do many things. There are some it cannot do. It can't be used to glaze, for instance. To glaze means to lay a transparent veil of color over another color so that the one underneath shows through the top layer. With pastel, glazing isn't possible in its truest sense.

Another factor that doesn't exist in pastel is the transparency and opacity of colors. Pastel is a dry medium, therefore you can't lay a wash with it the way you might in watercolor. But then again, if you wanted to paint in a liquid medium, you wouldn't have taken up pastel, would you?

Now that we know what pastel can't do, let's consider the manipulations that *are* possible with pastel, and delve into these at some length.

How to Hold the Stick

If you're going to paint in pastel, you're going to have to hold the stick in your fingers in order to make an impression on the paper. In pastel, your fingers can almost be said to be the brush handle, and the crayon—the brush hairs. Pastel is probably the most intimate painting medium, since it allows the artist to get physically closer to the painting surface than does any other medium. This helps to forge a kind of bond between the hand and the paper, which allows or should allow a greater control over the painting process. And since the pastel colors can't be previously mixed on a palette but must be put down as they are on the paper, this makes it imperative that the painter know precisely what will occur when he applies stick to paper.

The first thing to learn, obviously, is how to hold your painting tool—the pastel stick.

When working with soft pastels, my usual method is either to break the stick in two and, holding the stick between thumb and the first two fingers, to lay the color in with the *side* of the stick, unless—and these are important exceptions—unless I decide to work more toward the pointillist method, which I'll explain later, and which employs dots of color rather than broad, painterly effects. Another exception is if I decide to *draw* rather than *paint* with the crayon.

When working with hard pastels or with oil pastels, I try to keep the sticks whole and use the *point* of the crayon to put down the colors.

The hard pastels are usually square and they allow you to draw a fairly thin line if you so desire. They can also be sharpened to a point, which the soft pastels can't be.

Does all this seem confusing? It shouldn't. Basically, it comes down to this: when you're painting with hard pastels or oil pastels, when you're working in the pointillist method, or when you're drawing rather than painting, use the tip of the stick (usually, but not always). When you're painting with soft pastels in other than pointillist techniques, use the side of the stick (usually, but not always). When you're painting with hard pastels or oil pastels, use the whole stick; when you're painting with soft pastels, use a half stick.

The way you *use* the pastel stick will be dictated by the way you *hold* it. When you paint with the tip of the crayon, your hand is naturally held at a slightly different angle then when you're painting with the crayon's side. This is a natural action and you needn't become overconcerned with it. However, you should try not to let your wrists become too rigid and tense. This will cause less strain on your hand and tend toward a less-forced and an easier technique.

By all means find your own method of holding the crayon, just as long as it lets you switch from point to side without too much effort, and as long as it doesn't tire you too quickly.

EXERCISES AND MANIPULATIONS 43

Methods of Applying Pastel

Pastel can be stroked; dotted; laid in thickly; scumbled; rubbed with fingers, rags, or stumps; painted into with a brush; fixed (which means sprayed with fixative) and refixed; the stick can be dipped into fixative and laid on wet. The possibilities are broad. Degas, as I've said, let steam drift over his paintings and he worked into the wet mass. With oil pastels, you can employ the scratch or so-called resist techniques. Many, many manipulations are possible. I advise you not to lock yourself in too early in your career into one particular way of using pastels. Test and experiment with them all. Otherwise, you might become prematurely embroiled in tricky and exotic manipulations that will lead you further and further away from your prime task which is acquiring a thorough knowledge of the medium.

Therefore, let's consider some of the ways of using pastel.

Laying In Colors

To me, laying in means simply to cover an area of paper with a coat of pastel. This is a basic procedure, one that you'll be employing in most of your work, since a basic principle of pastel painting is: it's easier to paint with pastel on pastel, than it is to paint with pastel on bare paper.

To lay in an area of pastel, take a half stick of soft pastel and, using its *side*, make a row of strokes one next to another until you've completely covered a rectangle approximately 6″ x 4″. This should have taken you four strokes to accomplish.

Does your pastel coat seem thick and dense, or is it skimpy and wishy-washy? Do it again. This time, try to do it so that no paper shows through the layer. Did you apply the pressure so hard that the stick crumbled? Do it again, making sure that the coat is heavy and dense but that the crayon didn't crumble. Are you nervous watching your precious pastel stick disappearing under your fingers as you work? Forget it. If you're a parsimonious soul who can't stand to use up his art materials but enjoys watching them lying in neat rows in the box, *force yourself* to use them generously—even extravagantly. It's good for your artistic soul. It'll free you of certain psychological shackles that have stifled the development of many potential artists. In art school, I ran into more than one budding genius whose career never matured because he was too inhibited to squeeze out an extra blob of color, or to lay in a rich impasto. There is much more to this than you may imagine.

Trainees in the U.S. Army are given a minimum of rifle practice while the Marine Corps provides more than *twice as much* rifle practice as the Army, and the result is that Marine trainees are much better equipped for their combat duties. By allowing them a generous supply of ammunition, the Marine Corps trains men more inclined to *use* their rifles under combat conditions. Since a major problem in combat is men who *don't fire their weapons at all*, the practice pays off. It's the same in art, if you don't mind the

Laying in. *The tone was laid in with the side of the crayon so that the underlying surface is fairly well covered. Another coat over this constitutes building up.*

analogy. Through constant use, you acquire a familiarity and a kind of naturalness toward your materials and tend to think of them less as formidable impediments and more as helpful tools to be used freely, confidently, uninhibitedly.

Make at least twenty-five 6″ x 4″ rectangles, using different sticks each time. When you're done, make twenty-five more. You'll be surprised at how much you'll learn about the crayons, about their effect on paper, and about your own ability to lay in a good, rich pastel coat.

Crosshatching

Now that you've learned to lay in a pastel tone, let's go on to other exercises. Take one of the soft pastel sticks and stroke a series of vertical lines, one next to the other so that they run some 6″ x 4″. Run the *same* stick over this area, but this time, horizontally. This is called *crosshatching*. When it's done with two different colors, the result is a netlike blend of the two colors in an interesting, lively effect. Do it again, only this time do the first series of lines horizontally and the second vertically.

Now, run another series of vertical lines in *red* and the horizontal lines in *green*. Do you see how colors behave in such a mixture? Now reverse the process, using the green underneath.

Next, run the lines farther apart. Now, try them closer together.

Take two other colors and crosshatch them in all possible ways. Keep mixing the combinations until you've learned something about some of the different effects possible.

Now, try crosshatching by running the lines in opposite diagonals: one down from left to right, the other up from right to left. Try varying the pressure on the crayon so that some lines are light, others—heavy. Try waving some of the lines so that they run snakelike rather than straight. Pick up a hard pastel and make a series of soft and hard lines.

Are you beginning to note the differences in hardness, in color, in combinations of lines and colors? The variations are so numerous that I can't even begin to list them. I can only advise that you sacrifice ten dollars' worth of pastels if necessary, but that you try every possible combination of grade, color, and direction. If you pursue this practice vigorously, you'll gain much valuable knowledge in the behavior of pastel. This, and the other exercises suggested, are absolutely vital to your future as a pastellist.

Juxtaposing

After you've exhausted every possible method of crosshatching, try the following. Set aside some fifteen to twenty sticks of various colors, then picking up any one, run a thick stroke down the paper about 4″ long. Now, pick up the next stick and run a stroke right next to the first so that they abut. Do this with six colors, then repeat the first color, the second, etc. After you've completed three sets of six colors each,

Multiple crosshatching. *Up and down lines were laid in, then crosshatched with vertical and diagonal strokes.*

Diagonal crosshatching. *Running lines in opposite diagonal directions create a basketweave effect.*

Continuous line crosshatching. *This was accomplished in one unbroken line that run side to side then switched to an up and-down direction.*

Horizontal juxtaposing. *The strokes are laid from left to right (or vice versa) instead of up and down. The tip of the crayon is used.*

Vertical juxtaposing. *The strokes run up and down. Again, the tip of the crayon is used.*

Juxtaposing. *Here, the side of the crayon was used to achieve a broader effect. Naturally, juxtaposing can also be done in a horizontal direction.*

mix the order of the colors. Make number 1 number 3, number 2 number 1, and so forth.

Do this again and again until you've exhausted the possibilities. Now substitute another color for one of the six. Make more patterns. Switch, substitute, experiment. This method is called *juxtaposition*, the placement of colors next to each other in order to create interesting visual patterns. At this point, you're less concerned with color and more with the methods of applying pastel, but there's no reason why you can't learn about both at the same time.

Try all the juxtaposing combinations you can manage. They're infinite, but the information you'll learn is well worth the effort expended.

Dotting

You are undoubtedly familiar with the work of Georges Seurat and Paul Signac. These two were the exponents of a practice called pointillism, which in effect, is the placement of dots or strokes of different values or colors close to one another so that seen at some distance, they form shapes and masses of color. To simplify, I call this process *dotting*. It's not, as is widely supposed, a discovery of these two nineteenth-century French artists. Vermeer used it with great effect in some of his hauntingly beautiful seventeenth-century Dutch interiors, and other artists employed the principle, if sparingly, long before the impressionists. But whoever introduced it, it's a most valuable painting method and certainly worth every pastellist's attention.

Select six pure color crayons, then using the *point* of the stick, dot in small dabs of different color in conjunction with one other. Now stand back and observe the result. Is it dull and gray or is it alive and scintillating? Try different approaches. *Without drawing an outline,* form the shape of a house, using dots only. Are you beginning to see the possibilities inherent in this technique?

Switch the colors and try other shapes, forms, and color combinations.

Next, use *strokes* of color, perhaps only ½" long, instead of the dots.

Next, make the dots bigger. Then, *vary* the size of the dots or strokes; make some big, some small.

Next, *combine dots and strokes*—first, of the same size, later, of varied sizes.

The variations are endless. The rewards—if you're deeply interested in the pursuit of all knowledge concerning pastel—can be fascinating.

Scumbling

In oil painting, when you run a color rather sparely and loosely over a second area of color, leaving some of the first color showing, it is called *scumbling*. It differs from glazing in that glazing is a *total* coverage of the first color, albeit a transparent coverage. The practice of scumbling is calculated to liven or to mute —as the case may be—a dead or a too strident area, to add sparkle, to fuse distracting elements, to cool or

Scattered dotting. *The strokes run in all directions.*

Pointillist dotting. *Here, the tone consists of small dots of approximately the same size.*

Stroke dotting. *The strokes all run up and down and are fairly regular in length.*

Stroke and pointillist dotting. *This is a combination of dots and strokes running every which way.*

Scumbling—dark over light. *A light tone was laid in first, and a darker crayon is worked over the area.*

Scumbling—light over dark. *Here, the process was reversed. A light stick was worked over a darker tone.*

Multiple scumbling. *Over a medium-toned surface, a dark and a light crayon were used to scumble.*

to warm up a whole painting or a part thereof.

In pastel, scumbling is one of the most valuable practices known. Unless you are so scientifically oriented that you know exactly how your painting will turn out and you never make a false move, you'll scumble—particularly when your portrait is nearing its end.

An example. Take your cadmium red in a middle shade and lay in a solid area 4″ x 4″ square. Lay the color in with the side of the crayon so that a thick coat of pastel is left on the paper.

See how strident and hot the area is? Now pick up an olive green, either in soft or hard grade, and gently run the *tip* of the crayon here and yon across the red square, not covering entirely but wandering across the surface. Now, examine the area again. See how much cooler and subdued it has become? Scumble some more, examine again. The section has gone quieter. Now scumble until the red is nearly gone. The area has gone quite dead, hasn't it?

Repeat the same procedure with two other colors. Scumble with blue on yellow, violet on green, red on blue, etc.

Now lay in an area of gray and scumble some cadmium yellow over it. Notice the area growing livelier?

Unless you're an automaton with rigidly programmed movements, you'll scumble and scumble again, just as I do even after having completed hundreds of commissioned portraits.

There's absolutely nothing wrong with correcting your painting, which is what scumbling essentially is. The only responsibilities an artist must accept is first, to admit to himself that in nearly every instance a painting *needs* correction, and second, that he knows *how* to make these corrections and adjustments.

Scumbling is invaluable to the portrait painter. It has bailed me out of many critical situations and I recommend that you learn it, practice it, and revere it.

Building Up

If you've followed my suggestions and practiced laying in a pastel area, you'll have at least a dozen 6″ x 4″ rectangles of such solidly laid-in areas. Pick one of these rectangles, then take the *same stick* in which you did the original, and with the side of the crayon, lay in another coat of pastel directly over the first.

This, in essence, is building up. It follows the traditional painting procedure in that coat after coat of paint is applied until the painting is done.

After you've applied the second coat, lay in a third, a fourth, a fifth coat. Use the pastel boldly and thickly, seeking at all times to completely cover the layer below.

Now, pick another of the squares, and make the second coat with *a different color than that of the original layer.* Make the third coat a still different color, and so on through the fifth layer. Do you see now that pastel is not the fragile, ethereal little medium you once believed it to be? It can, as you have found out, be applied thickly and heavily so that it expresses depth, strength, and virility.

Take another rectangle and *four new colors* and

repeat the procedure; only this time, run the stick in *opposite* directions for each coat. For instance: the second coat from left to right, the third from bottom to top, the fourth from right to left, the fifth from top to bottom.

Building up is one of the basic pastel painting manipulations and you must practice it again and again until you can lay in a coat of pastel over another coat of pastel swiftly, boldly, and with assurance.

Blending

Blending pastel can mean many things. To me, it means using something other than the pastel stick itself to fuse colors or tones together. In other words, artificial manipulation, be it with a finger, a stump, a rag, a brush, or what have you.

The practice of blending or rubbing in, in pastel, is a dangerous one since it can lead the immature pastellist to excesses, to a finished painting that is slick, sweet, and precious. Blending is all right if done sparingly, or if the area is gone over with additional broken strokes of the crayon. Left as is, a blended area appears like a poor illustration.

Strangely, most laymen when they think of pastel envision a thinly painted, lightly colored picture (usually of flowers) that is completely blended and rubbed so smooth that it seems to be blooming. Yet, *this is the technique used least by professional painters*, at least these days. This misconception is probably born of the fact that most *bad* painters rub and blend their paintings to death.

Be that as it may, let's try some blending.

Pick up a stick of soft pastel and lay in an area 4″ x 4″. Now, pick up a stick of another color and lay in a 2″ wide area right alongside the first square. Now take your best finger and rub the two adjoining edges together so that they fuse. Pretty, isn't it? Now rub the second color completely into the first square and blend the whole mess together. Now scumble a third color over the center of the square and blend *that* into the first two.

Blending can be a useful tactic at certain limited times. It's comparable to laying in a wash in watercolor. It can be an efficient timesaver when you want a foundation for a sky or a body of water or a background. But for art's sake's, *don't leave it that way!* Go over it with some bold, broken strokes of color. Still, in all fairness, I must report that there have been some excellent pastels that were almost completely blended. It probably all depends on who is doing the blending.

Now that you've successfully employed digital blending, try a stump, a rag, a brush, a piece of sponge —anything. Try drawing some straight lines and run a finger over them. See them grow soft and blurry? Lay in another area and rub only part of it, leaving the surrounding area rough and unblended. Study the different effects of blending. Rub hard edges together, blend color over color, vary your pressure so that the effect is altered.

Building up. *Three tones in all have been laid, one on top of the other. In practice, you can lay tone over tone almost indefinitely.*

Smooth Blending. *The tones are rubbed together vigorously to create a smoother, blended effect.*

Rough blending. *Less rubbing together of tones tends toward a rougher effect.*

My prejudices notwithstanding, blending is a perfectly acceptable pastel practice and if you feel able to control it, don't let me talk you out of working this way; better men than I have done it successfully. Only don't let it carry you away.

Indicating Textures

There's a limit to the extent of impasto that you can achieve with pastel. In oils, the binder surrounding the pigment allows you to build the paint into mounds as much as ½″ high. This is impossible in pastel. Such variations in the depth of the paint layers make it easier to indicate textures in oil paintings. Rembrandt used this method effectively to portray gold, jewelry, armor, and other distinctive textures.

Pastel, being an even more two-dimensional medium than oils, makes it harder to indicate textures. But there are certain means and manipulations that permit this to be done, if in a limited fashion. One way is to paint with oil pastels which—having oil as a binder —permit a wetter, juicier technique. You can build a heavier impasto with oil pastels and show textures more easily than with conventional pastels. Another method to achieve better textural expression is to "liquidize" pastels by some of the means I've touched on before. You can do this in three ways.

The first way is by dipping the stick in pastel fixative, then painting with it. Very interesting textures can be achieved in this fashion.

The second way is to thoroughly soak a piece of paper by either blowing or brushing it with fixative, then painting into the "soup" with the dry or wet crayon.

The third is to paint a layer of pastel, spray it thoroughly, then paint into it, then spray, paint, spray, paint, and so on.

I've already mentioned Degas' trick of letting steam from a boiling kettle hit a pastel painting and working into the wet mass with stiff brushes.

As in the other exercises, variations of the above procedures are possible.

I urge you to try all these methods no matter how bizarre they may seem to you, and with the fullest understanding that you'll probably never resort to them. They'll broaden your knowledge of pastel and will render your journey to artistic maturity a smoother and more interesting road to travel.

Dark to Light or Light to Dark?

The question most frequently asked by aspiring pastellists is, in my experience, "Do you work from dark to light or from light to dark?"

I answer them in the most honest way I can. "I, personally, don't follow a definite course. Sometimes, I work from dark to light, other times, the other way around. Most pastellists, however, do work from dark to light."

There are good, valid reasons for painting from dark to light. One is that it's easier to establish true middletones by establishing the darks and working toward the lighter areas. According to Daniel Greene, if you work from light to dark the middletones tend to go too light. Another reason is that pastel sticks tend to be softer in the lighter shades, and it becomes easier to apply the softest crayon as the painting progresses and the painting acquires an ever thicker coating of pastel. This is particularly true in the painterly, or building-up, method that I'll discuss in Chapter 7.

Despite all these undoubtedly meaningful reasons, I don't feel obliged to work from dark to light, but only as the mood strikes me. As a painter who is guided mostly by instinct, I do more or less as I please. But my justification for this is that I'm a mature craftsman who can better avoid the technical traps that painting presents than would a less experienced artist, and it, therefore, would be good practice that you work in the traditional way—from dark to light—until you feel ready to do otherwise. But why not try for yourself? Lay a coat of a light color—let's say, lemon yellow— then lay progressively darker and darker colors over it until you achieve a deep, dark, shadowy area.

Now reverse the process. Using the same colors that you used to go from light to dark, transform the order of the layers.

Which way seems easier and better for you? Do each at least a half dozen times, using various colors, then determine which way seems the more natural. When it comes to doing your portrait, you'll have a better notion as to which direction your tendencies indicate.

Erasing and Correcting

It's not a good idea to erase pastel, but as the man said, "that's why they put erasers on pencils"—because people *will* make mistakes.

If you must erase (a better way to correct mistakes is to go over the offending area with a fresh layer of pastel) at least do so with extreme care.

The best eraser for pastel is the kneaded eraser, a soft and malleable bit of plastic that can be molded into different shapes, which is least harmful to the painting surface. The trouble with erasing pastel is that it can leave the erased area a scummy mess which is impossible to work over.

One way to erase pastel is to *press* the eraser against the pastel rather than rub it. The more you rub, the more you destroy the workable surface. Another way, is to use the edge of a single-edge razor blade to scrape the color away.

Elinor Sears in her *Pastel Painting Step by Step* suggests that you can lift color off a grainy board by dabbing it with a rag saturated with fixative.

Another expert suggests that you can scrape pastel away with a stiff brush such as a toothbrush. Someone else advises that you tap the back of the board or paper to dislodge the offending particles.

No doubt, all these methods work to some degree, but I still maintain that it's best to avoid erasing and/ or lifting off if at all possible, and to go over the undesirable area with additional coats of pastel without trying to mess around with it by artificial means.

If the area has gone slick and unworkable, blow some fixative on it, *then* rework.

But if you *must* erase or lift off, do it in the prescribed fashion. If you begin to vigorously erase a pastel painting, it'll go bad on you and you won't be able to rehabilitate it by any means.

Testing Surfaces

Here's a final but most important note. By all means perform all of the exercises and manipulations I've listed, but to garner the fullest benefits therefrom, *vary the surfaces that you work on.*

This way, you'll be learning not only how pastel can be used, but also how the various surfaces react to the various manipulations.

Get yourself a sheet of fibrous paper, a sheet of velour paper, a sheet of sanded paper, a marble dust paper, a piece of pastel canvas, linen, etc., and perform the exercises and manipulations on the various surfaces.

See how a velour surface responds to a soft, a hard, and an oil pastel. Feel the bounce of the pastel canvas, the grittiness of a sanded board.

Test, learn, and file away for future reference.

Uses of Fixative

Although I'll discuss the pros and cons of fixative in a subsequent chapter, I want to mention here that fixative can play an important role *in the various intermediate stages of pastel painting.*

Fixative is a two-faceted tool. Its one function is to protect the final painting. Its other function is to serve as a means of isolating, defining, and controlling the intermediary stages of the pastel painting.

It's this second function that we must consider now, since it definitely affects the methods of applying and of building up a pastel painting.

Fixative is a colorless solution made up of different resins and solvents, according to various formulas. When it's sprayed or brushed on a layer of pastel, it binds or fixes the particles of pastel so that they cease to fall or blow away from the surface. The fixative also affects the appearance of a pastel painting, so that it looks denser, harder, darker. What happens is that when sprayed with fixative, the color particles alter in relation to one another and, in effect, sink into the surface.

Although the *final fixing* of a pastel painting won't be discussed here, fixative can be employed most effectively as a means of separating the intermediate stages of a pastel painting, especially in the building-up technique. This practice is comparable to the traditional practice of oil painting in which the underpainting serves as the base for the subsequent paint layers.

I touched on the method in the section entitled "Building Up." I mention it here again only to establish the fact that a fixative is a tool that can be employed to good effect in pastel painting, and to urge you to see what happens when you apply fixative to the various stages of your painting.

Buy a can of ready-made pastel fixative in liquid and in spray can form and consider its uses as one of the pastel exercises and manipulations. Later, I'll tell you about homemade fixative and go deeper into the subject, but for now, experiment with the fixative as you have with the various grades of crayon, the various methods of applying pastel, and the various surfaces.

Blow the fixative first lightly, then heavily, on different layers of pastel. See what it does to them after a light, moderate, or heavy application. Spray it on an area, then after it has dried, work over it with fresh strokes of the crayon. See how it affects the blank paper, the lights and the darks? Blow it on each of the colored areas separately. Now spill some fixative into a saucer and dip a color stick into it and work this stick over a dry area, then, over a heavily sprayed area. Note what happens each time. Now spray a sheet of paper so that it's dripping, and work into it with a dry stick, then, with a saturated stick.

No amount of words can replace the value of actual experimentation. Get to know your fixative as intimately as you do your pastel crayons. It's yet another tool to be exploited to its fullest capacity by the innovative pastellist.

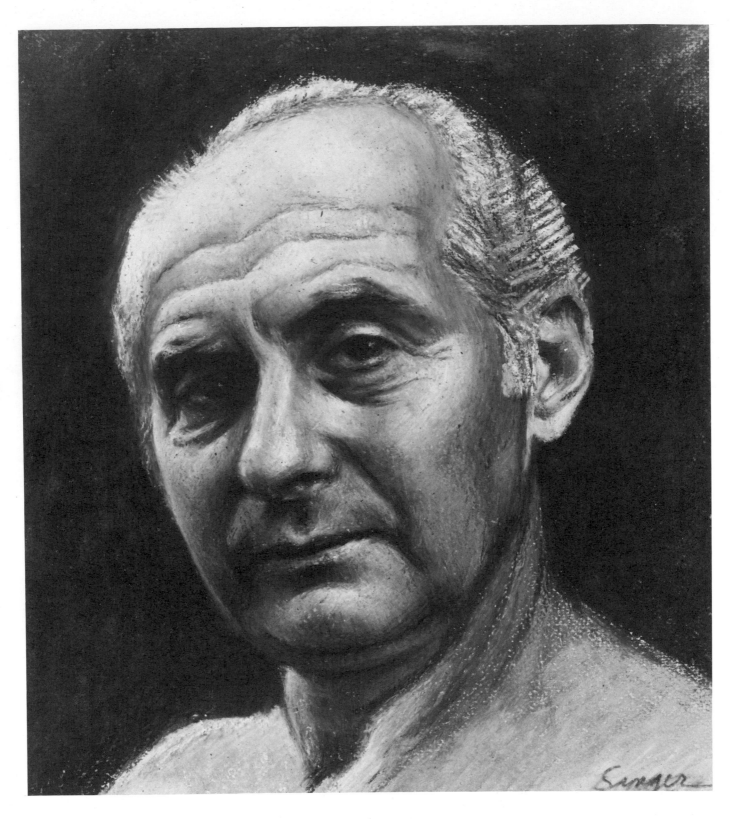

Self-Portrait *by Joe Singer, oil pastel on paper, 12" x 10". I tried to paint a complete and a totally revealing portrait of an individual who, in this case, happened to be myself. The treatment is calculatingly tight, since I was seeking to achieve a super-realistic effect aimed at providing insight into the inner characteristics through a most detailed rendering of the outer characteristics. Oil pastel is excellent for building a thick and fluid impasto, which helped me in my effort to effect a lifelike and precisely painted portrait.*

Three Major Techniques

If you're going to paint portraits in pastel, you'll ultimately adopt one of the three major pastel techniques. At first, you may combine features of two or even three of these techniques, but eventually you'll begin to lean toward one or the other and, with maturity, you'll most likely make a decided commitment toward the first, the second, or the third.

As someone wise once said: "All generalizations are false, even this one." My statement falls neatly into this category. Of course, there are and there have been pastellists who couldn't be grouped into one of the three major techniques, but I maintain that most good ones can. Not all, but most. The one notable exception is the best of them all—Edgar Degas.

In any case, let's consider these three techniques, one at a time.

Pointillist or Linear Method

Pointillism, which I've already mentioned in the previous chapter, relies upon dots or strokes to create shapes, tones, and color. There's no attempt here to fuse these dots; this effect is visually accomplished by the viewer's eye. This is a principle long employed by artists who know that the human eye groups separate entities placed closely together into a unified form when it views them from a distance.

Glance at your newspaper page. It may surprise you to know that the pictures you see there are composed of tiny dots which *your eye* formulates into recognizable shapes. If you doubt this, hold a strong magnifying glass to a newspaper photograph and take a closer look.

The impressionists made good use of this principle, and some went so far as to formulate scientific doctrines which dictated a regimented use of color, the dots being placed with strict regard to mathematically computed directives.

Naturally, this movement went just so far and then petered out, as do all rigidly prescribed systems of art when they wash up against the bulwark that is the human factor in painting.

Artists are human beings. Some say, that they're even more human than other people. One reason men and women become artists is that they feel a strong need to express their individuality. Artists cannot and will not be dictated to, particularly when it concerns their creative efforts. Tyrants over the centuries have had trouble with artists who simply didn't tolerate the slightest attempt to regulate their lives or way of working.

This is the reason that pointillism, like all other "isms" regardless of their worth, hasn't become a prime factor in painting.

Impressionism and Pointillism

Still, we have much to be thankful for to these daring young men who showed us the beauty inherent in broken color; who thumbed their collective noses at outlines; who heaved out the dark, moody, gloomy bitumens of antiquity and introduced the fresh colors of sun, air, and wind into their palettes and taught us a new way of seeing the glories of the beautiful world around us.

Who dared paint green-fleshed men with purple shadows and blue hair? Who dared portray a human figure lacking eyes, a nose, ears, and a mouth? Who whistled at tradition and transformed a holiday crowd into a pudding of blobs, smears, and colored daubs? And who made all this work so magnificently that today even the most ignorant boob acknowledges that a Madonna mustn't be painted with every fingernail and eyelash showing, and that her flesh may be a bright yellow instead of pink?

The impressionists, that's who. The impressionists and their first cousins, the pointillists, and those who followed after.

Although to my way of thinking, the impressionists and the pointillists essentially followed the same principles, I want to make a distinction here.

Manet, Renoir, Cézanne, and company, although they used broken color freely, generally painted in *tone*. The pointillists Seurat and Signac—as well as the impressionists Monet and Pissarro, in some of their efforts—painted in *line*. Specifically, they used dots or strokes of color that were often unconnected, not blended as tonal areas would be.

A linear technique is usually associated with drawing, and rightfully so. But the pointillist method—which

includes the dots and strokes of Monet and Pissarro—completely does away with the linear treatment of outlines; linear touches of the brush are concentrated *within* forms, rather than on the edges of forms. Pointillism doesn't connect the various planes and angles as tonal painting does but allows the viewer's eye to do the job through skillful use of tone and color.

Let's consider the pointillist method as it applies to pastel.

By its very nature—the dots of color being separate—this technique makes it possible to employ the underlying surface color as part of the total painting. Thus, if the pointillist method is employed in its thinner form, the paper can come through the strokes and serve as one of the dark, middle, or light tones of the portrait.

Then again, you may choose to execute a more heavily applied technique of pointillism, which places separate dots of color on top of one another, thus building up a sparkling and scintillating web of broken colors that should virtually sing to the eye.

This method tends to completely cover the paper and disregard its color contribution.

Imaginative Use of Color

Essentially, the pointillist method calls for a most daring and imaginative use of color in that it employs colors not normally associated with human skin to portray its hues and textures. To use dozens to hundreds of dots of, let's say, only a light ochre to portray the skin tones of a sitter means to negate the benefits and charm of the pointillist method. The beauty of this technique is the skillful blend of blues, greens, reds, yellows, and violets (preferably in pure-color form) to provide the *impression* of flesh.

Pointillism requires a bold spirit and an inventive personality. If you're the timid type who's afraid to slap a bright blue onto the tip of a nose, this method isn't for you. Pointillism is for those who aren't afraid to let their fancy soar and are willing if not eager to take chances. It's definitely not for Nervous Nellies to whom every stroke of the crayon is a life-or-death decision.

If you see only skin color where there's only skin; if a purple dot on a forehead offends you; if shadows seem only brown to you and never blue, green, or purple, think twice before adopting this technique. It's no affront to you that you're conservative in your outlook. It's also fair to point out that most leading pastellists *do not* essentially employ the pointillist method.

Another factor in pointillism is that you'll have to learn to do without outlines. A pointillist painting with visible outlines or sharp edges is an abomination. The very character of the technique demands a free and loose treatment of shapes composed entirely of dots or short strokes of color. All of its linear character is confined to the *inside* of the shape, none of it to the perimeter.

Therefore, if you would paint in the pointillist method, you should keep these things always in mind:

(1) You'll probably be working more with hard and semihard crayons and less with the softer grades.

(2) You'll be working more with the *tips* of the crayons rather than with the sides.

(3) You'll be more concerned with the color of the paper that you'll be using since it can serve as an integral part of the painting.

(4) You'll be bold and imaginative in your use of color.

(5) You'll learn to rely less on contour and more on total form; less on detail and more on mass.

(6) You'll make greater use of backgrounds—painting across the entire surface—than will artists using the other pastel methods. A vignetted portrait in a pointillist style is usually wrong; it can be a sight to make strong men quiver.

(7) You'll erase and correct even less than your fellow pastellists, since you'll have little chance to build up or blend botched areas. (Pointillism is basically a one—or two-coat affair—built up too thickly, it loses all its charms.)

(8) And finally, you'll have to weather the scorn of indignant sitters who may object violently to a purple chin or a greenish nose.

Are you strong enough to withstand these challenges and limitations? Then, by all means take a crack at the pointillist method. Gather an assortment of good, rich, strong crayons and dot or stroke away with verve and with audacity. Give free rein to your vision and imagination and let your instinct and taste dictate your choices of color. Neither I nor any writer can tell you precisely what crayon to use in any particular area. This all depends on the light illuminating your sitter, on his natural coloring, and on hundreds of other qualifying factors. But the exercises you've performed as suggested in the previous chapter should help you on the road that you've taken, and repeated practice will serve to *keep* you on this road so that your step grows firmer and more certain with each painting that you execute.

Painterly or Building Up Method

If such comparisons are any help, the painterly method can be said to be like oil painting and the rubbing-in method (which we'll take up next) is reminiscent of watercolor washes. In the painterly method, you put down layers of color, one over another without blending. This amounts to building up a rich, juicy impasto with a sculptural, three-dimensional, almost plastic quality.

This is a bold method most commonly employed by modern pastellists, particularly by those who paint pastel portraits, except for a few dear old ladies who still paint wispy studies of rosy-cheeked little boys and girls.

It's a sound and solid method of working, which for some strange reason, few beginners ever attempt. This may be due to some ingrained fear on the part of the uninformed, along with a well-nurtured notion that pastel must be handled gingerly and brushed onto paper like a butterfly's wing.

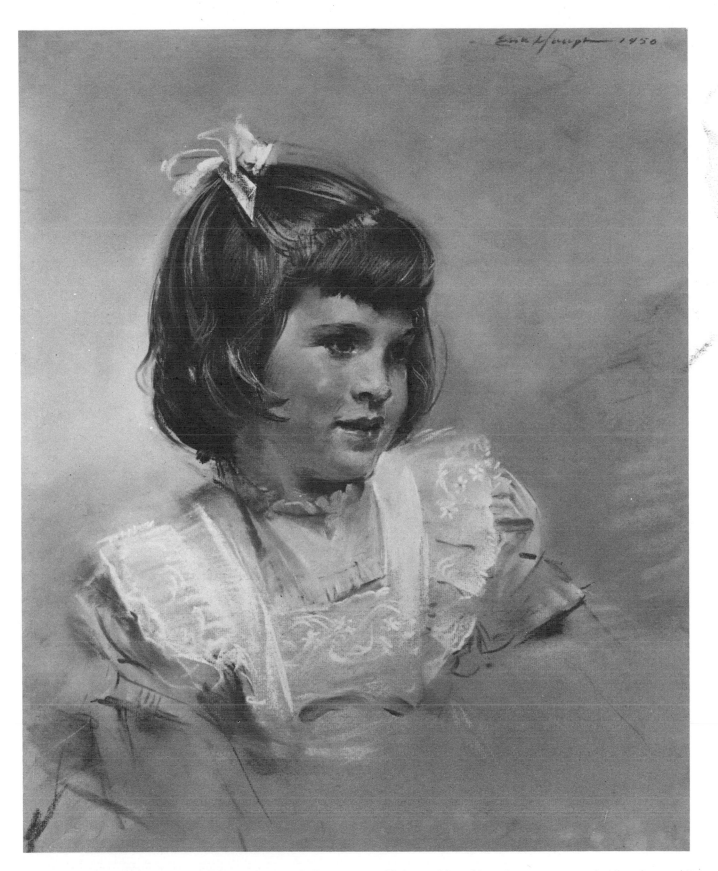

Daughter of Mr. and Mrs. Bartlett Harwood *by Erik G. Haupt, pastel on paper, 19½" x 25". A charmingly painted portrait of a pretty, young lady that happily doesn't fall into the trap of so many children's portraits—excessive sentimentality. In this essentially blended technique, the artist has retained the strength of the head by maintaining a fine balance of darks and lights, and by subjugating unnecessary detail to the overall shape of the big forms. The mouth and eyes are treated simply, but with vigor. The hair ribbon and dress are indicated, but not over-rendered. The result is a handsome, meaningful portrait of a bright, alert young person. Note the loose treatment of edges in the head and clothing.*

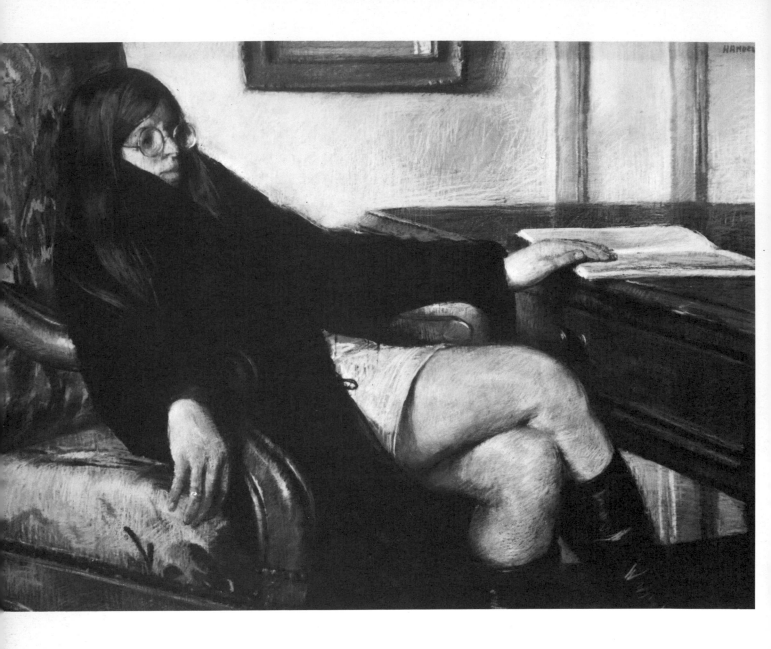

Portrait of Susan *(Above) by Albert Handell, pastel on board, 18" x 24". This is a perfect example of the noncommissioned portrait in that the artist has been permitted to create a mood in which the sitter is an integral part of the composition, yet doesn't necessarily dominate the painting. Despite this, we are made immediately aware of the sitter's personality through her attitude toward her surroundings and by the way she sinks inside her coat (the gesture of an introvert). The artist has handled the coat as a flat, dead, dark mass which directs the eye to the model's sturdy legs and to the rather small face which is fixed in a mystical, introspective expression. The hands seem somewhat large, but are in harmony with the subject's patent if controlled resignation. (Collection Mr. and Mrs. John O. Hill)*

Meditation *(Right) by William Merritt Chase, pastel on paper, 20" x 16". This is a lovely and touching memento of the not too distant past. The pastel has been handled in a fairly dense and solid fashion. The only discernible rough accents are in the glove and in parts of the background. The skirt looks exactly the way it should—as if made of shining taffeta. The muff is unmistakably fur. The total effect is somewhat somber yet the face is painted with delicacy, sensitivity and great charm. This portrait is a superbly realized rendition of a beautiful and gracious subject. (Collection Roger Storm, Photograph Courtesy Chapellier Galleries)*

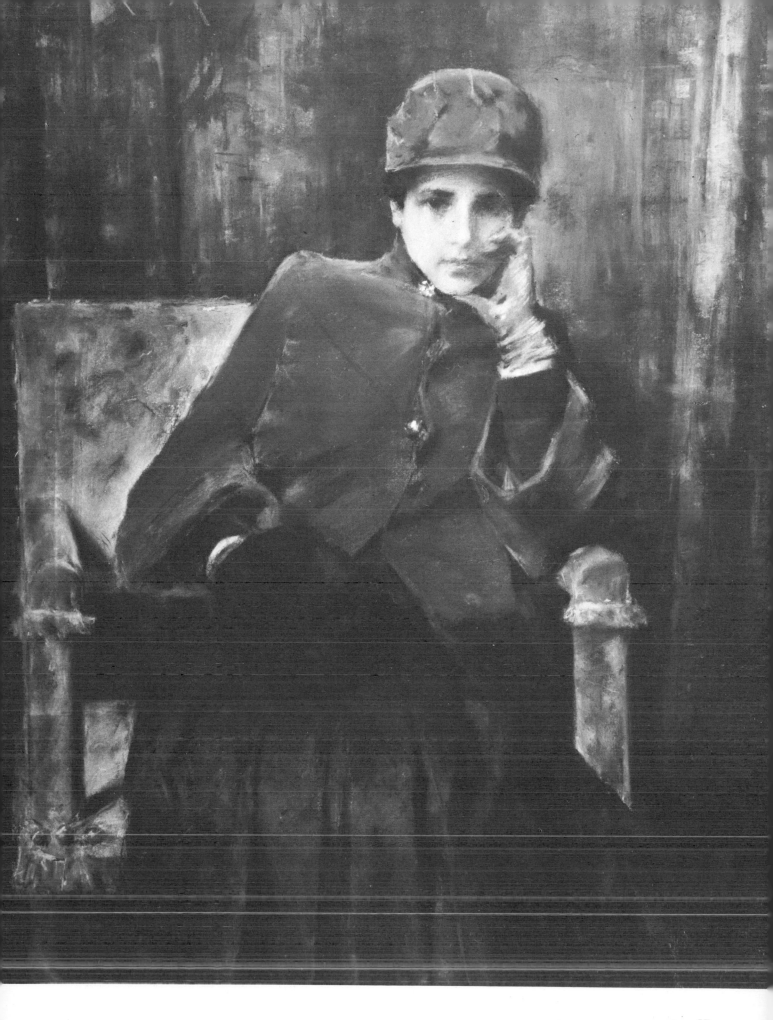

This is, unfortunately, a prejudice abetted by writers on pastel who repeat the ancient canard that a pastel must be "fragile," "ethereal," and so on. The writer who prepared the article on pastel for the *Encyclopaedia Britannica,* no less, comes out with statements such as: "A life-sized head in pastel is seldom satisfactory and generally becomes overloaded with colour . . ." and "pastel is a more humble medium (than oil) . . ." and "pastel is a method of applying colour . . . thinly to the surfaces of the paper. . . ."

To this, I say: "Banana oil."

Still, countless hundreds if not thousands of people read such pap and come to believe it. Then, when some of them go on to try pastel painting, they hold the crayon as if it were broken glass and touch it to the paper as if it might damage the surface.

Look at pastels by Degas. Fragile, indeed!

Greene, Shikler, Silverman, and Kinstler—the fine artists whose demonstrations are included in this book—can hardly be said to work thinly. Their pastels fairly glow with depth and richness.

The painterly method allows you to build successive coats of pastel until the desired effect is achieved. This method may employ the color of the paper as a component to the painting, *but usually not as part of the painted area itself.* When a painterly portrait is left unfinished (vignetted), the paper usually *serves as part of the area background or the area surrounding the head.*

In the painterly method, you do most of the work with soft pastels, using the side of the crayon to build the thick, solid layers of color.

This method is most beneficial for the beginning pastellist, since it counteracts whatever feelings of hesitancy and timidity he might feel toward the medium. It forces you to work in a vigorous and an assertive fashion, and it helps free you of inhibitions and a tendency to fumble.

While most beginners in pastel naturally turn toward the rubbing-in method (they become too frustrated trying to paint planes, angles, and values and they seek the easiest way out—rubbing), they should be steered toward the painterly technique, which allows more correction than the pointillist method and provides a greater insight into the craft of painting than the rubbing-in technique.

I've seen some remarkable transformations in students who have switched to this method. After having diddled around for months and even years, students felt their confidence soar as their work suddenly acquired strength and body.

I don't wish to turn this into a polemic promoting the painterly or building-up method. I only want to point out that it's a good method *to begin with,* one that will help buoy your faith in your abilities, and one which allows ample correction by the repeated application of fresh coats. I say "repeated" because contrary to general opinion, pastel *can* be laid on, coat after coat. Although artists disagree as to the number of coats that can be thus applied, some say it can go just so far and others, that it has no limit—

there is enough leeway in which to build up and to correct in the painterly method even for the sloppiest technician.

The exercises leading to a proficiency in this method are listed in the section on building up in Chapter 6. They should be performed again and again by artists eager to execute pastel portraits in the painterly technique.

Rubbing In or Tonal Method

Pastel, being the dry medium it is, lends itself to manipulation by blending, or rubbing-in with some foreign object in order to create a tonal effect. In fact, it's difficult to avoid blending pastel since an accidental swipe of the surface will instantly smudge the paint layer.

Although I personally don't hold with blending pastel, good artists have employed the method to execute spectacularly successful pastel portraits.

If we wish to make comparisons, the rubbing-in method can be compared to watercolor or gouache painting, while the building-up method as I've already stated, is more comparable to oil painting.

If you choose to work in this method, you'll essentially use the soft pastel which is the most friable (crumbly) of all the grades and thus lends itself best to blending. You'll use the side of the crayon to put down a color note, then rub and smear it into the planes and tones that you want. You'll have to carefully control the pressure of the blending instrument so that you don't rub away the underlying coats, unless this is your aim.

The danger in this technique is that your painting may suddenly become too saccharine and precious, like an 1890s illustration for *Little Women.* You must, therefore, strive to retain strength and virility in your painting at all times and not allow the various tones and values to fuse too closely together. It's vital that the masses of the head and figure aren't subjugated by too finished detail and overworked color.

Since the rubbing-in method tends to produce colors that look too gaudy, you'll have to exercise particular care to keep your colors nicely grayed and muted.

You can control this to some degree by choosing sticks of subtle color—as opposed to the strong, pure colors used in the pointillist method—and by keeping a full assortment of grays and earth colors handy.

Generally speaking, what I suggest is that if you're going to employ the rubbing-in method, that you stay away from the gorgeous ultramarines, cadmium reds, and viridians and lean heavily toward your browns, grays, and earths. Keep your shadows good and dark and emphasize the difference of values a touch more than you would in the other techniques. This will lend strength to your painting and help keep it from seeming effete and fragile.

In other words, when using the rubbing-in method, *concentrate more on the values and tones and less on the color.* If you like to work in pure, rich colors, take the pointillist road. A blended pastel that's

overloaded with color tends to resemble a shampoo ad.

Of course, you'll complete the painting with several strategically placed strokes of vigorous, unrubbed color. To me, the beauty of pastel lies in its strokes of pure color—that is, color which does not blend into its surrounding areas but stands by itself as a firm, powerful accent. A rubbed-in painting can be instantly invigorated with a few strokes of this kind, and even the most smoothly blended portrait should contain a few such positive notes.

To effectively work in the rubbing-in method, you must endlessly practice the exercises described in the previous chapter in the section on blending. You must try every instrument listed there and perhaps invent a few of your own, from fingers to powder puffs. It's perfectly legitimate and ethical to use any tool to arrive at one's artistic goals—the only thing that matters is the final result.

So paint your pastels, if you will, by blending and rubbing in, but do try to inject strength, vigor, and vitality into your work. Maybe you'll effect an important breakthrough and lend additional prestige toward this historic and well-tested pastel method.

Combinations of the Three Techniques

It's superfluous to say that there's no compelling reason for you to adhere rigidly to any one of the three techniques. You're perfectly free to combine any two, or even all three, or to work in any way that you please—light to dark, dark to light, from bottom to top or from the eyes out to the ears.

All I can do is list the usual, the more conventional ways of pastelling, and you can take it from there. If you're a fiercely independent person who's determined to do things in his own individual fashion, good luck to you. There's plenty of room for rugged individualists in the art world.

But if you're like most of us, you're rightfully seeking a sense of direction, and this I hope to provide.

The three techniques I've discussed are the three *major* ways of using pastel. I must point out that in time, your own style of painting will evolve, and that this style will be a natural extension of the technique that you've adopted as your own. Therefore, it's most important that you select a technique that's best suited to express that which you elect to say artistically. Since your style of painting will be greatly influenced by your technique of painting, it's most important to research, to discard, and finally to adopt the technique that works best for you. To do this, you should try *all* the ways of pastel painting and learn all that you can about the various ways in which pastel can be used.

The three techniques are a significant step in that direction. Try them all separately or together, then think up some new ways of varying or improving upon these traditional methods. This way, you'll not only enhance your own knowledge of your craft, but at the same time possibly expand public knowledge of the medium.

Some Historical Precedents

Throughout pastel's long history, eminent artists have employed the medium to make significant contributions to the world's treasury of art masterpieces. In the context of the present chapter, let's concern ourselves with the basic techniques employed by some of these masters.

The earliest pastellists such as Rosalba Carriera (1675–1758) rubbed away merrily to produce beautiful, silk-smooth portraits of lords and ladies of the court. Maurice Quentin de La Tour (1704–1788), Jean-Baptiste Perronneau (1715–1783), and Jean Etienne Liotard (approximately 1702–1790) also blended, but they threw in rough touches here and there, which added vigor to their rather overworked portraits (overworked by *today's* standards that is, not by those of their time).

Sir Peter Lely (1618–1680) produced sweet pastels rubbed so fine that they should be avoided by all diabetics.

Jean Baptiste Siméon Chardin (1699–1779), the great French master, broke with the tradition of his day to paint many of his works in the pointillist method, that is, by juxtaposing strokes of color without blending—surely, an innovation in his day. His portraits sing with vibrating, scintillating color.

A century or so later, we encounter Edouard Manet (1832–1883) who painted several outstanding pastel portraits on canvas in a true painterly method, building up layer over layer. The irascible James Abbott McNeill Whistler (1834–1903) executed a number of beautiful pastels in what appears to be the painterly, mixed with the rubbing-in technique.

Mary Cassatt (1845–1926) and Pierre Auguste Renoir (1841–1919) both painted extensively in pastel. Mary Cassatt's pastels are more or less rubbing-in plus pointillist, while Renoir's are in the building-up camp.

The world's greatest pastellist, Degas, can't be pinned down as to technique. His genius transcends any classification. At one time or other, he employed every pastel technique known to man and invented many new ones.

Odilon Redon (1840–1916) who won renown as an outstanding pastellist, smudged and rubbed his delicate studies freely.

And so it goes.

Importance of Technique

What does all this prove? Simply, that *there is no right way of doing pastels*. To an advanced painter, technique is a slave harnessed to do his bidding. Unfortunately, this pattern is too often reversed among the uninitiated, to whom technique represents an implacable adversary.

By all means acknowledge the factor of technique, but don't let it become your master.

Test and research all the pastel techniques, then let instinct, intelligence, and an objective analysis of your personality guide you to the one or ones that will best serve your objectives.

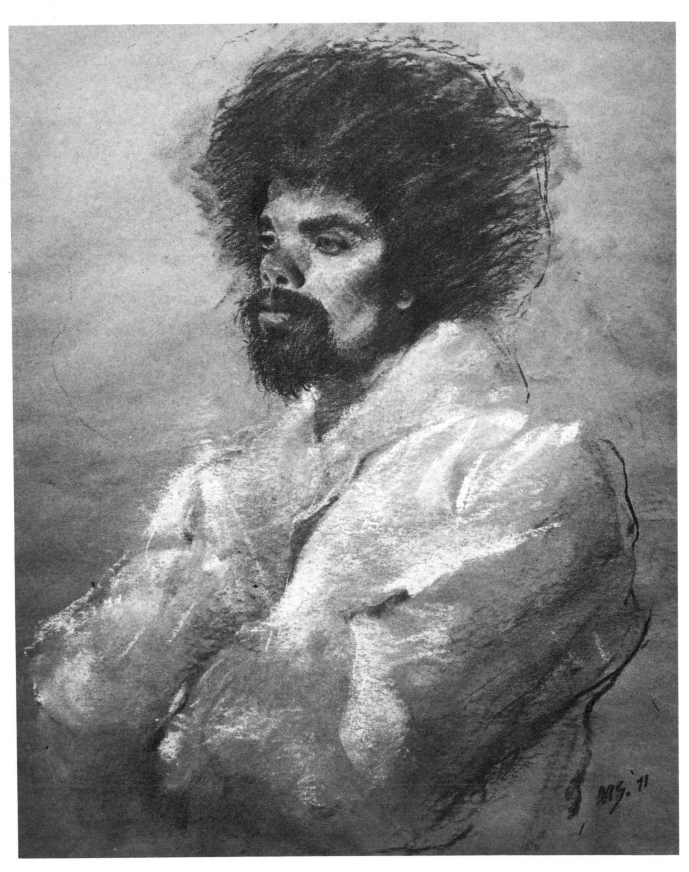

Felix *by Aaron Shikler, charcoal and pastel on paper, 10¾″ x 8″. This handsome example of the mixed media technique—in this case, charcoal and pastel—shows a graphic quality. The charcoal was used for the hair and beard; the pastel has been sparingly used to indicate the tonal values. Note the treatment of the beard which is stroked in with lines, rather than painted on as a mass. The beauty of pastel is that it can be used in a minimal way—as it is here—and heavily—as in some of the other plates—yet each method can produce a highly effective portrait. (Courtesy Davis Galleries)*

Making Color Work for You

There is a universal human preoccupation with color. From early childhood, youngsters smear and scribble with crayons, usually selecting the rawest and most brilliant colors for their work. As these children grow up, it is hoped that they'll acquire a taste for color, which will wean them away from the crude, the cheap, the gaudy hues used in fluorescent paints. Considering the way color is used in our society, it's not surprising if this taste never develops in adults.

Impact of Color

Wherever we look around us today we are assailed by color in its crudest form. Posters shriek at us from all sides; signs promote sales, contests, and causes; neon lights strive to outdo one another in blatancy, size, and color. This is perfectly understandable, since these are all attention-drawing devices intended to evoke a momentary response.

But when this calculated gaudiness is carried over into areas such as clothing, furniture, and hair dye, it's little wonder that people don't acquire a cultivated color taste.

Nature in her infinite wisdom provides man with a full panoply of colors, none of which clashes with one another. Man in his infinite stupidity provides fluorescent paints, neon lights, henna, and bad art—all of which are an affront to the eye and soul. An artist dare not compound the sins of his fellow men by producing atrocious color in paintings. But all is not lost. There is one curative ingredient to which we all have access. That ingredient is taste.

Taste in Painting

Taste is an intangible quality that is hard to describe in general terms. As applied to color in *painting,* taste is perhaps more easily definable. To me, color taste in painting means the limited use of primary colors, not placing primary colors in conjunction with one another, and striking a fair balance between warm and cool colors. I suppose that there can be many other definitions of color taste but since this is my book, mine must suffice.

Let's take up each of the three theses one at a time.

(1) If we were to compare a painting to a full-course steak dinner, the primary colors could be designated as the steak itself. What civilized person enjoys a meal consisting of steak, steak, and more steak? A good steak is best appreciated when it's preceded, accompanied, and followed by other dishes. The same applies to the primary colors: red, yellow, and blue. One to a painting is usually sufficient; two—more than enough; three—superfluous unless—and there is always an unless—unless you are Vincent Van Gogh. Keep your primaries to a bare minimum and you're off on the right foot on the road toward a good, tastefully colored painting.

(2) The second factor—placing primaries next to each other. Unless you're seeking a particularly strident effect, don't put a pure cadmium red next to a pure cadmium yellow next to a pure ultramarine blue. The effect may be striking, but at the same time it's upsetting to the digestion.

Primary colors, or other full-strength, vivid colors (not restful browns or grays) are (if you *must* use several in a painting) best kept as far apart as possible. Bring them together and they'll clash like the temperamental stallions they are. Are there exceptions to the rule? You bet there are! If you are a color genius such as Gauguin, Lautrec, or Bonnard, don't pay any attention to anything I have to say regarding color. But assuming that you're not, keep your bright reds, yellows, and blues down to a minimum and far apart. It'll help keep your portrait from turning into a comic book cover.

(3) The third principle of good color taste is to balance your cool and warm colors. As we've already established, there are warm and cool colors included in our palettes. There may be some controversy as to which are the cool and which are the warm. A yellow, for instance, can fall into either category. A deep cadmium yellow, which is somewhat on the orange side, would be considered warm. A pale cadmium yellow is more toward the greenish side and would, therefore, be essentially cool. Not every color or crayon can be classified with absolute certainty it's basically a

Anne Morrow Lindbergh, *by Robert Brackman, pastel on paper, 14" x 18". Here's a touching and sensitive study of the noted author and wife of one of the nation's most prominent personalities. There's an old-master quality to the mouth and careful handling of the cheek and temple. The treatment is soft and misty throughout except for a few expertly placed accents such as the side of the nostril where it meets the cheek, the tops of the upper eyelids, the slight bump on the bridge of the nose. Note how delicately the artist indicated the gentle roundness of the small protuberance just to the side of the lips. The tonality is fairly even all over except for pale highlights on the tip of the nose, the inside corners of the eyes and the eyeball itself. This is a simple yet highly sophisticated sketch that reveals a hand of great skill and experience. (Courtesy Mrs. Dwight W. Morrow)*

Charles Lindbergh *by Robert Brackman, pastel on paper, 14" x 18". Solidly painted in the traditional method, the facial planes have been painted in with the side of the pastel crayon, then blended so that there's a harmonious transition from shadow to halftone to light. The underlying surface is covered in the painted areas except for a few spots in the ear, cheek, and hair. Note that the thickest applications of pastel are reserved for the lighter areas of the portrait. The hair drifts into the forehead in a smooth, natural fashion. There's hardly a hard edge anywhere* inside the head, *except for the rather heavy outline that the artist has run around the* outer *contours of the face and neck. The absence of a truly luminous highlight lends veracity and naturalness to this highly effective, intelligently painted portrait. (Courtesy Mrs. Dwight W. Morrow)*

matter of opinion. But a good pastel portrait should be composed of warm and cool colors enhancing and complementing each other, a factor which should add immeasurably to the achievement of a painting which projects good color taste. Going back to a gastronomical analogy, it's like eating hot pork chops with cool, bland applesauce; hot lamb with cool mint jelly; hot apple pie with ice cream. The contrasts add spice to the taste.

Keeping Color Under Control

Color is a mercurial creature that like a frisky horse must be kept under tight control. If you give color free rein, it'll run rampant and cause irreparable damage. Like a good horse, color must be dominated and kept somewhat subdued in order to be fully appreciated.

We've discussed some of the principles contributing to good color taste. Now, let's consider some means of implementing these principles.

Since one of these principles entails limiting the use of primary color, there'll be times when you'll want to tone down a color that's too loud or strident; a color that may appear raw, garish, overly aggressive.

How? By employing the device of scumbling. By going over the offending area with a gray or a brown, or with a color that's complementary to the one you're trying to subdue: for instance, going over a red with a green, a blue with an orange, a yellow with a violet. A color that's the complement of a primary color is one that is a mixture of the other two primaries, as for example: red's complement is the mixture of yellow and blue which is green. Blue's complement is a mixture of red and yellow which is orange. Yellow's complement is a mixture of red and blue which is violet.

Another way to keep color subdued is to select clothing and background for your subject that will neither clash with nor take away the emphasis from the prime area of importance which is the face and, possibly, the hands.

Thus, we wouldn't paint a lady in a bright red blouse and an equally bright green skirt (even if she has the poor taste to wear such a combination) but would tactfully suggest a change of costume. This is a good time to recall Rembrandt's portraits. In some of these, you actually *can't tell* what the subject is wearing. It's only in portraits by lesser, fussier painters that every bright-blue lace and ribbon is evident. Look at a portrait or a reproduction by Ingres next to a Rembrandt. How do they measure up against each other?

By painting in a *slightly cooler key* than the actual colors you see, you can also keep color subdued and under control. Stare at the face of a friend or a relative bathed in strong daylight (not sunlight). Is it really the pink that you've always believed it to be? Isn't it closer to a kind of yellowish-tannish-gray? Aren't there bluish, greenish, yellowish, or purplish tones there? The natural tendency is to paint (Caucasian) skin in pinks and reds, when you should actually paint most such skins in yellow ochres and whites.

The next time you paint a person, paint him cooler than you actually see him. You'll be pleasantly surprised at the results.

Another way to keep color controlled, of course, is to keep down the strong, full-color crayons, especially those of the primary colors in any one painting. Although this may sound contradictory to my earlier statement that pure color crayons are valuable to a pastellist, this isn't really a contradiction. I'm merely suggesting that only one or two of these crayons be used *at any one time in any one painting*, and that they be used with discretion and with restraint. In the pointillist technique, we allow a little more leeway since a smaller area of color is covered with each dot or stroke and the areas of primary color would not be as prominent.

Choosing Sticks For The Painting

From the total palette that you'll eventually settle on, you'll learn to select a smaller assortment geared to the specific portrait you'll be doing. Thus, if your subject will be wearing green, you'll need greens, reds if he's wearing red, and so on. However, your palette for painting the skin tones need not vary too greatly from portrait to portrait. True, there may be distinct varieties of complexion colors that you'll encounter, but there isn't that much difference between skin tone colors, *only degrees of lightness and darkness*. In this vein, a fair Caucasian skin and a dark Negro skin may ostensibly be painted with the same set of colors, *but in different shades thereof*. By discarding all your preconceptions and concentrating your vision upon skin colors, you'll note that human skin tends to be not the hot, bright, or glowing substance you've imagined it to be, but is actually much grayer, duller, muddier than you might have assumed. There are exceptions, of course. Certain Negro skins actually possess a rich, warm, chocolate sheen. There are, likewise, Caucasians who are a florid red or a rosy pink. But these are the exceptions.

Over the years, artists have successfully painted flesh without resorting to the reds, pinks, and so-called "flesh colors." When I look at Rembrandt's

Madame Pierson, Chanteuse by Henri Fantin-Latour, pastel on paper 22" x 18". Pastel was used traditionally and very effectively by Fantin-Latour, one of the masters of the impressionist school. In this portrait, the skin tones are cool and translucent; the shadows and highlights are properly refined and subdued. There's nothing startling or quite revolutionary about this technique, but the total effect is one of dignity, grace, and gentility. The head is beautifully painted with the planes gently turning, the features perfectly placed. The hair is a bit more roughly handled to indicate the somewhat fuzzy texture of Madame's topknot. A few broken lines just below the cheekbone hint at the cool downward slope of the jawline. The mouth, nose, and eyes are superbly realized in this lovely and charming nineteenth-century gem. (Courtesy Schweitzer Gallery)

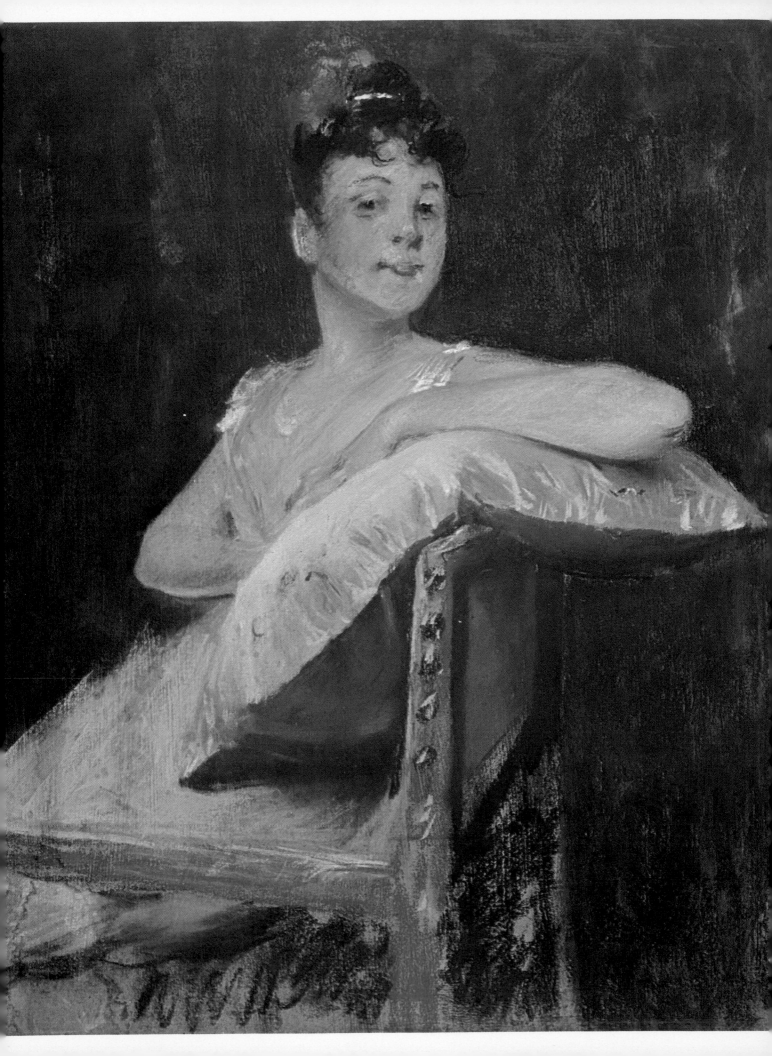

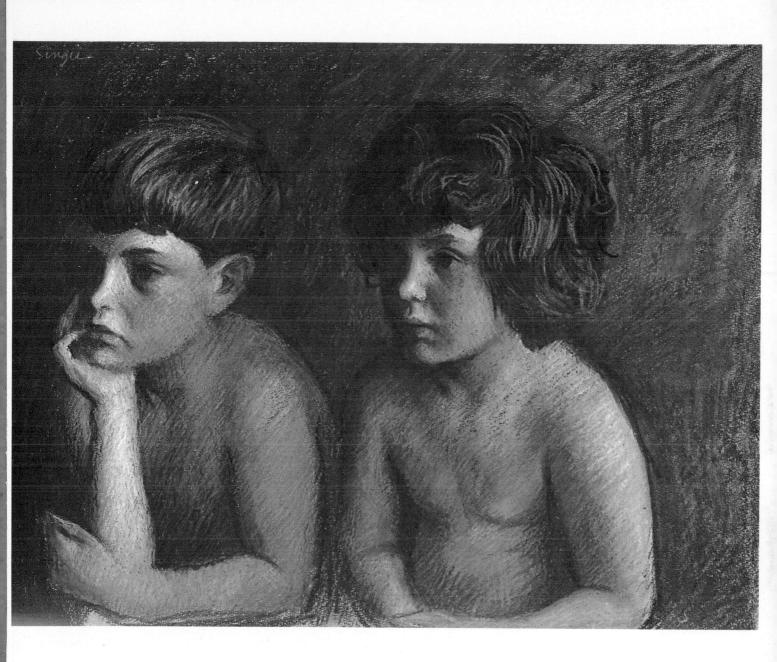

Young Woman in a Yellow Gown *(Left) by William Merritt Chase, pastel on paper, 20⅛" x 16". This portrait is a delightful reminder of the era of great American portrait painters at the end of the nineteenth century. The handling is painterly throughout; the colors are high, fresh, bright, and luminous. The pose is coquettish and flip, but the artist has avoided what might have easily turned into a mannered portrait with his sure and masterful hand that evokes our admiration for the virtuoso, bravura style that exemplified Chase, Sargent, and their contemporaries. The bold and free treatment of the head serves as a compressed painting lesson for the aspiring portraitist anxious to overcome his apprehension and timidity. (Courtesy Schweitzer Gallery)*

Television *(Above) by Joe Singer, oil pastel on board, 16" x 20". About ten years ago when my two younger children were around six and seven, I saw them one morning half-awake, but totally absorbed in the exploits of one Mighty Mouse. I tried to show this concentration, a wonderful childish attribute that deserts us as we grow older and wiser. This picture is in the oil pastel medium that I find particularly sympathetic to my method of working. Everyone who enjoys painting with pastel should try oil pastels for their nice, buttery quality and richness of color.*

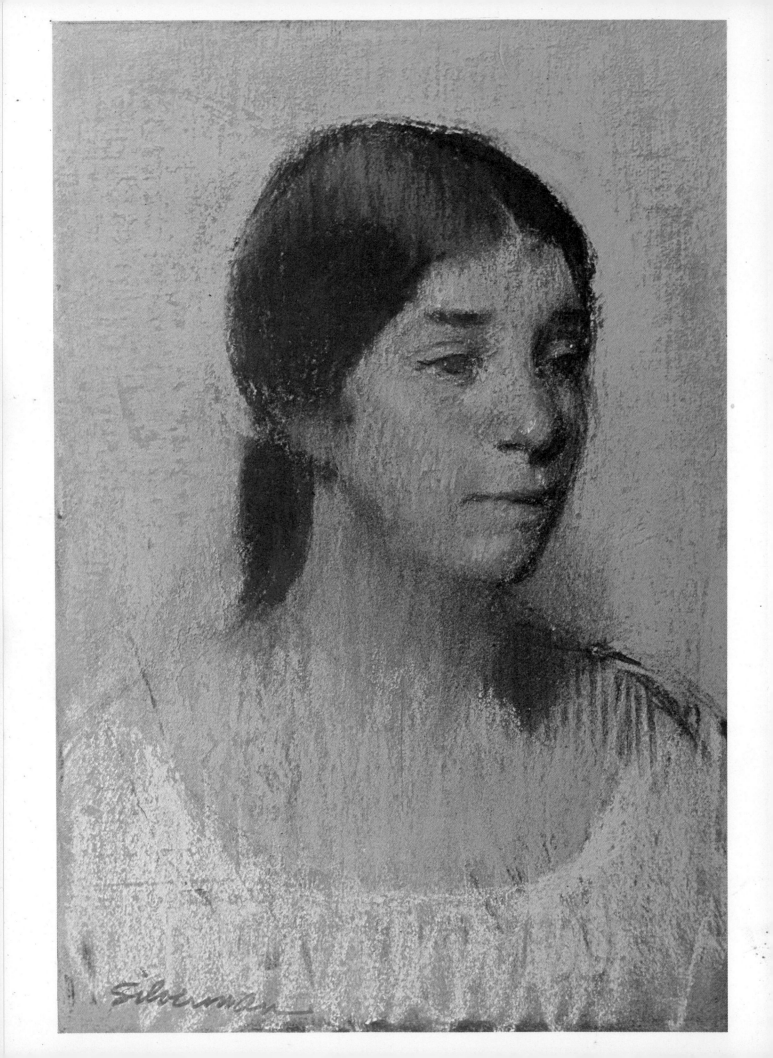

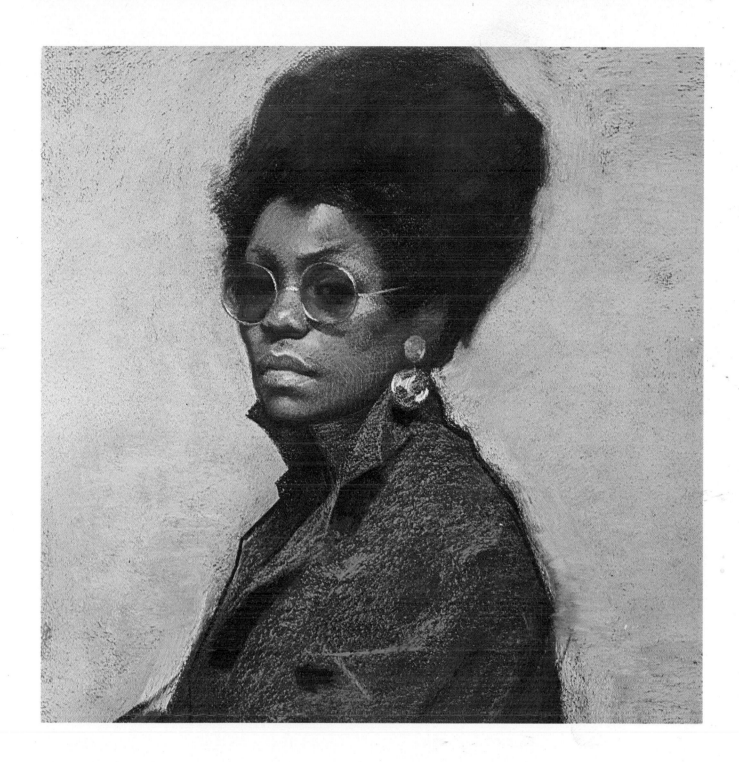

Amy *(Left) by Burt Silverman, pastel on canvas, 9" x 12".
Here is a fine example of a high-key painting. Everything is
in the upper tonal register except for parts of the hair. The
handling is simple throughout in the true impressionist tradi-
tion. The strokes of the pastel are almost exclusively vertical.
There's a Degas-like quality to the portrait with many lost
outlines, blurred edges, and cool, luminous shadows. Note
the ease with which the jaw flows into the neck and the soft
treatment of the ear. It takes great knowledge and experience
to employ this method and to carry it off so effectively. The
student can learn much about the use of pastel by copying
portraits of this kind and by trying to reproduce their decep-
tively easy technique.*

Blue Shades *(Above) by Harvey Dinnerstein, pastel on paper,
17" x 16¾". The artist uses cool colors judiciously to indicate
skin tones in the upper lip and along the jawbone of the sub-
ject. The hair is treated as a single dark mass and, through
blurred outlines and a few lighter accents, it conveys its tex-
tural effect. The technique here is broad and painterly with
emphasis on the large masses. Note how really subdued are
the few highlights on the nose, brow, cheek, and lips. The
highlight of the earring is very important to the tonal balance
of the portrait. Cover it and see how much of the painting's
sparkle is lost. The disdainfully raised eyebrow and the
upturned collar are significant character touches that help
delineate the subject's personality. (Collection Mrs. John
Buhrer)*

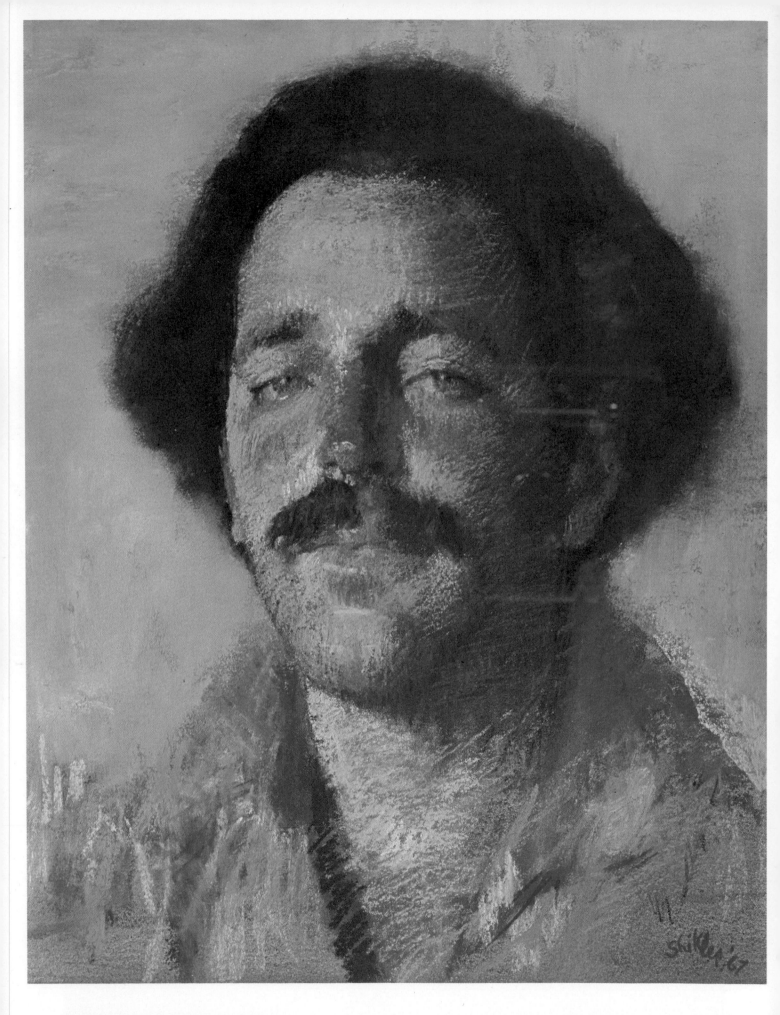

74· HOW TO PAINT PORTRAITS IN PASTEL

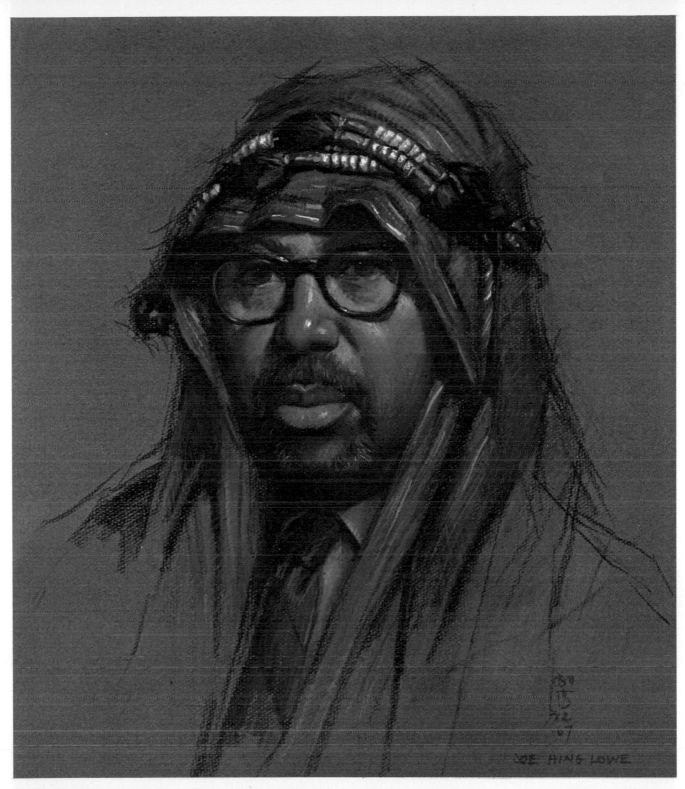

Bruce *(Left) by Aaron Shikler, pastel on board, 16" x 12". This is an example of pastel used in such a way that it immediately identifies the medium. The artist has boldly and distinctly employed warm colors in the nose and upper cheeks and cool colors in the chin and lower cheeks. The pastel is thickly applied all over and built up in short, choppy strokes that lend verve and a rich sparkle to the overall painting. The artist has employed selective focus to good effect by painting the forward features a bit more tightly and throwing the hair and ears into a soft blur. There's a very interesting treatment of the throat, with strokes running this way and that, overlapping and creating color rhythms and tensions. The highlights are applied most sparingly. (Collection Mr. David Levine)*

Saidi Bey *(Above) by Joe Hing Lowe, pastel on paper, 20" x 24". This Arab is an exotic subject that the artist handles with attention to detail. The whiskers are carefully painted so that each seems to stand out from the rest, the glasses are precisely painted, and the ornaments in the turban are drawn in with care and devotion. This is a tight technique which works well when the artist knows just how far to go without becoming too fussy. It demonstrates the versatility of pastel which permits the full gamut of methods—from the roughest to super-realistic.*

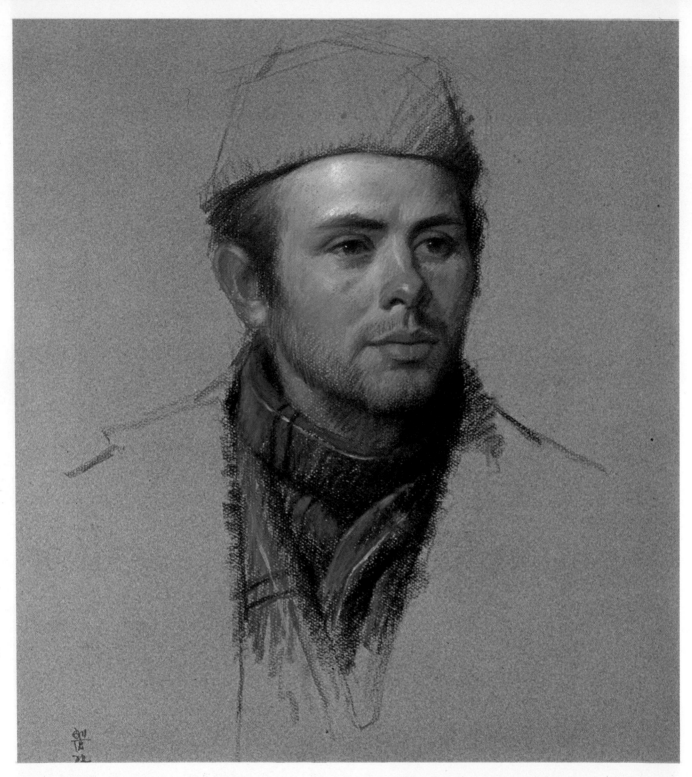

Portrait of a Young Man *(Above) by Joe Hing Lowe, pastel on paper, 18" x 24". This portrait is a true vignette. The lines of the cap and coat are merely indicated while the face and scarf are loaded with color. The artist sees many hues in the subject's flesh tones—high, warm reds in the cheeks, lips, nose, and ears; pale ochre tones in the forehead; and blue shadows on the chin and jaw. The highlights are bright and sharply defined. This might be designated a "contrasty" painting since the artist breaks up the skin tones into many variant colors. (Courtesy Mrs. Margaret McCarthy)*

Four Girls *(Right) by Robert Philipp, pastel on paper, 30½" x 24½". By a clever use of construction, the artist guides our eyes so that they fall first on the girl in the green dress, then work their way up to the girl in blue, the girl in red, and finally the fourth girl with the black hair. The artist's technique is loose, fluid, and sketchy throughout, yet the impression is one of sureness and of total command of the medium. Note how freely, yet how effectively the artist has painted the uppermost girl's face. We can almost feel what she's thinking. The brunette whose face is seen only in profile is an authentic human being, despite the fact that her features are barely indicated. The four figures seem to be inexorably bound up with one another, yet each is a distinct and individual personality. This is a most successful group portrait painted by a modern master. (Courtesy ACA Galleries)*

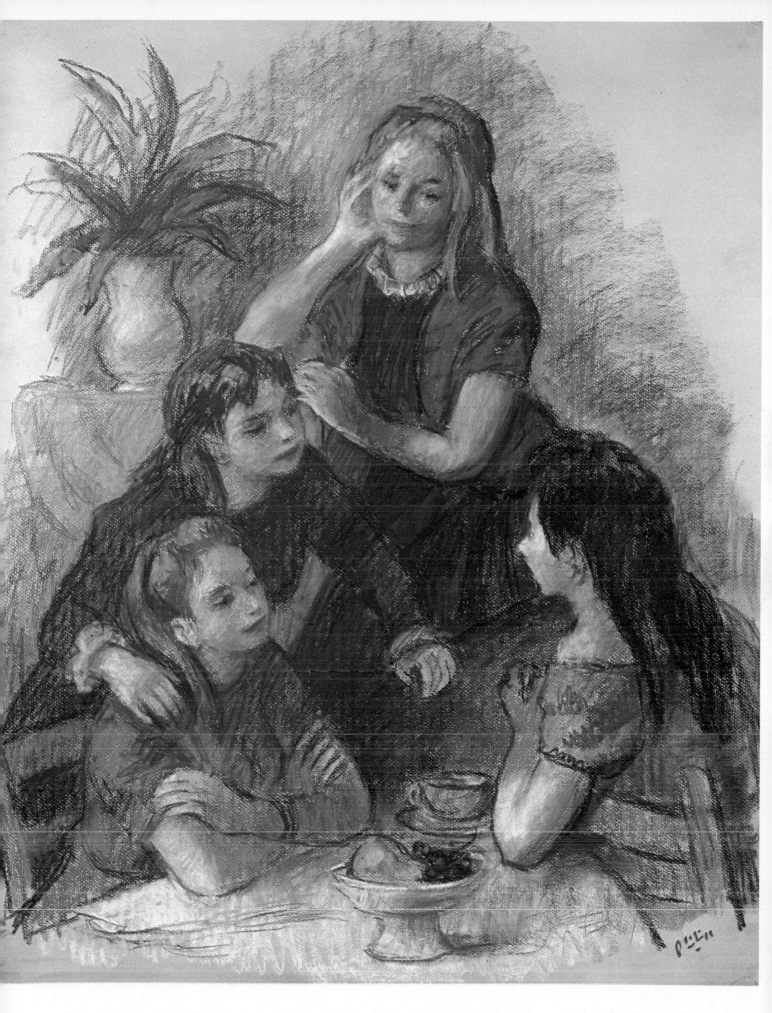

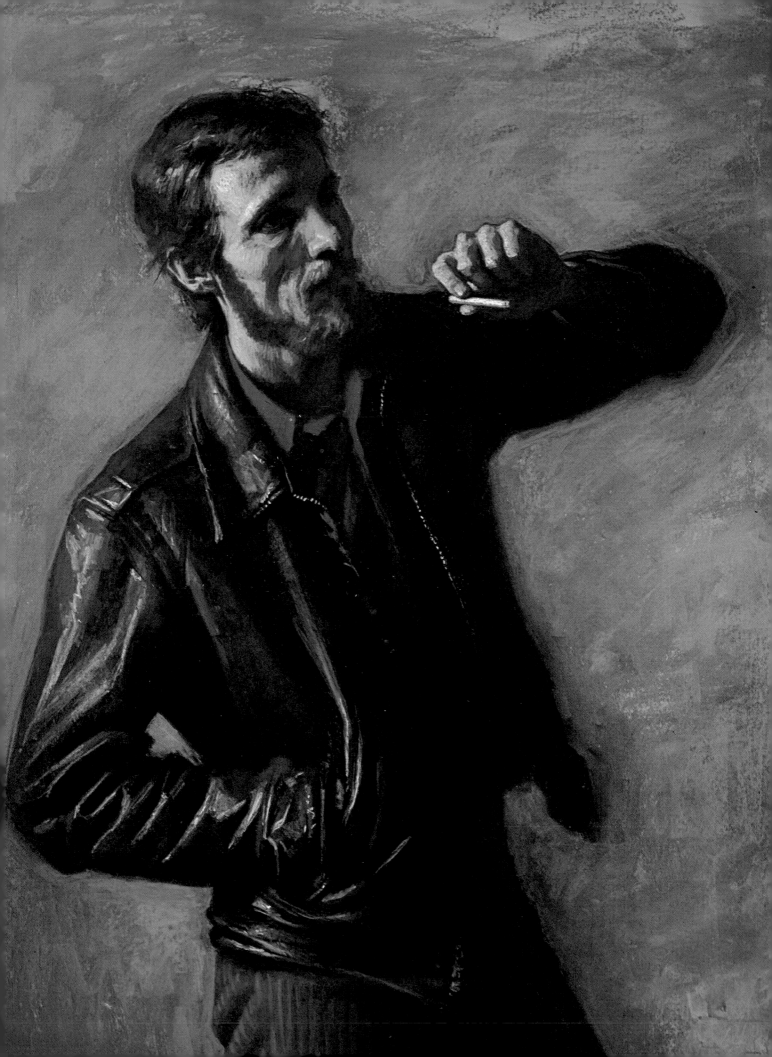

Head of Christ, I see hardly a trace of red in it. The master did employ a warm red on occasion, but he kept it nicely confined to merely an accent here and there. Rembrandt's faces occasionally show a lot of warm yellows, but this may be due to either the natural yellowing processes of oil paints, to improper cleaning which removed glazes—or to the fact that he painted skin tones in warm yellow!

On the other hand, look at some Gainsboroughs and Stuarts; they seem to glow with pinkness.

Corot painted skin tones beautifully in very subdued, almost grayish tones, as did Whistler. Perhaps, it's my personal prejudice, but I heartily dislike a portrait that's too warm. The impressionists, of course, painted with many bright colors, but they are more celebrated for their landscapes and figures than for their portraits. Renoir's women seem to burn with reds and pinks. These colors may be all right in a figure study, but they wouldn't do in a portrait unless the subject was actually a victim of some medical condition. Sargent, one of the finest portraitists of all time, kept his flesh nice and cool in most instances.

What sticks to choose for the painting? For any one portrait (excluding whatever exotic colors the subject may have included in his attire) you'll need no more than twenty to thirty crayons. I advise you to study closely the subject's personal color scheme (skin tones and hair), then pick out the one crayon that most closely approximates the *overall* color impression. This might be a yellow ochre, a flesh ochre, or a raw umber. Next, go two shades darker and two shades lighter of that crayon. Then, study the subject's shadow areas and again select a stick to match *the overall* tone of his shadows. This might be an umber. Repeat the procedure by going two shades darker and two shades lighter. Now follow the same routine with the subject's highlights, then with his hair. Now add a white, a black, two or three grays, a couple of blues or greens and you should have enough crayons to do a creditable portrait. This comes to some twenty crayons. Of course, you'll need extra crayons to do the costume and background, or you can make do with the sticks already selected.

Thus, you are working with between twenty or thirty

crayons on any one portrait. Of course, you can use every crayon in your assortment or work with even less than the rather limited palette I've outlined. But be assured that it isn't necessary to use the hundreds of sticks provided in some of the more elaborate so-called "portrait assortments." It's possible, but not necessary.

Nor is it necessary to arbitrarily restrict yourself to the least amount of crayons merely for puritanical reasons.

Painting Skin Tones

Caucasian skin, as I've mentioned, is not the pink, rosy, peachy thing commercial artists make it out to be. To paint it with honesty, lean to the raw umbers, pale shades; to the yellow ochres, pale shades; to the whites and flesh ochres. Add red accents on cheeks, lips, eyelids, and possibly ears. The shadows, depending on the light, may be raw umber with green and blue cooling tones. Save the darkest umbers or burnt sienna for the deepest shadows, the insides of nostrils, the eyelids, the slash between the lips, the eye sockets, the backs of ears, the planes beneath the chin.

These are, of necessity, arbitrary designations. I make them merely to help guide you on a course, a direction. Your eyes and your color sense must ultimately determine what crayons you'll choose to paint skin and everything else, but I want to caution you away from going too hot, too red, too pink and pretty. Practice skin-tone painting by observing the back of your hand under all light conditions, and by trying to paint the colors you see there. At first, you'll see only a single, overall tone, but gradually your eye will learn to discern nuances of other colors that you normally wouldn't associate with skin.

To learn how to paint skin tones, restrict your palette severely to a white, a yellow ochre, and a black, then try to reproduce the skin tones with these three colors. After you've struggled a while, add a touch of some red and see what happens. Now introduce a blue. Rework this combination and change the blue for an olive green.

One last reminder: if you do go off on your skin colors, it's better to slip into the cool key rather than the warm. Your portrait may appear a bit ghostly, but it won't appear ghastly. I much prefer El Greco's pearly, ivory flesh tone to François Boucher's tomato-red surprises. It's all a matter of good color taste.

The Dark-Skinned Subject

Black, they say, is beautiful, but not when it's painted with a black crayon.

Unless you're dark-skinned yourself, you may have misconceptions as to the true colors of dark skin. It is never black. Speaking in purely artistic terms, it can vary from a warm chocolate brown to a cool bluish-purplish brown. The variations are infinite. There is dark skin with a great deal of red in it, dark skin with a violet sheen, and so on.

The first thing to determine when you're painting a dark-skinned subject is, does his complexion tend

Smoking by Daniel E. Greene, pastel on board, 30" x 40". In this striking painting, the artist gives the lie to all those who would demean pastel as a weak, effete medium. Painted thickly and solidly, the portrait reveals the depth and the rich textural effects that can be achieved by a skillful craftsman who knows how to exploit the fullest potential of pastel. The subject's jacket is painted in smooth, fluid accents and tones that accurately represent the feel and touch of leather. Note how loosely Greene has painted the right arm so that the more-detailed hand holding the cigaret seems to thrust forward. While the inner contours are sharper, the outer contours of the right side of the figure appear to float into the background which tend toward an extremely realistic impression. The shadows of the neck and face are a luminous green-gray so that we know that there's real flesh underneath. Here's an extremely effective and lifelike portrait. (Courtesy Markel Gallery)

more toward the warm or the cool classification? Another important consideration is to closely observe the subject's highlights. Do they appear somewhat bluish? (They do in some of the darker skins). Excellent! This lends to a most excitingly colored painting.

Under no circumstances, should you ever paint dark skin with a black crayon. No matter how dark the subject, the black crayon will only make him seem clownlike and unreal. Work with your dark umbers, siennas, violets, and blues. Save touches of black for possible hair accents. The combinations of browns, blues, and reds will provide deeper, richer, more meaningful skin tones than a straight black tone, which is downright ugly. Explore the rich, deep values and nuances characteristic of dark skin. Seek out the highlights, but don't go too high in value. Remember that they may *appear light* in contrast to the darker areas around them, but ask yourself if they *are* as light as you're painting them. This is a most important point, since the tendency is to ignore the *true* value of a highlight and to consider it only in relation to its surroundings, thus exaggerating the contrast. And this can lead to trouble.

Another factor in painting portraits, and one which is particularly applicable to subjects with dark skin, is eyeball color. Nothing stamps a portraits as amateurish more quickly than eyeballs that are too white and in too sharp contrast to the irises. The whites of the eyes are never white. In Caucasian subjects, they are tinged with pink, blue, or yellow, depending on the person's circulation and glandular tendencies. Experienced diagnosticians can tell volumes about a patient's condition and prognosis by looking at the whites of his eyes. Experienced portrait painters keep the whites of the eye down in color, they render it the color and value of skin, never the snowy white of mascara ads. In dark-skinned subjects, this color goes correspondingly down. I've seen such eye "whites" a deep red, brown, or yellow.

Otherwise, when you're painting a dark-skinned subject, follow the same procedures as for his paler brothers. Determine his overall tone, go two shades lighter and darker, and so on.

Painting the Hair

Nature, boasting the superb color sense that she does, assigns her subjects hair that befits each individual's natural coloring and general condition. The infant's fine, flaxen hair which goes well with its delicate, rosy complexion, darkens and coarsens as the individual grows into a man or woman who, in most instances, would appear somewhat foolish in a cottontop. Later, when the skin grows drier, duller, and grayer, thin gray hair is a more suitable accouterment than a thick red, blond or black thatch.

The average head contains some 100,000 hairs, but as far as the artist is concerned, a head of hair is *one solid form* composed of various planes and angles. And he paints it accordingly.

The most ridiculous sight in a portrait is one in which the face stops abruptly and the hair begins just as abruptly. No matter how startling the color contrast between face and hair may actually be, they must *flow into one another*, not meet at some harshly defined borderline. Only a toupee exhibits such a marked division point, and good toupees don't do even that.

So even if your subject's face is as white as ivory and his hair black as ink, *ignore what you think you see* and run some of the face color, or a greenish middletone, into the hairline and effect a felicitous marriage between skin and hair which are, after all, merely an extension of one another. Your portrait will appear more lifelike, and less like the stills of Rudolf Valentino with the gallons of pomade on his glossy head fur.

Hair is wavy, curly, or straight. In whatever texture it comes, it should always be painted as a mass, never as individual hairs. Have you ever seen a portrait in which the eyelashes are painted in, one by one? You'll agree that this is an atrocity; painting the head hair this way is just as grievous an act of desecration.

When you look at the head of your subject, you'll note that it's made up of face and hair (in my case, it's face and more face). Paint it as a single form, not as two distinct entities. If a shadow falls on the face, it falls across the hair as well. Treat it as one shadow that happens to run across two adjoining terrains. When the shade of a tree falls over a field of corn and a field of spinach that's alongside, it's still *the same shadow*. Both corn and spinach fall into the same shadow value.

The same applies to face and hair. If both are in light, treat both as light areas, if both are in shadow, treat both as shadow areas. Don't paint the face shadow and stop dead when you reach the hairline. Keep going, for heaven's sake! Yes, keep going with the same crayon! Later, when you refine, pick up the light areas in the face and those in the hair with appropriate crayons, but use the same shadow crayon for both. This will teach you to paint shadow as shadow, no matter where it falls.

Another thing. When you're doing a portrait, remember what the main area of interest is. It's the face, not the hair, no matter how gorgeous it may be. The hair, as nature very properly intended it to be, is the frame for the face, a background to set off the center of interest. If only the dames who dye their mops in all the colors of the rainbow would realize this most important point! Or maybe they *do* realize it and consciously seek to draw eyes away from their faces.

Still, you'll encounter this particular problem as you go on to paint portraits. Women (and these days, men, too) will pose for you with hair the color of straw, of pitch, of fire engines, and of violets. One matron whose portrait I was doing appeared at one sitting with white hair, at the next—with her head a bright, electric blue.

In such instances, you must exercise strict discipline and at least *tone down* the monstrosity you see before you. When John Sargent painted his famous Madame X, he was viciously attacked for portraying a woman with *blue skin*. The fact was that due to some glandular or pigmentary aberration, the lady's skin *was indeed*

blue! Sargent kept it down, but he couldn't completely disregard the bluish tinge.

Therefore, artist, treat hair as a living extension of skin rather than an extraneous, alien substance that just happens to be attached to the scalp. If the subject has done things to make herself resemble a clown, help her by minimizing the damage. Think of a natural hair color that's closest to what she is wearing up there on her crown, and strike an acceptable compromise. Who knows? She might even be persuaded by the portrait to go back to her natural color.

In any case, don't let the hair dominate the face in your portrait no matter how tempting the prospect may be. Hair is hair and it belongs in the balcony, not in the front row. Paint it with your softest crayons as a single, flowing mass and leave the gleaming curls and the dazzling wavelets to the guy who paints portraits for ten dollars a throw at the local carnival.

Painting Objects

In the portraits that you'll be painting, there will be chairs, tables, sofas, vases, pianos, etc. Paint them if you will, but don't make a fuss over them. Objects in a portrait are like garlic on a salad—a hint is all that's needed.

Of course, there is a school that produces studies of fashionable women seated in their drawing rooms. This is perfectly fine if that's the road you intend to take. In this genre, all the furnishings are studiously painted and the figure is treated with possibly the same devotion to detail as may be a Sèvres vase. A portrait of this type is imbued with a kind of individuality, since it instantly identifies the apartment of Mrs. So-and-So. John Koch, the eminent American painter, is a master of this kind of portrait.

However, if you don't intend to portray a *specific room* but just a room with a *specific figure* in it, don't paint objects with overemphasis; merely suggest them. The arm of a chair, the back of a piano, or the side of a console can serve to strengthen the construction of a painting—but they shouldn't be delineated with such care as to draw attention away from the sitter, unless you are deliberately doing one of the aforementioned interiors.

A flash of gold from a gilt frame may be just the color accent you are seeking; don't work the effect to death by painting the entire frame.

If your chair becomes too interesting, what will this do to your sitter's face? After all, who is paying you— the sitter or the upholsterer?

There are such things as portraits of rooms, even of houses. I've done a few of these myself. But unless you have some specific reason for showing the inanimate objects surrounding your sitter, keep their value and color subdued. They are notorious scene-stealers and they'll so effectively upstage your sitter that you may deal your painting career a grievous blow. Remember at all times that you're painting a *portrait*, not a schematic for an interior decorator.

However, there will be times when you'll *want* to emphasize an object: the book or books of a famous author, the painting tools of a fellow artist, a building model lovingly fondled by a construction executive. At these times, you must render the object in question with some care, yet at the same time see to it that it, too, doesn't steal the limelight. You can do this in several ways. One, by assigning to it a lesser place of importance in the overall picture. A fact of life is that the eye will travel first to the lightest areas in a dark painting and to the darkest areas of a light painting. It will also be drawn to an area which is either brighter in color or different in color from the other areas. After it has fasted on these individual portions, the eye then leisurely travels to those areas which are most like the rest of the painting. Therefore, learn to assign priorities to those parts of the painting that you want to stand out, and to relegate the less-important parts to areas where the overall color and the overall tone predominate, and to a place on the paper where the eye is not likely to settle first.

For instance, if your painting is essentially dark brown, don't paint your book a gleaming white, lighter in value than your sitter's face. Neither should you paint a book with a bright yellow cover that will outdazzle everything else on the paper. Don't place it in the exact center of the paper, nor should you arrange your sitter's arms in such a way that the eye will be immediately drawn to the book. Instead, keep it subdued in color, less contrasting in color and value to its surrounding area than is the face, and lying or being held in a natural position so that it won't in anyway cause the eye to dart there to see what strange things are going on.

There are many books that delve deeply into the construction of paintings and to methods of guiding the viewer's eye to the more important areas of a painting. In a portrait, this instruction is somewhat superfluous since the eye will most naturally travel to a sitter's face—unless you've taken special efforts to counteract this normal condition, for instance, by painting objects with too much care, in too bright a color, in too contrasting a value, at exotic angles, or in unfamiliar settings.

Painting Clothing

The clothes that your sitter will be wearing in his portrait should be selected with the greatest of care. You, as the artist, must discuss this aspect at length with your sitter, and hopefully arrive at a mutually agreeable decision.

There are many people who simply don't know how to dress, people whose taste in clothing is atrocious. They'll come to you ready to pose in garishly colored, wildly patterned garments, and it'll be your job to persuade them to change into something more appropriate. You'll encounter fierce opposition. Women will insist on a favorite dress, on a particular piece of jewelry. They'll load themselves down with every knicknack they own and even borrow a few from friends and relatives. They'll ask you whether they look better in pink or blue, and frown when you ask them to wear black.

Sit them down and explain to them why it would be better for the portrait if they wore plain, unadorned dresses of a solid pattern and a quiet color. They'll weep when you ask them to leave off their heirlooms and to comb their hair in a simple, natural style. Tell them how their beautiful faces will suffer if they wrap themselves in ribbons, bows, sequins, pins, brooches, and what have you. Explain to them how a busy pattern of a check, a stripe, or a rick-rack will draw attention away from their delicate nose and will restrict your efforts to make them beautiful. Ask them if they want to be remembered for their hot-pink blouse or for their lovely complexion.

They'll get the message if you make the point forceful enough. Of course, there'll be some who simply won't be moved. In this case, *you* must serve as the final grand censor and simply leave off things that offend the eye and tone down others. If a dress is a combination of blue, green, purple, and brown polka dots, paint it as a solid color, embodying some of these elements. Slough over tiaras, pearl necklaces, and earrings; either suggest them or leave them out altogether. If questioned about it afterward, display some of the legendary artistic temperament and proclaim: "It would have hurt the portrait". By then it will be too late, and you'll have gotten your way.

Clothes—like objects—are best relegated to the back rows of painting. Only inferior artists worry over every fold and stitch and expend hours of work on lace, doodads, and furbelows. Rembrandt slashed in a hunk of armor so that it seemed to glow like fire, but he knew when to stop. You'll note that most of his sitters wear sober, unadorned black

If your subject is in uniform with rows of ribbons, use these decorations as color accents, but don't dally over each one till infinity. Suggest, don't render. Keep clothing darker than the face. If you must work tightly, save the fussiness for where it will mean something. Clothes are the shields we assume to protect our vulnerability from our fellow human beings. Since a portrait is intended to reveal rather than conceal, why overemphasize masks?

Painting the Background

The background in a painting is exactly that—something that should hang back and set off what's in front—namely, the figure. Whole libraries could be written about the special character of portrait backgrounds: the mysteries inherent to them, the depths hidden within them, the secret formulas the old masters used in their execution. I would never argue the importance of painting a good background, but if it was all *that* important, why would it slink about in the back of things? The figure is what's important; the background is only there to make the foreground look better.

I suppose that there are times when the background is the more important aspect of a painting, but never in a portrait. In any case, backgrounds must be painted in other than vignetted portraits.

Backgrounds come in two basic types: one, a color

area devoid of detail, the other, portraying an interior or an exterior scene. The kind you select must be predicated upon the kind of portrait you want to paint.

Some of the earliest portraits were presented against exquisitely painted exteriors. Certain early masters liked to place the figure in a fantastic landscape. Later, the emphasis shifted inside and we were treated to views of castles, palaces, cathedrals. Later still, we sauntered outside again amidst scenes of war, hunting, horseback riding. Rembrandt was one of the first major artists to paint a completely formless background. He is probably the best painter of backgrounds there is. Rembrandt's backgrounds serve to show off the figure without doing anything to take the spotlight away from it, yet at the same time they are understated.

It was relatively much later that artists began to paint portrait backgrounds that were light, airy, brightly colorful. The fantastically bold and uninhibited Van Gogh painted portrait backgrounds of bright orange, bright yellow, or lime green. Many of the impressionists did likewise.

Today, portrait backgrounds come in every variety: light, dark, formless, detailed, bright, dull, or no background at all. This is as it should be, since art should be as diverse as possible. However, certain ground rules should prevail when it comes to portrait backgrounds. The question the portrait painter must ask himself is: "What do I want my background to do"? The answer to this remains: "Set off the figure."

How is this done? It can be done in several ways. One way is to paint the background in colors *that contrast in hue* to the overall color scheme of the figure. Example: a dull green background for a ruddy cheeked colonel in a red mess jacket.

A second way, is to paint the background *in values that contrast to the overall tonal scheme of the figure.* Example: a dark gray-brown background for a pale girl in white organdy.

A third way, is to paint the background in colors *that contrast in temperature to the overall color scheme of the figure.* Example: a warm, creamy pink background for a black-skinned man in a cool blue dashiki.

The variations are endless, but if you remember to incorporate the first, the second, the third—or all three of these principles—you'll come up with a background that won't clash with your figure, that will remain discreetly in the rear, and, what is most important, that will enhance your sitter and your total painting.

In this, as in all other considerations, a long and concentrated study of the backgrounds of important portraits will pay rich dividends. Go to your museum, take books out from the library, and look at good portraits. Try to analyze the reasons why artists choose certain colors for specific backgrounds. Apply the three principles I've mentioned to your investigations and seek to determine which artist used which principle for what purpose.

In pastel, the figure is sometimes vignetted (no background is painted at all) but even in such instances, there is a background (the paper).

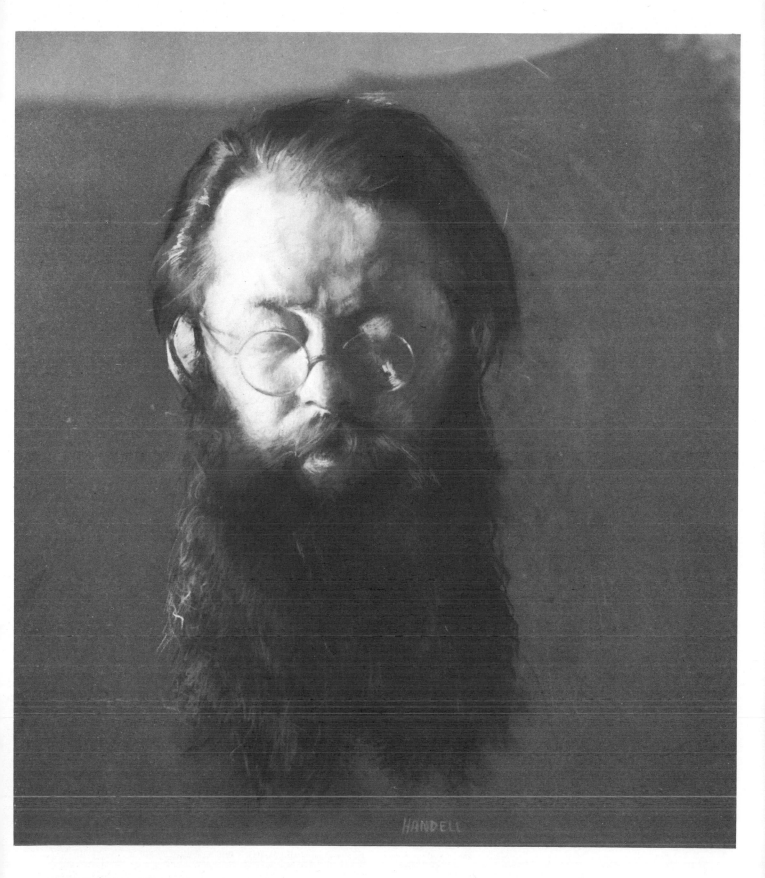

HANDELL

"**Budda**" *by Albert Handell, pastel on paper, 18" x 18". Softly handled in a painterly technique throughout, the portrait acquired a kind of lyrical, mystic quality. The artist has nearly obliterated the subject's eyes and has softly modeled the planes of the face going from light to halftone. Only in the* *beard are there several sharp and distinct details suggesting a few stray whiskers in the great abundance of hair. This is a distinct character study which is reserved for noncommissioned portraits, yet it's a solidly and most handsomely painted head.*

Value of Grays

I read somewhere that you can tell a great colorist not by his bright colors, but by his grays. There is much merit to this statement; grays are the spices that add piquant flavor to the main dish which is the bright area of exciting color that draws the admiration of viewers and critics alike. Grays (and this might be expanded to include *dull* browns and *dull* greens) can be a potent weapon in the colorist's bag of tricks. We've already learned that no painting should include more than a limited number of strong, bright colors. The exception is in the pointillist method in which hundreds of such strokes may be employed since the principle applies to larger *masses* of color rather than to small dots and strokes.

Grays are the calm seas that lie between such islands of vivid color. Grays rest and restore the eye after it has sated itself on the rich feasts of red, yellow, purple, or orange. Grays between two strong colors throw the bright areas into the spotlight and keep them from overpowering each other. Think of a ruddy-faced sailor, his face glowing from sun and wind and dressed in an orange-pink shirt. Now visualize the same man dressed in a cool, gray windbreaker. Or consider a bowlful of red apples standing against a purple wall. Ghastly, isn't it? Now substitute a cool, olive gray-green for the purple. Better, isn't it?

But the use of gray doesn't mean to simply pick up a gray crayon and lay in a mass of gray where you think it would do the most good. In painting, gray is a color as much as any yellow or red and must be treated with equal respect. A gray tone can be composed of many complementary colors (red and green, blue and orange, yellow and violet) which together form a gray by cancelling each other out in hue. Red, blue, and green, when blended, will produce a kind of brown-gray, as will a mixture of yellow, red, and blue, as will certain other combinations. These grays are much more interesting than a gray laid in with a gray crayon—more alive and vibrant.

Study carefully the backgrounds of old master portraits. You'll see their rich varieties of tone, of warm and cool color and of subtle accents, even though the whole background may at first glance appear all gray or all brown.

Gray areas must be handled intelligently and with the same care attended to other areas. A plain, evenly painted gray can be a bore and an eyesore. Sparkle it up by introducing other colors into it. If it grows too lively, you can always gray it down again with a complementary color. But above all, don't let the gray turn into an insipid, monotonous area. The ocean may be gray for thousands and thousands of miles, yet it never grows dull to the eye. The reason is that even on the most overcast day there are subtle lights, shadows, blue greens, yellows, or browns to liven it up. Take a note from nature and see what you can do to make a gray *interesting, yet not overbearing.* It's the function of grays to play up the bright colors but not to overwhelm them—ever. Liven up a gray by dosing it with some yellow, a violet, or a green. There are warm, reddish grays; cool, bluish grays; brown-

grays; green-grays; yellow-grays. What there musn't be are shallow, vapid grays.

And *don't overdo.* You can gray your portrait down to such a degree that it will lose all its life. Exercise good judgment and, if in doubt, remember this: *Better a portrait that is a touch too lively than one not lively enough.* So use your grays with taste and with discretion. They're indispensable items, but like salt and pepper they should accent the main dish, not be the main dish itself.

Warm or Cool Colors

I've spoken at length throughout the book about warm and cool colors. The next logical question may well be: "When to use either?" This is not a question to which I can honestly supply a conclusive answer. I can make only suggestions, since every portrait poses different challenges and it's exclusively within the artist's province how he elects to meet these challenges. Of course, the subject himself helps decide the kind of treatment that will be applied to the portrait. If the subject is a flaxen-haired young lady with ivory skin, pale blue eyes, and is wearing a white dress, all this already spells "cool" and the artist has his path clearly marked for him. He'll incorporate warm accents into the painting, but it'll remain essentially cool due to the nature of its main component, the cool, young lady. The reverse would be true of an exotic, chocolate-colored woman with deep red lips and dressed in a bright yellow turban and a red blouse. Such a sitter fairly exudes a warm aura.

However, most sitters don't fall into such definite, distinctive categories. They constitute the great, drab, nondescript majority (color-wise, of course). At one point, the artist must take himself in hand and plan a color temperature scheme for the portrait. Although he may and should incorporate both warm and cool areas into the portrait, he should determine an *overall* temperature scheme. He must ask himself: "Will this be a cool or a warm portrait?"

How is this to be decided? First, the artist must come to understand what "warm" and "cool" symbolize to the world.

"Warm" suggests passion, instinct, impatience, exuberance, extroversion, hedonism, sensuality, temperament, and hope. We speak or used to speak of "red-hot passion," of "red-hot mamas," of "seeing red."

"Cool" suggests logic, sensitivity, restraint, aloofness, intellect, self-control, puritanism, perhaps a touch of melancholy, morbidity, or cynicism.

The artist might take these color clichés or associations into consideration when planning his portrait—if this seems right for the sitter.

If the subject is young, it may not hurt to portray him in a cool setting. As for the college freshman—he has enough going for him; cool him down a bit (artistically speaking). Cool colors will lend his portrait some self-doubt, some earnestness, some introspection. His whole life is still before him and a touch of thoughtful melancholy at this stage would not be offensive. It may even appear romantic.

But if he's an eighty-year-old man and the wings of the angel are close in the offing, why not present him in an optimistic setting, warm and pulsating with life? Then again, skin tends to turn gray and colorless with advancing age and it would flatter and enhance the elderly sitter to surround him with warm and positive accents. Urge him to wear something warm and bright; drape a colorful, vibrant cloth behind him and revitalize him with the symbols of some of the things that may have gone out of his life: joy, enthusiasm, physical love, expectation.

If a woman tends toward stoutness, cool her down. Reds and yellows tend to exaggerate bulk; blues and greens serve to minimize it.

Of course, I'm assuming that you're trying to present your sitter in a favorable light. If you're executing a noncommissioned portrait and you *intend to please only yourself*, then, by all means stress the model's grossness, sloth, or cupidity—if *it's your artistic intention to point out these undesirable characteristics*. My suggestions apply only to instances in which you're seeking a flattering representation of your sitter, as is the case in most commissioned portraits.

Therefore, give some psychological consideration to help you determine the color temperature and direction you wish to follow. A dignified bank president might dictate a cooler overall treatment than a fiery, young flamenco dancer. However, you might opt to present each in a setting that *contrasts to his obvious image and personality.*

I wish I could be less equivocal and tell you precisely what to do in every instance, but I can't and won't overstep my bounds. This would be arbitrary, presumptuous, and pedantic, and contrary to the purpose of this book which is to stimulate you to draw upon your own resources, to expand your individual consciousness, and to force you to think and plan and consider before painting a portrait. Certainly no responsible author, nor even a good teacher who shares your presence, can tell you *exactly when* to use cool or warm colors. You can only feed the information that I and other sources supply you into your own personal computer, then come up with solutions based upon an intelligent and thoughtful consideration of all the factors inherent to a particular situation.

Treatment of Shadows

Shadows are to a portrait painter what his animals are to the lion tamer. If you don't understand their behavior, one day they'll turn on you and maul you.

Our concern, in this chapter, is the treatment of shadows in regard to color. The next question may well be: "Is there color in shadow or is shadow by its very nature colorless?" The best way to answer this is to think of shadow as a gray veil that falls over an object, darkening the color of the object and rendering it greatly reduced in hue. Thus, a yellow dress becomes a dark yellow in shadow, and can even appear as a dark brown or a deep gray-black. The one thing to remember is: the *darker its shadow, the less color* an object possesses in the shadow area.

Another thing to remember: the *stronger* the light striking the object, the *darker the shadow* the object casts or possesses. Thus, a spotlight shone directly upon a figure would produce almost a black and white effect. Black because shadows darken under a strong light, and white, because a truly bright light tends to rob the color from objects seen in this light, and to render them whiter and less colorful! You can study this effect on a beach. You'll notice that under a blinding, bright sun a red bathing suit (seen in the light, not the shadow side) *will appear less red* than the same suit seen under a moderately bright light. This effect can be compared to someone suddenly shining a spotlight into your eyes. All you see is a blinding glare that is completely bereft of color. Thus, colors appear brightest in a moderately bright light. Under strong lights, they tend to whiten and the shadow areas to darken.

One way to treat shadows in painting is to exaggerate these factors, to render shadow areas with a minimum of color so that the shadow area of a pink face, a yellow shirt, and brown trousers all come out *the same brown or gray* tone and color. This is the way painters handled shadows in pre-impressionism times.

But the impressionists added a new dimension to the handling of shadows. They cast aside the browns and grays and began to use greens, blues, and violets in the areas where until then, only browns and grays dared to tread. This, then, is another way to handle shadows. By the use of bright but essentially cool colors instead of dark colors in the shadow areas.

A third way, is to compromise between these two methods and to combine them by employing basically browns and grays in the shadows, and by livening them up with strokes or dots of bright, cool, or occasionally, even warm colors.

Whatever method you employ, there are some basic factors to remember. One is not to become too involved in the color of objects in shadow, but *to treat the shadow area as shadow first and as something possibly possessing color, secondly.* This means to render the shadow as one continuous tone and to *indicate*, if so desired, the pink of flesh, the yellow of a shirt, the brown of trousers. Keep your shadows soft and flowing. If you mark off strict divisions in the shadow areas, you'll end up with a cut-out figure, not a human one. Let it all kind of float together in a pleasing, homogeneous mass. Liven it up with a few sprightly touches and your shadows will live and breathe.

The fact is, that most immature painters destroy their portraits with shadows. They either paint them as a flat, dull, black mass, or they ignore the entire thing and merely dab in some mousy, timid, undefined blobs.

Shadows must possess strength and authority. Shadows are deep and full of mystery. They serve to glorify the striking light areas to which the eye naturally roams. Never, never paint a shadow so that it looks like a dark hunk of tarpaulin! If you don't wish to introduce bright colors into the shadow, then balance the areas of dark color so that there is an interplay

of color against color, tone against tone. Stroke umbers next to violets next to grays, etc. Make the whole area a kind of network of muted excitement. Go several tones lighter or darker within the shadow area to build up a rich patina. If you lay in a shadow with just the side of a crayon or rub it together and do nothing else to intensify it, your painting will go dead no matter how you doodle around with your light areas. Shadows must have life just as light does. A mixture of cools and warms can create a most exciting shadow area. Degas often scumbled red over green to create a visible shadow area.

Even though a shadow area can be of the same hue and tone from head to toe, it must possess richness and variety from head to toe. By this, I mean: you might have browns and greens and dull yellows in the shadows of your subject's head. In that case, carry the same browns, greens, and yellows all the way down. Don't stop at the neck, but imbue all the shadows with the same nourishing touches of color and tone.

Several other points to consider.

Many artists reserve the brightest notes of color for the areas *where the shadow meets the light.* They claim that this lends richness to their paintings. I've always considered these border areas as halftones and therefore not the brightest areas of color, and consequently do not follow this procedure, but I give it to you now for all it's worth.

Shadows have been described as basically transparent areas, and light areas as basically opaque. This is more significant in oil painting where opaque and transparent colors exist, and in which you can apply a glaze (a transparent veil of color). Pastels, being opaque, don't allow this procedure. Therefore, you might try to remember the transparency of shadows and attempt to render shadows as veils that come in varying degrees of darkness and which lie draped over the subject. If you ask me *how* to do this, I can only suggest that a variation of lighter and darker colors in shadow is the nearest practical approach toward this objective.

The subject of color in shadow in painting is an inexhaustible one, and we must move on to other matters. I want to leave you only with this final observation. Think of shadow as a living, vibrating, pulsating substance, not as some distant, dead, aloof mass. Shadow is as much a part of us as light and must be accorded the same care and devotion. Glance at your hand right now as you're reading this book. Part of it is in shadow, isn't it? Is that part any less visually stimulating than the light area? It possesses its own beauty and character. Look at it closely. Do you see that it's not one solid blob of dark but a combination of thousands of little color areas? It really pays to take a week or so and closely study those areas of skin that lie in shadow on friends, relatives, and strangers. Look at these areas with sharpened vision. Don't they seem to scintillate and to *move* in a rhythm all their own? Think of the shadow areas as millions of atoms continuously shifting, swirling, spinning, sparkling. Don't these shadows seem more alive to you now?

There is great beauty in shadow. Treat it with the respect it deserves, not as some churlish stepchild. It will return this devotion in your painting. Go to a museum and gaze deeply into the shadows of great portraits. After a while, you'll feel a hypnotizing effect. I've become as if intoxicated after looking for minutes into the shadows of Rembrandt's self-portraits. It's a heady experience, but a most enlightening one.

Use of Black

The controversy regarding the use of black has embroiled artists for generations. Some claim that they can't be without it; others eliminate it entirely from their palettes. Neither course is obligatory. You can keep your black, but you should use it sparingly. In pastel painting particularly, black is often an annoying factor due to the innate hardness of the crayon. It's hard to apply and it breaks at the most inopportune moments.

Many artists claim that black isn't necessary at all and, that by combining ultramarine blue and burnt umber, you can approximate the color of black. The truth is that a black *can* be most offensive in a painting and its use should be limited to an occasional accent or two. I personally seldom use black in pastel. I find it harsh, abrasive, and too assertive. However, I've seen black used most effectively by pastellists, and I recommend it in my suggested palette. The only advice I'll offer you is: don't use black if you can approximate it with other colors, and use black only when nothing else will do.

There's nothing uglier than a black mass of unbroken color. A black accent here and there may be fine, therefore, relegate black to the spice rack of colors. Use it only to point up something, to strike in an emphatic note. If you must use black, lay an area of softer color (umber, ultramarine, or sienna) underneath it to facilitate handling, then scumble over the black area with another color to cancel its stultifying effect.

But don't arbitrarily eliminate black from your palette until you've tested it thoroughly. Maybe you'll discover that you *like* its effect and come up with a whole new way of using pure black in pastel painting in such dramatic fashion as to shame me and all those who demean its effectiveness.

Incidentally, some of the most expressive portraits in history have been painted with white, black, and a shade of red—so where does this leave my prejudices? Exactly in the same place where they were before. I still don't like black in full-color painting; it certainly has its place in a three-color technique. But as I've said again and again—don't take my word for it. Use black, until you've personally decided that you don't like it. As far as I'm concerned, it has its limited uses.

Jake Williams *by Richard L. Seyffert, pastel on paper, 15½" x 17". With sure lines the artist has put together a solid and well-constructed portrait head. The strokes of the crayon follow the planes of the face naturally. The surface of the paper is often employed as the middletone, especially in the forehead, where only a few light strokes are employed to indicate skin texture. Although rather sketchily painted, there is no sign of hesitation anywhere—the artist obviously knew where to place his stick for greatest effect. There is little if any blending anywhere in the portrait; this is a good example of the versatility of the pastel medium, which allows just such a loose and bold technique. (Collection Jake Williams)*

Michael S. *by Harvey Dinnerstein, pastel on canvas, 16" x 12". In this striking portrait of a contemporary youth, the artist has applied his pastel rather thickly, building up layer after layer and concluding with a series of horizontal strokes. We can consider this as a fairly tightly painted picture—the edges are toward the sharp side; the details are pretty much* worked out. *Only the hair is handled in a broad, loose fashion with indistinct outer contours. There's a disturbing quality to this somber and brooding portrait, greatly abetted by the device of having the subject's eyes looking directly at the viewer, creating a certain intensity of expression. (Collection Mr. and Mrs. Samuel Sporn)*

What Is a Portrait?

Until now, we've spoken about the tools, the techniques, the characteristics and some of the esthetics of painting. Now, we must consider the other side of the coin, the portrait itself. What do we hope to accomplish in painting a portrait? Is it to set down a two-dimensional copy of a three-dimensional object? Or to capture the exterior likeness of some individual so that it clearly identifies him and sets him apart and above his fellow men? If you think about it, there's something pagan about creating a facsimile of a living being. It imbues that person with certain divine qualities and it's little wonder that one of the ten commandments forbade the formation of graven images.

Commissioned and Noncommissioned Portraits

To begin with, a person must possess a monumental ego to commission his own portrait. Many subjects adopt a modest and humble air, but I've yet to meet a portrait sitter whose self-esteem didn't tower above Mt. Everest. Therefore, it's reasonable to assume that those who commission portraits very frankly want to be exalted, deified, immortalized, not to mention—flattered. There's nothing wrong with this, if you as the artist acknowledge these attitudes and properly assess your own role in this act of glorification.

Before we go on, I must establish a clear distinction between commissioned and noncommissioned portraits. If you get the urge to paint your kid sister because you like the way her red hair and freckles stand out against her luminous skin, that's one thing. She may or may not want to sit for you, but the portrait is the product of *your will*, not of some need by your sister to become part and parcel of posterity.

But when the president of the local bank seeks a portrait to celebrate fifty years of foreclosing mortgages and dispossessing orphans and widows, that's another kettle of fish altogether. Mr. Skinflint is anxious to show the world what a sweet, lovable guy he really is underneath all that crust, and it's your job *to give him what he wants*. If you don't like the rules then quit the game, but above all, face the facts squarely. As a professional portrait painter you'll be called on to paint people whose politics, mores, habits, morals, and appearances you may despise, but you'll

paint them if you want to keep feeding your family. This is not to suggest that you must become an unprincipled sellout when you go on to paint portraits for a living. On the contrary, you must become extremely tolerant of humanity and place yourself in the position of a physician who heals people regardless of his own opinions regarding their worth to society.

Of course, you can always turn down a commission, but I regard *this* as a sellout. Barring the rare probability of your having to paint a mass murderer, you must consider every commission as an artistic challenge

The grosser and the uglier the subject, the more effort you'll have to expend to paint him successfully and the greater the resources that you'll have to draw on to execute a creditable portrait. As any two people drawn together in any situation, you'll even establish a rapport with Mr. Horrible, despite all your reservations. And this will lead to a more tolerant view of all mankind, sadly lacking though it may be.

Of course, not all of your commissioned sitters will be offensive to you. Toward most, you'll be politely indifferent; some will become your good friends.

But at all times you must face up to the hard fact that there are people perhaps whom you wouldn't have chosen to paint, but you're obligated to paint. Obligated to whom, you may ask. To yourself, that's whom. Not only financially, but artistically—above all, artistically—for to me, art represents discipline, and what greater discipline than to paint someone who means nothing to you, and to paint him as magnificently as you know how?

This then is commissioned portraiture. Now then, if you choose to paint noncommissioned portraits, these can be considered labors of love. You've elected to paint someone whom you either love or admire, or whose face or character have stricken a responsive chord in your soul.

You must learn to distinguish between these two kinds of portraits, not in the quality of your work, but in your mental approach toward each.

Drawing Out Your Subject

The point that I'm trying to make is that in neither case will you be able to remain completely objective

toward your sitter. If it's a noncommissioned portrait, chances are good that you're acquainted with your sitter's character or that you're in some way emotionally involved with him. (Obviously this doesn't apply to professional models.)

But when the commissioned sitter first plops down before you, you know little about him. He may have won a dozen medals and been appointed to presidential commissions, but who is he? What is he? The length of his nose is of little consequence at this stage. What's important is: What's he really like? You begin by probing, asking questions, hoping to draw him out. But he may be a cagey old bird who has learned to play it close to the vest, and then where are you? The bigger the man (statuswise), the harder it is to gain a true evaluation of him. He has been in the public eye; he has learned to keep his inner self hidden, and to present only his best side to the outside world. You ask, he parries. You probe, he clams up. You stare at each other like bull and bullfighter.

This is the time to lighten up on your reins and to ask yourself: "Why am I painting his portrait? What's the object of the portrait?" All right, sort out the facts. By *whom* was it commissioned? By himself? By a board of directors? By his wife? By his mother? By his children? *Why* was the portrait commissioned? To repay a favor? To pay off a debt? Out of fear? Out of love? Out of obligation? You sit there looking at him and he stares back. He doesn't seem quite as formidable now as he did a moment ago. Some of the veneer seems to be slipping away and you begin to see the shnook who can't get out of sandtraps in his golf and whose children disobey him. In other words, a human being. You ask him a question that poses no challenge. "I see you've got big shoulders. I bet you played football in college." His face flushes a bit and he responds. He's glad to get away from the problems of industry, government, or finance and to talk about something really close to him—himself. Underneath all that protective armor is a farmboy who wanted most of all to drive a locomotive. There, you've made a breakthrough! You're no longer antagonists but two human beings thrown into a situation. You talk; you joke a little; you ask him questions about his youth, his background. He's happy to talk about his favorite topic—himself. The defensive layers peel away a bit and you begin to see the man underneath. He's not the tough, driving executive who bends people to his will, he's human. He reveals himself to some degree and now you have something to latch on to. Now you ask yourself again: "What purpose will this portrait serve? What is its object? Where will it hang? In the boardroom? In his living room? In his bedroom?"

Object of the Portrait

There is no one object a portrait serves. It's one of many. It's predicated on all the factors I've mentioned before. Who ordered it? Where will it hang? Whose need is it intended to satisfy?

Obviously, if it's intended for the boardroom it must reflect strength, confidence, leadership, determination, responsibility. If it's going to his wife's boudoir, it should express devotion, tenderness, concern. And so on. What you must do then is to select from the complexity of your sitter's personality those traits that will *serve the object of the portrait*. This is particularly important in your commissioned work. In your noncommissioned work, you're the master of the situation and you can stress those personality factors that you choose to portray.

Obviously, you wouldn't paint a four-star general the same way you'd paint a television comedian, unless—and there's always an unless—you feel sufficiently confident to present your sitter in a pose and an attitude not commonly associated with him. This means to paint the comedian in a completely serious vein—a side that every person possesses—and the general in a frivolous, lighthearted manner. But if the general's portrait is to hang in the lobby of the West Point museum, this hardly would be appropriate, would it?

Therefore, you must first establish within your own mind *the object* of the portrait, then try to balance the sitter's qualities in such a way as to present a more than one-sided aspect of him. It's basically a matter of compromises. The general may be shown smiling slightly—the comedian, thoughtful. To completely reveal the reverse sides of their character may be too daring a step and one which might create painful repercussions. I know, for I've encountered them.

Deciding What You Want To Accomplish

Now that you've considered your sitter's needs, it's time to reflect upon your own. What do *you* hope to accomplish by painting this particular portrait? Is it merely to earn a commission? That's not enough. You owe yourself a much deeper responsibility. Every portrait that you paint and sign becomes a reflection of your talent and abilities. It's your duty not to release anything that won't add to your reputation as an artist.

You must plan each portrait as if it will be the crowning achievement of your life! This sounds like a pompous statement, but I make it in all sincerity. There are only so many paintings within you—natural attrition limits every artist's output. But whether you'll paint six portraits or six hundred in your lifetime, each one is a part of you and will remain so for years after you pass on. You may not give a damn about posterity, but if you're serious about art, you *should* give a damn about the quality of art in general. Every painting that represents something less than the artist's best effort demeans art, and whether you know it or not, you are honorbound to do your bloody best to improve and to enhance all the world's art. Bad painting that could have been better is a pollutant just as much as carbon monoxide and phosphates.

What you should want to accomplish in painting any portrait is to provide a technically correct representation of the physical aspect of a person, which will also reveal his psychological side, please the eye of

the viewer, represent a period of time to future generations, and add to the treasurehouse of world art.

What you *shouldn't* want is to knock off a quick job, to get the dimensions between the eyes exactly so, to flatter the hell out of the sitter, to take his money and run.

Even if you're only starting out, force yourself to do the very best that you can, then take a step back and ask yourself if you can't improve upon this effort. Man doesn't even begin to fathom the resources with which he is endowed. Rembrandt, Velásquez, and Rubens each had only one brain, two eyes, and ten fingers to work with—no more or less than the rest of us. The great artist is only better than the fair artist in that he's able to draw deeper upon his resources. There's actually no such thing as genius; there's only the ability to completely fulfill a person's potential. Most of us simply don't bother to keep lowering the bucket into the well in order to reach the water. We stop halfway or three-quarters of the way, depending upon our self-discipline, our determination, our sincere desire for artistic fulfillment.

After you *think* you've done your best, ask yourself: Was this really my *very best* effort?

Years of struggling with all the problems of painting have shown me that each time I did this, the painting improved. *Why then*, I would ask myself, *didn't I do better in the first place?* The fact that I could paint *one* good picture proved to me that I had the ability to paint *five hundred* good pictures. Why then didn't I? The answer was inevitable: sloth, arrogance, laziness.

What then do you want to accomplish in a portrait? First: a fine work of art. Second: a good psychological likeness of the subject. Third: a meaningful representation of a time in man's history. Fourth: a means of enhancing your artistic reputation. Fifth: a source of satisfaction to the sitter, his family, and friends.

To Flatter or Not to Flatter?

There are two kinds of portrait sitters: those who come right out and ask you to flatter them, and those who secretly hope that you will but they're too timid or ashamed to ask.

There are also two kinds of portrait painters: those who frankly admit they flatter their subjects, and those who loudly proclaim that they would never stoop this low. The latter are those who have had trouble getting portrait commissions.

Again, I must emphasize that I'm differentiating between commissioned and noncommissioned portraits. Flattery is obviously a more important issue in the commissioned portrait.

Should you flatter? That depends upon your conception of flattery. Consider the ugliest person you know. He may be bald, long-nosed, weak-chinned, pot-bellied; he has coarse skin and jug-handled ears. But maybe—just maybe—he has large, expressive, luminous eyes. There's your escape hatch. You paint him just as he is, but you focus attention upon his one good feature. How? By de-emphasizing the rest of his face and painting the eyes with great care.

How? By arranging your light in such a way that it strikes his eyes in dramatic fashion and mercifully obscures the rest of his face. How? By tilting his head backward a trifle to shorten up on the nose and firm up the jaw. How? By having him reading a book and throwing the spotlight onto the page so that the eye somewhat avoids your man's unfortunate features. How? By posing him in such a way that only a part of his face shows. You may even win critical plaudits for your audacity in painting an innovative portrait.

All these tricks fall under the heading of *constructive* flattery. But when you take a woman who weighs two hundred pounds and paint her to seem one hundred and ten, you're cheating and you don't belong in the category of a serious portrait artist.

Flattery is one of the tools that a skilled portrait painter employs to execute a painting which meets the five requisites listed in the preceding section. It's a valuable tool when used with taste and restraint. But don't ever fall into the trap of going too far. Since you don't possess a license to practice medicine (and even if you do), you aren't empowered to perform plastic surgery. If your sitter makes impossible demands, pass him up. At all times retain your dignity and your integrity, even though the mortgage payment is overdue. I know, for I've faced this situation frequently and the few times that I overrode my convictions and went against my instincts, I regretted it for years afterward.

By all means flatter, but don't invent unless you're executing a noncommissioned portrait and are after a certain effect. In your commissioned work, you're obliged to render a likeness, and you're cheating yourself and your client if you stray so far afield that Quasimodo becomes Dorian Gray. In three or four decades you both may be angels, but the portrait will live on. Shouldn't it be an honest work of art?

A good artist digs deeply into a sitter's personality and paints the inner man encased in the form of his outer garment—his skin. Ugliness is a subjective thing and we've gone far away from the concepts of beauty as formulated by the magazine illustrators of the 1930s and '40s. Today's movie stars are often homely people with blunt or uneven features and what people of my generation considered handsome is thought laughable by my teenagers. Who can foretell what the next ten or twenty years will bring?

So paint your subjects as honestly as you know how; make the necessary concessions, but don't let yourself be talked into compromising your integrity. If they demand the impossible, send them on their way. The vain sitter will eventually meet the greedy artist he deserves, and together, they'll form an alliance to produce the cheap, the banal, the dishonest portrait. But you must avoid this kind of marriage of convenience which conceives the art that ends up on sale at second-hand auctions or in somebody's attic. Have the guts to do what you *know* is right, and you'll be a better man for it. Art is eternal and we are temporal, and the fleeting rewards are usually not worth selling your artistic soul to the devil. If you care all that much about money, take up accounting.

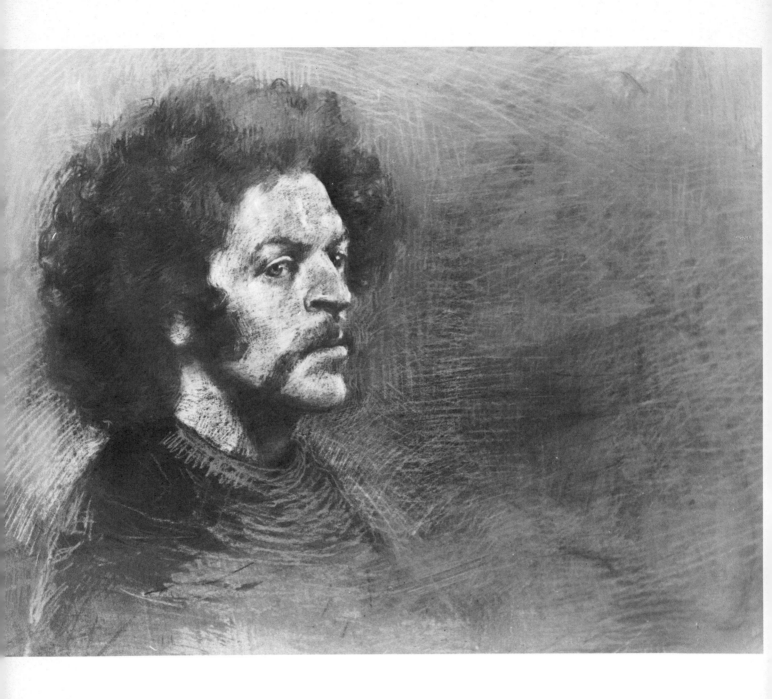

Portrait of Jack Lipner, Playwright *(Above) by Albert Handell, pastel on board, 18" x 24". The strokes here follow the natural form of the planes in the face, the hair and the sweater. The artist has also drawn lines into the background in almost a reverse, scratchboard effect in which light areas are hacked out of a black surface. The large space left on the board in front of the sitter's eyes helps the illusion that he is somewhat introspective and inclined towards self-contemplation. The light seems to be coming from several directions at once, but it works to pleasing effect here. A good, incisive character study of an alert, creative subject. (Collection Mr. and Mrs. Robert Ross)*

Mrs. Eleanor Roosevelt *(Right) by Daniel E. Greene, pastel on paper, 29" x 21". The little half-smile and the forward thrust of the head are brilliant, characteristic touches that lend immediate credence and recognition to this tender and devoted portrait of the late, beloved First Lady. The artist added to the almost plastic, three-dimensional effect by softly modeling the planes of the neck and cheek and by wisely concentrating light on the area apparently nearest to our eyes. The hair is handled loosely but with several skillfully placed accents that provide a revealing insight into Mrs. Roosevelt's rather cavalier unconcern with her outward appearance. The eye—shown here as a dark wedge of shadow—hints at the dry humor and good-natured tolerance possessed by this great and noble human being. (Collection Mr. John Tembeck)*

Learning to See

If you're going to paint portraits, you must face up to the fact that this is an enterprise that should consume *every waking moment you can devote to it*. Even if you hold a job and paint portraits in your spare time, you must learn to *think portraits* even when you're away from your easel. Every time you look at a person you must consider: *how would I paint him?* Every pose a person assumes—typing, reading, driving, drinking, eating, talking, laughing—is a portrait. You as an artist must mentally photograph and file away this pose in your memory bank for future reference. Learn to really *see* people, not merely look at them. *Seeing* means to note the main thrusts of the body, the patterns formed by twisted spines, by arched arms, by bent legs. Seeing means to study the angles of the face as it changes expressions due to humor, perplexity, indignation, joy, rage, etc. Seeing means to frame every head and figure in an invisible canvas, against an appropriate background, under an appropriate light.

Do you go to work on a bus, a train, or a subway? Study the faces of those around you. I do this whenever I come to the city and I never cease to wonder at the range and complexity of the human face. What a rich variety of types: white men, black men, brown men; tall, short, medium-size men; smug faces, tragic faces, greedy faces, angelic faces; hunchbacks, giants, crones, and bodybuilders; girls in miniskirts, boys in jeans, executives in business suits, playboys in dashikis. For the average person, it's only a boring subway ride, for you and me it can be a panoply of riches. What Daumier did for the third-class railroad carriage you can do for the subway train. It's all there before you —all you have to do is learn how to *see*. Study the effects of artificial lights on pallid, city faces. Note how material looks in the dappled sunlight of a park. Watch what the reflection of sand and water does to skin on a sun-drenched beach. Don't just look— see! Looking is superficial; seeing is penetrating. Civilians look; artists see.

If you began to think of everyone as a portrait, you've already taken the first step toward seeing. John Rewald in *The History of Impressionism* tells how Claude Monet stood over his dying wife, and to his horror caught himself studying the color variations on her face. It wasn't that he didn't love his wife—for he did—it's just that his painter's eye had followed the dictates of its training.

Don't think that you can be a portrait painter only when you throw your creative switch and actually paint. *You are a portrait painter twenty-four hours of the day*. It's only your actual working time that's limited by physical considerations.

Learning to see rather than look is a big step toward this total concentration of effort. Without it, the most you can hope for is to be mediocre.

Incidentally, be discreet about your seeing. Be careful that strangers don't suspect you of staring at them. I have rather piercing eyes and I take care not to let people know that I'm studying them. This piercing look is a characteristic of many artists, particularly of portrait painters. Don't let it lead you into embarrassing or threatening situations.

Light, Halftone, and Shadow

Now that you are learning to see, you must also restructure your method of seeing so that you no longer see things the way your less-fortunate fellow men do, *but as a painter*. This means, dividing the world into three categories: light, halftone, and shadow. From here on in, you'll never see anything as other than one of these three classifications. I've planted this concept in your brain and I hope you're hooked for life. But I've addicted you out of benevolence rather than out of villainy, and you must take advantage of this addiction. Every object that is bathed in light is modified by this illumination and transformed into light, halftone, or shadow. To define these three categories quickly: that which is neither light nor shadow is halftone.

In painting, these are the three divisions of tone and the artist must determine to which category he'll assign every area of his painting. But it's not enough to *paint* light, halftone, and shadow; it's vital to *see* things this way as well. As you consciously prod your eyes and brain into seeing, you must just as consciously teach yourself to *separate what you see into the three divisions*. See that cute girl's knee? Never mind how nice and round it is—what is it: light, halftone, or shadow? Perhaps it falls in between halftone and shadow? No good! You must be decisive and force it into one or the other. In painting, there is no such thing as in-between. All right, reconsider. It's not dark enough to be shadow; it's too dark to be halftone. Decide to paint it as halftone. There, you've learned not only to see, but to classify. Another big step forward. Now, you see people with an even more sophisticated eye. Are they light, halftone, shadow? Which part of them is which?

You're no longer using your eyes to skim over the surface, you've taught them to serve your artistic purpose. They've become your trusted, *trained* assistants and you're gleaning maximum use from them instead of fleeting impressions. Are you beginning to conceive the vast reservoir of potential ability that lies dormant within you?

Just as a good physician mentally diagnoses every person that he encounters in social situations, so must you train yourself to artistically classify every person and object that crosses your path. Learn to see, to classify, to compare, so that mental paintings flow from your brain like individual frames in a motion picture film. Every time you see something, paint it in your mind. Savor forms, shapes, contours, colors, and file these images away for future reference. They'll form a vast archive of colors, tones, and sensations on which you'll draw again and again.

The Big Picture

The third aspect of learning to "think" portraits is learning to see the Big Picture. The world is filled with gorgeous detail: the bristly side whiskers of my St. Bernard, Sam; the bubbles of foam on an incoming wave; the delicate scales of a goldfish in sunlight; the shiny pebbles on a beach after the tide has receded.

If you're blessed with good sight, those are images to quicken the heart and elevate the soul. But in your capacity as portrait painter, you must educate yourself to *disregard detail for the Big Picture.*

A portrait that is obsessed with detail is an affront and an abomination. In the days of Durer and his friends, artists were revered for their ability to limn lace, filigree, and warts. We've advanced too far over the bodies and reputations of good men to revert to these practices. From Rembrandt to the impressionists, men have starved and suffered to pave the way, to teach us to ignore gee-gaws and furbelows, and to concentrate our vision on masses, on forms, on the Big Picture.

This then, is the third rule of portraiture: *Learn to ignore detail and to consider the main, the foremost, the Big Picture.* To do this, fix your eye on a girl sitting in an easy chair and reading a book. What do you see? If you're not trained, you see everything: the birthmark on her neck, the place she scratched her finger, the run in her stocking. Assuming your vision is sharp, you see the buttons on her sweater as clearly as the highlight on her forehead. Your eye hasn't yet learned to be selective and it roams from area to area without aim or direction. Do you want a complete portrait of her the way she is right down to the scuff on her shoes and the tiny wrinkles in her skirt? Then get out your Polaroid, focus it carefully and in fifteen seconds you've got her the way she is. Is this what you really want? For, what you have now is a photographic image of Mary Ann, but nothing of Mary Ann herself. By this, I don't imply that photographs can't be an artistic form of expression, for many can be and are. But why bother to *paint* a portrait of Mary Ann, depicting her every freckle and eyelash if you can photograph her in this way so much more easily and quickly? Obviously, a painted portrait is intended to serve a deeper, a more intense purpose.

A portrait can only be considered in the light of its initial requisite: is it or isn't it a work of art? And by today's standards, which are the result of generations of trial and error, a portrait that is inundated by a wealth of detail is usually a bad work of art.

This is not to say that a portrait of this kind *can't*

be well painted, it's simply that such a portrait will likely be dismissed as perfunctory and superficial. I happen to admire loosely painted portraits; that is, those that subjugate detail for the big form, but I'd never presume to tell you that you're obliged to eliminate detail in your work. I only suggest that if you're addicted to buttons, bows, and eyelashes, that you *build a solid foundation upon which to display these goodies.*

Learning to see the Big Picture means to consider the *mass forms as the foundation for your portrait.* Even if you choose to add detail on top of it, the elements underneath will hold up your portrait.

How do you learn to see the Big Picture? Easy. If you have good vision, squint your eyes down until all detail grows obliterated and only the basic shapes remain. Do you see how the objects fall into light and shadow? Do you see how the big curves and angles remain while the minor ones vanish? An arm loses hair, veins, freckles, beauty spots, scars, vaccination marks, etc., and becomes a big, round object that's either bent or straight, either light or dark. A man's figure captured within the narrow range of your squint becomes a simple object composed of light and shadow, of several basic curves and angles. This, in essence, is the Big Picture. This is the basis of all figure painting.

The process is to consider the Big Picture first, then to progressively sharpen the focus so that more and more detail comes into view. Where you stop is a matter of personal choice. Some choose to stop early; you may choose to go all the way. Only time and experience can dictate your decision, but the rule of thumb among artists has been that as experience mounts, so does the desire to discard detail.

In any case, learn to see the Big Picture. First, do this by squinting your eyes or removing your glasses if you're near-sighted. Later, you'll come to see the Big Picture with your eyes wide open. Seeing the Big Picture will enable you to come to the core of your portrait quicker, to establish a basic pose and a basic division of light and shadow. It will ultimately become part of your artistic second nature. But for now, you must force your eyes to see in big forms, just as you've forced them to see and to classify into light, half-tone, and shadow.

Bruce Kurland by Daniel E. Greene, pastel on paper, 29" x 21". In this portrait of a rather self-assured young man the artist displays his confidence and virtuosity by leaving the ear and neck almost unfinished and handling the head in a loose and vigorous manner that exemplifies the finished and mature painter. The nose was rendered in long, painterly strokes. There's a sharp, vivid highlight on the subject's right forehead. Little effort was expended to blend the planes; they were handled in bold, individual fashion. The right upper eyelid is made to turn in a series of crisp, distinct planes. The shadow on the nose cuts sharply into halftone as it goes toward the light, but fades off softly on the left half of the face, toward the shadow side. Altogether, this is a vigorous and powerful rendition of a male head. (Collection Norfolk Museum, Norfolk, Va.)

Planning the Portrait

Before you go on to execute the portrait, I advise you to take a long, deep breath that should entail a thorough period of artistic soul-searching and contemplation. I call this period the Vital Pause. What is its purpose? It's to remind you that *painting* the portrait is only half the job—planning the portrait is the other, equally important half of the total project.

How to Take the Vital Pause

This is the time when you've already met your subject (if you didn't know him before), when you've exchanged a few pleasantries and commenced the probing maneuvers that preface every human relationship. At the same time, you've formed some kind of impression of the person whom you are going to immortalize, and granted him an equal chance to look you over.

This is the time to put on your thinking cap and to delve deeply into that area of your being that's reserved for important decision-making. Important, because I consider *every portrait that you'll paint in your career of vital significance not only to you and to your sitter, but to all art.* Just as a good carpenter takes pride in his profession, I take pride in mine, and I'm deeply concerned about the quality of the product that I and my fellow artists turn out, since each portrait reflects upon us all. And so should you be.

Unless a portrait is carefully and intelligently planned, its chances of success are that much slimmer and *dependent strictly upon luck.* You can help cut down the odds against failure by painting the portrait twice—once in your mind, the second time on paper.

The Vital Pause is the time you devote to planning the portrait, to anticipating some of the problems that'll crop up later, to eliminating possible obstacles, to reducing deterrents and nuisance factors, to arranging shortcuts and solutions.

Of course, there are portraitists who plunge in without a moment's hesitation and knock off a portrait with great dash, flair, and élan. The result may be pleasing enough to the eye, but it's seldom *a portrait*, but more likely a competent or incompetent *rendering* of a subject. John Singer Sargent could complete a full-length portrait in three days and his virtuosity and bravura style were, and continue to be, a source

of deep admiration to all portrait painters. But few stop to consider that Sargent not only boasted a swift hand but an equally facile brain, and that he planned his portraits with a great deal of care. Otherwise, he wouldn't have been able to achieve such superb results with such uncanny consistency. The fact that he could accomplish this planning swiftly, too, was due to his thorough knowledge of his craft and to an experience honed by years of dedicated effort. Like a skilled surgeon, Sargent could go to the nub of a problem with a minimum of confusion and come up with a stunning solution.

Few of us can match this brilliance. We must think things out slowly and with great deliberation.

It took me years to learn to restrain myself; my tendency was, and remains, to pitch in and go at it. But by sheer effort of will I've learned to sit back, to take a grip on my impetuosity and to partake of the Vital Pause. The results have justified this self-denial and I strongly urge you to do the same. Even though your fingers itch to grab the crayons and start painting—don't give in! One day, your reputation may hang on this very painting. Don't you owe it to yourself to invest it with every facet of your skill, talent, and intelligence?

Defining the Subject

One of the first things you must do when you're planning a portrait is to define your subject. This means analyzing the subject and categorizing him in your mind both as to his physiological and psychological attributes. Formulate a kind of mental questionnaire, answer it, then fix every answer firmly in your mind. Is your subject tall, short, medium-sized, squat, lean, massive, strong, spare, wiry, pudgy? Is he long-armed, short-armed, square-shouldered, round-shouldered, straight-backed, stooped? Is he short-necked, long-necked, bull-necked, turkey-necked? Is he barrel-chested, pigeon-breasted, narrow-chested? Is he wedge-shaped, pear-shaped, pencil-shaped, melon-shaped? Is his head large, small, medium, long, wide, narrow, pointed, square? Are his hands and fingers blunt, spatulate, sausagelike, bony, gnarled, soft, calloused, hamlike? Are his wrists thick or thin? Do his arms

hang straight or bent; do they dangle to the middle of his thigh or to his knees? And so on and so forth. Look for all this, before you even consider the subject's face and features. Now, look at the face: the color of the complexion, the texture of the skin. Freckles or no. Heavy or light beard. Wrinkled or smoothfaced. Blotched or even-colored. The eyes: the color. Clear or bloodshot. Big or small. Round, narrow, slanted. Wide apart or close together. Straight, cross-eyed, or wall-eyed. Clear or rheumy. In line or one higher than the other. Droopy-lidded, heavy-lidded, baggy, deep-set, or bulging. Pink-lidded, long eyelashed, sparsely eyelashed.

On to the nose. Long, short, broad, straight, hooked, pug, bulbous, wide-nostriled, and so on.

The possibilities, as you can see, are infinite. As you check off the various classifications, you'll find yourself gaining new insights into your subject. He's acquiring dimensions you never suspected he possessed. Tick them off, feature by feature. Consider the features in relation to each other. Consider his hair, his bearing, the way he smiles, sits, speaks, smokes, glares, wears his clothes. Dig as deeply as you can, look as piercingly as you know how. This time, you needn't concern yourself if your vision simulates an X-ray machine. If the subject feels apprehensive over this close inspection, let him learn to cope with this condition now instead of later when the actual painting begins. Tell him that this is a vital spadework that will lead to a better portrait. Explain your need to get to know him as well as possible. It's not unusual that he's anxious. No one likes to reveal himself, to have his defenses stripped. But it's up to you to be discreet and charming about it. Keep the mood light and pleasant and you'll get the sitter's cooperation. After all, we've all subjected ourselves to medical examination. This is far less arduous and uncomfortable.

After you've fixed the subject's physical image in your mind, try to formulate a psychological concept of him. Is he tough, compassionate, timid, fey, bright, dull, humorless, sophisticated, pious? You as the artist are sensitive enough to receive vibrations from your subject, and your insight and perception should supply you with clues to his personality. This way, when you're actually ready to paint him, you'll come to the fray armed with all kinds of information that'll greatly assist your efforts. You'll put together the factor of *what you want to accomplish* with the factor of *who your subject is*, and you'll be that much closer to the realization of your goals.

How you will ultimately paint your portrait will remain your decision and prerogative, since it'll be a choice dictated by the collective data you've fed into your personal computer. But knowing *who* your subject is will help in setting the mood for the portrait, and knowing *what* he looks like in part and in toto, will help in fixing this mood onto the paper.

Does Sex or Age Matter?

To a stranded sailor stuck with a companion on a desert island—yes. To a portrait painter—no. I don't hold with those who say that children and women must be painted one way, and men—another. Men, women, and children are people and must be treated as individuals both in life and in portraiture. There's no reason why a little girl has to be done in delicate pinks and violets. That's pure banality and should be put to death with many of the other so-called "rules" of portraiture. Little girls look just as good in black or gray and don't need halos around their heads to make them attractive or believable. I've known little girls with the souls of a Torquemada—even the decent ones needn't be painted as little daffodils, but as the unique individual human beings that they are.

Women too are supposedly gentle and delicate creatures and teachers advise students to paint them in light, airy colors. More baloney! Women? What's delicate about a woman except possibly her false eyelashes? Women, children, and men can be painted in any way the artist pleases.

When you paint a portrait, you're not painting a man, a woman, or a child but a person. Don't let arbitrary rules perpetuated by pedants of both sexes and old maids lead you astray. There's nothing more nauseating than the too-frequent pastel portrait of a child which is frothy enough to decorate a wedding cake. Don't add to this compost heap of atrocious art. Study the paintings of children by Sargent, Breughel, Murillo. These masters painted children as they are: lusty, vital, instinctive, with healthy urges and appetites.

Stow your preconceptions and prejudices and become a truly liberated human being. Paint people *as they are*, not *as they're supposed to be* according to some moth-eaten formulas.

The Outer or the Inner View

Now that you've extensively studied and gotten to know your subject, you must consider whether you've allowed the inner view to overshadow the outer view, or vice versa? In other words, have you focused too intently on the inner man to the exclusion of the outward appearance which, in the final analysis, is what you'll be painting? Or are you so enamored of the subject's magnificent red hair that you've forgotten that she's a philosophy professor and a member of the Legion of Honor?

The solution then, is to strike a balance between the two—to paint the outer surface with as much fidelity as possible, but to include such facets of the personality as will lend truth and substance to the portrait. This might mean a twinkle in an eye, a stern jawline, a quizzical eyebrow, an imperiously flaring nostril. These little touches help reveal some of the subject's inner traits and will help to produce a fully rounded, total portrait of a human being. Never sacrifice one view for the other; give equal consideration to both the inner and the outer view.

Planning the Size: Head, Bust, or Full Length?

Now that you're getting closer to the actual painting time, it's time to consider the size of the portrait you're

going to execute. Will you do a head, a bust, or a full-length painting?

If you're doing a commissioned portrait, the size is usually determined by the price the subject is willing or able to pay. Most professional portraitists set their fees by the size of the portrait ordered.

But here again, we confront old and shopworn prejudices. Why should a 50″ x 36″ portrait be any dearer than one that's 8″ x 10″? Is a 9″ x 9″ head by Vermeer less valuable than a 10′ x 4′ canvas by Joe Shmoe? Do the portraitists charge more for a bigger painting because they use two dollars' worth more of paint or pastel? Art is art no matter what its size, and sitters aren't beef that sells for so much a pound. As far as I'm concerned, a portrait is a portrait and there should be only one standard to establish its price: quality.

Fees aside, however, there are other considerations regarding the size of the portrait. Should you paint heads and figures the same size that they actually are—or bigger or smaller? This is a matter of personal choice. Good pastel portraits have been painted in every size imaginable. I prefer to work life-size; others follow their own inclinations. Most people seem to feel that a pastel portrait should be smaller than an oil. I ask: "Why? Why can't a pastel be as big, or bigger than an oil?"

When should you paint a head, bust, a full-length portrait, a life-size figure, or a miniature? Whenever you feel like it, that's when. There's no hard and fast rule regarding either size of a pastel portrait or the size of the heads or figures painted. Use your judgment.

Full Face, Three-Quarter Face, or Profile?

Most portraits are painted either full face or three-quarter face; few are painted completely in profile. This doesn't mean that either of these ways is best. What's best is *not to become settled into one way of doing portraits;* not to grow locked into and dedicated to a single way of working.

This is a fault most common not to beginners or occasional painters, but, surprisingly enough, to *busy, experienced* portraitists. As they swing from portrait to portrait, they fail to partake of the Vital Pause between jobs and fall into a routine, a formula for painting. After a while, each portrait they do looks like the six before it and like the half dozen that will follow it.

This, my friends, is the beginning of the end. This is the onset of the rust that will foul even the finest painting mechanism. Guard against this condition by *always taking the time to plan a portrait* before commencing work. Then, whether you plan a full, a three-quarter or a profile view, it'll be a thought-out and, therefore, an honest portrait. By planning, you avoid the easy solution, the trite formula, the repetitious sameness.

Full face, three-quarter face, or profile? Each is a perfectly acceptable way of painting a portrait. Each has its uses. Partake of them all; vary your approach so that you avoid the pitfall of stagnant repetition and your work will retain its freshness and spontaneity throughout your career.

The Subject's Dress

What your subject will wear in his portrait is extremely important. It can enhance, and certainly detract from the painting. Here again, the choice of costume bears directly upon the effect you're seeking: a dark, somber outfit for a brooding portrait of an aging tragedian or bright red for a young matron—whatever coincides with your artistic statement.

The matter of clothes is something you'll have to discuss with your sitter. Most people abide by the artist's suggestions, but here and there you'll encounter a strong personality who'll insist on wearing what he wants. Often, it's a case of a husband wanting to see his wife in a favorite dress that evokes some pleasant memories, or parents outfitting a child in the way *they* would like him to dress.

Try to persuade people not to wear clothes in which they don't feel comfortable or which are somewhat alien to them. You've all seen men who've practically lived all their lives in overalls looking ill at ease in business suits, or rookies when they first put on a uniform. People have to have lived in a certain kind of clothes before they appear natural wearing them. If you're going to show a woman in a fox-hunting outfit, try to determine if she has actually ridden to the hounds or is merely indulging some snobbish whim. If she is a bogus horsewoman, talk her out of the costume and into something more appropriate. Tell her that the red clashes with her complexion. Above all, be discreet and diplomatic. You're now exercising a measure of authority and you musn't let the power go to your head. Usually, you and your sitter will arrive at a mutually agreeable decision.

There are some general guidelines governing the choice of garments in a portrait, but no hard and fast rules. Here, as in all other matters dealing with the portrait, you're the final judge and authority.

The general admonitions are to avoid clothes that are too busily patterned or that contain too many colors, as for example: a checked orange and blue blouse; a yellow, green, and violet print, etc. Most astute portraitists stick to solid colors, either light or dark, depending on what they're trying to do. In the so-called Rembrandt lighting, the spotlight is focused on the face while the rest of the figure is bathed in shadow. This obviously calls for darker clothing. In the works of the impressionists white or light costumes seem more appropriate.

In either case, the artist will prefer plain, simple, unpatterned garments that won't take the attention away from the face. Sargent painted some beautiful portraits of men and women in white boating clothes, and other equally beautiful portraits of folks in black outfits. Rembrandt used gleaming, metal armor, fur and starched ruffs to advantage. The society painter Boldini did wonders with silks and satins. Today, people tend to dress more casually and there's nothing wrong with

a portrait of a young woman in a denim shirt and jeans. What's most important is that the sitter wear clothes that suit him. An evening gown on a housewife who spends much of her day picking up socks and making peanut butter and jelly sandwiches may look pompous and pretentious; the same gown on a nightclub singer may be fine.

I prefer casual attire both for living and for portraits. It intrigues me to portray a board chairman of a corporation, controlling fifteen companies, in a windbreaker and ducks. They don't always go along with my suggestions, but now and then I run into a tycoon with a sense of humor and flexibility, and we come up with a most agreeable portrait.

So don't be awed by your sitter or hidebound by traditions that are encumbered by clichés and conventions. There's no reason why a bishop can't be painted in T-shirt and slacks if you *both* decide that this would be fun and attractive.

The Multiple Portrait

There'll be times when you'll be asked to paint a multiple portrait, one in which more than a single sitter is portrayed. This may be a couple, a family, even a board of directors. Some marvelous group portraits come to mind: Franz Hals's *The Regentessen of the Haarlem Almshouse*, Rembrandt's *Day Watch* (formerly *Night Watch*) and the various "tributes" painted by disciples in honor of their teachers and masters.

I'd travel thousands of miles for the chance to do a group portrait which to me represents the greatest challenge an artist can face. What fun you can have with composition, with light and shadow, with color!

You must approach the multiple portrait the same way you approach the single—with one exception. The group portrait offers an excellent opportunity to shift figures about, to show persons in full face, in profile and in what-have-you; to create a marvelous mélange of angles, curves, lights and shadows—all within one painting. If you've ever wanted to show a person all in shadow or with his back to the "camera," here is your chance.

A group portrait shouldn't resemble a coroner's jury with all the faces staring back at the viewer in a single pose and with a single expression. A group portrait provides you the opportunity to exercise your inventiveness and to allow your imaginative processes to flow. In Sargent's magnificent *The Daughters of Edward Darley Boit*, the master dared to lose one girl completely in shadow; the placement of the girls is so casual and natural that the painting stands far and above the usual, pedestrian "group shot."

In a multiple portrait, especially, you should try to show the people *doing something*, not just sitting or standing around vapidly. After all, people react to one another, and what better opportunity to portray the love that exists between a husband and wife or between parents and children than in a multiple portrait?

When planning a multiple portrait, pay particular care to the composition of the painting, since the center of attention must now be focused on more than one figure. You'll have to assign *priorities of importance* to the various individuals peopling the portrait. The eye first darts to one place, then to another, then considers the overall view. You must control where the eye will light first, second, etc. How? By the placement of light or dark accents or bright colors in the areas you wish to emphasize. Consider psychologically who deserves the viewer's first glance—the wife, the husband, the children? Each situation is different and I can't tell you how to assign these priorities, only that you make the determination. If you paint your group portrait so that all the figures share equal importance, you vitiate much of its effectiveness. Consider yourself a host at a diplomatic function who must seat his guests in accordance with their status. Only one person can sit in the place of honor, you must decide which one it shall be.

Another factor in the group portrait is the use of props. Here you can avail yourself of such handy objects as dogs, cats, toys, pipes, saddles, guns, canes, books, or what not. A group portrait somehow calls for *things*, and here's your chance to go a touch busy, if, like me, you enjoy a bit of organized clutter. The best time I ever had was painting a sailing family right on their boat with all the beautiful junk that accompanies such an enterprise: coils of rope, canvas, tackle boxes, and so on.

So, go after those group portraits. If need be, persuade a family to be painted together. It should be an unforgettable experience for you and for them both, and it will instill you with the confidence that you can tackle any painting job, no matter how complex.

The Self-Portrait

There's a most fascinating person whom you've known since childhood, someone whom you understand and love deeply, someone whom you trust implicitly. You've been looking at his face in the mirror ever since you can remember and you feel that you know it. But did you ever try to paint it?

A perfunctory study of the subject leads me to believe that the custom of painting self-portraits dates somewhere to the seventeenth century. I'm sure that artists did this before, but with the exception of Dürer, I find scarce record of this practice prior to the 1600s.

In any case, the best artists at one time or another took a whack at painting their own faces with varied results. There are two marvelous portraits by La Tour and Liotard, two noted pastellists, which offer each one's conception of himself. The one by La Tour shows a cocky, confident man with a wise, smug, yet deeply ironic smile. He is dressed in the height of fashion and seems to be saying: "Yes, I know that it's all vanity and delusion, but I'm going to get mine anyway."

The one by Liotard shows an old man whom life has passed by completely, yet who remains unembittered by the hopes and expectations that life continues to dangle before us, and by the disappointments that it

Mrs. Dryfoos by Erik G. Haupt, pastel on paper, 19½ x 25". A vigorously painted portrait in the tradition of Romney, Gainsborough, and Constable. The stormy sky lends an apt backdrop of romantic grace to the strongly indicated forms of the head and torso. The head is solidly constructed with rich, deep shadows. The planes of the cheek are painted in long, decisive sweeps. The edges are treated rather sharply, which would be appropriate to the harsh, overhead light. All in all, a dignified and dramatic presentation in the genre of the so-called "society portrait."

Mother and Child *(Above) by Mary Cassatt, pastel on paper, 26" x 22". Mary Cassatt was a student and disciple of Edgar Degas. She learned well from the master and developed a style of her own which places her among the finest painters of all time. Here, as in many of her other paintings, she has taken a subject easily bent to oversentimentalization and produced a powerful, touching, and deeply humanist work of art. The handling is masterful throughout. The baby's body, particularly the rump, is superbly printed. I consider this one of the masterpieces of pastel painting. (Collection The Metropolitan Museum of Art)*

Sailor Boy, Portrait of Gardner Cassatt *(Right) by Mary Cassatt, pastel on paper, 24⅝" x 18⅞". Mary Cassatt painted her six-year-old nephew's portrait with all the love and affection of a devoted aunt, and the skill and experience of a totally fulfilled artist. We can look at the boy's face and know immediately what makes him tick. This is portraiture at its very finest, rather than would have been the precise rendition of the buttons of his sailor blouse. This is a magnificent example of one of our finest and—sadly—one of our most neglected American artists. (Collection Mrs. Horace Binney Hall, Courtesy Philadelphia Museum of Art)*

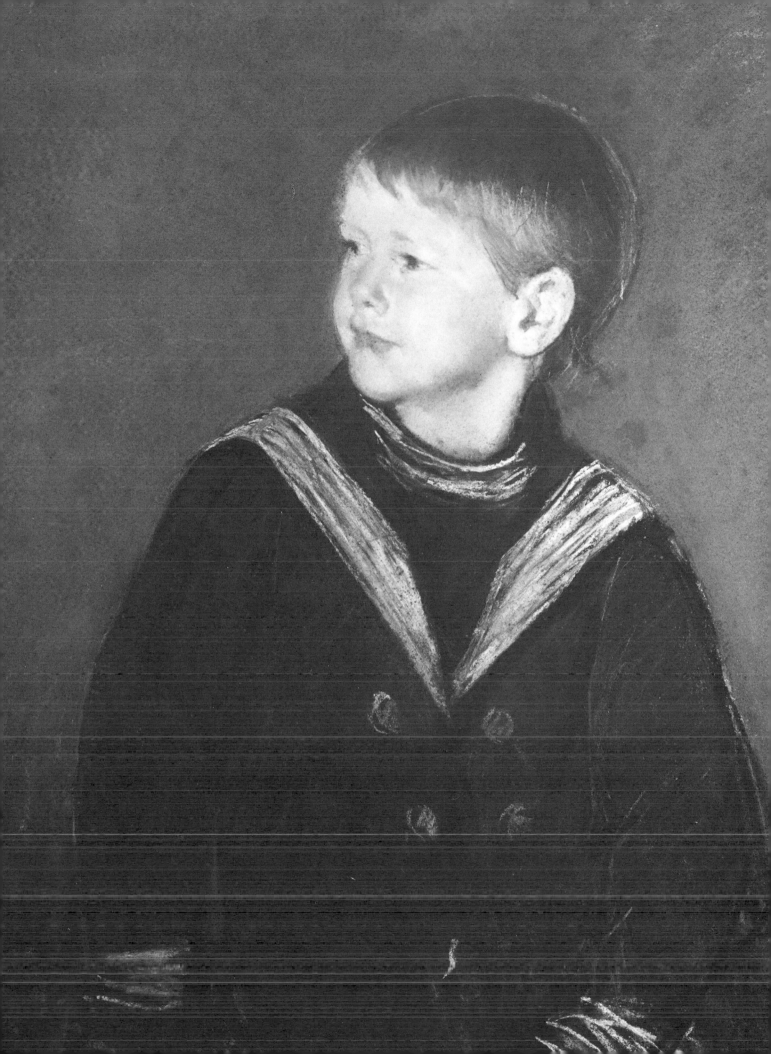

serves up instead. These are penetrating, analytical studies executed by two great portraitists at the height of their powers. They tell much about the men who painted them, and are superb works of art—just what good portraits should be.

Rembrandt's decline from a rather proud young man to a lonely old misfit is magnificently realized in his series of self-portraits, of which he did some sixty odd.

The self-portrait can be a source of extensive learning and investigation for the serious, aspiring portrait painter. You can pose yourelf under every conceivable light, against every conceivable background, at every conceivable angle.

The purchase of a three-way mirror will give you a front, side, and back view of yourself, which, incidentally, can prove quite an unnerving experience. In yourself, you have a model who is the epitome of cooperation. He'll work when you want him to and stop when you're tired. He'll smile, frown, sneer, gape, grimace, grin, or do anything you tell him.

The self-portrait provides the opportunity to paint a truly honest picture. There's no need to flatter, no need to deceive. You know yourself better than anyone can ever hope to know you, and you're free to paint not only what you see, but *what you know.*

Try to be completely objective. Does the face that looks out at you from the mirror show traits you don't particularly like? Paint them in, anyway. Later, you can work on correcting these traits within yourself, *but don't mess up the portrait!*

The self-portrait also helps teach you through continuous trial and error how to avoid mistakes. It's difficult to find models who'll sit for you while you test and research. The least they'll expect out of it is a finished portrait. They'll be hard to persuade to sit for studies and experiments. Of course, you can always hire professional models, but this can run into a lot of money. In yourself, you have a model who'll patiently endure all tribulations without complaint, the perfect sitter who'll function as your partner in the implementation of the assignment.

Use yourself as the model when you test the three major techniques. Practice and probe all the possibilities, all the variations I've touched on throughout the book. A self-portrait can be a serious and meaningful work of art. It should be approached with the same care, concern, and devotion as any other portrait.

Painting the Animal

One of the most enjoyable assignments a portrait painter can fulfill is to execute an animal portrait. Owners of horses, dogs, and cats will often pay good money to have their pets painted, and I've dropped whatever I was doing to accept such a commission, which I consider the most fun imaginable. Because I love animals so insanely, I've made it a point all my life to observe their ways. When I held down a full-time job, I spent all my lunch hours at the Central Park Zoo, looking at, listening to, even smelling the animals, whom I consider the handsomest, the most lovable, the most amusing and entertaining creatures on earth. It amused me to watch some pot-bellied, bow-legged, pimple-faced human pause in front of a magnificent gorilla's cage and call *him* ugly.

But it isn't enough to love animals to be able to paint them correctly. It entails extensive study and observation. Before you can properly draw or paint a dog, you must know how a dog sits, stands, lies, walks, runs, stretches, jumps, lopes, sleeps, laughs—yes, laughs. Dogs are capable of many expressions which reveal their feelings no less than people's do. A dedicated dog-lover can tell exactly what his dog is thinking from his expression. Dogs can express joy, sorrow, distress, anger, disappointment, embarrassment, etc. I can sit inside my house and tell from my dog's single bark whether he wants to come in, whether his rope is entangled, or if he is thirsty, hungry, or wants to be walked. I wouldn't feel qualified to paint any animal unless I knew quite a bit about it. A dog is not only hair and claws and eyes and whiskers; there's an extensive bone structure and musculature underneath the coat and it is incumbent on the aspiring animal painter to learn what propels and animates the beast before he can successfully put him down on paper.

First, you should go to your public library and take out books on animal anatomy. Second, you must learn to observe animals. Watch what happens when your dog walks. Which two feet out of the four come down together? How do the bones bend? What differences do you note between human and animal anatomy? If you are near a zoo, visit it and look at the animals with a new pair of eyes—an artist's eyes. Try to ascertain the similarity of construction among all animals. Note the proportions of heads, torsos, and limbs among them.

We're all accustomed to seeing people, and we know from personal experience what the human skeletal structure can and can't do. You must expand your knowledge to include the physical characteristics of animals as well. Here is where drawing can play such an important part. If you own a pet, draw him at every opportunity. If you don't, try to remember what you've seen of a neighbor's dog or cat, and draw him from memory. Don't merely copy pictures of animals from magazines. This will teach you nothing about how animals move or how they're put together. Draw only from life and from memory. Copying photographs is an exercise in futility when it comes to learning anatomy. Copying paintings is dangerous because it might lead you to repeat the mistakes of some boob who didn't do his homework either and merely copied from some other incompetent. There are more bad paintings and drawings of animals than of people. Most artists never bothered to learn how a horse is built and either copied from other paintings or hired other artists who specialized in animals. This was a common practice in the old days when several artists worked on one painting. One did the figure, another—the background, a third—the animals.

Today, few artists paint animals, except for illustration purposes. You seldom see an easel painting with a dog, horse, cat, or other animal in it. The reason is that there's only a handful of artists who are

capable of painting the animal (most can barely paint a human being). An exception that comes to mind is Andrew Wyeth who paints dogs, cows, etc., with the same skill and knowledge as he does people and landscapes.

Animal painting is an extremely challenging, yet a most fulfilling, experience. I spend every spare moment I can drawing and painting my St. Bernard, Sam, and each time I do, I find that I've learned something excitingly new about one of God's most perfectly realized creations.

What makes painting an animal that much more difficult, of course, is the fact that in most cases, he won't pose. This challenges the painter to be his most inventive self. I go about it in this manner. First, I arrange to see the pet, to visit with him, and to assess his personailty. After we've met and conversed, I take as many as three rolls of color film of him to guide me in my portrait. I then make a few quick drawings and color notes to etch that most important *first impression* in my mind. In this fashion, I try to ascertain the *first thing* that struck me when I first looked at Corky. Is he fuzzy? Bristly? Curly? Placid? Spunky? Dazzling white? Gleaming black? Hyperactive? *That first impression is what I try to express in the final portrait!*

The first thing people exclaim when they see my Sam is: "He's enormous!" I know a thousand more delightful things about him, but if I were to do a portrait of him, I'd attempt to convey the impression of size, and *this* would be the major statement of the portrait.

After I had established this prime objective, I'd look Corky over with a more objective eye. What are his proportions? Are the legs short, long, narrow, wide? Is the head big for the body? Does he carry his tail high or drooping? Do the ears stand or hang? Are his eyes deep-set, bulging, close set, or wide apart? I would record these facts on a sheet of paper which I'll have prepared beforehand, leaving room for an observation next to each feature.

I would then develop and enlarge the color pictures and study them carefully.

Now, with my head filled with all kinds of information, and drawing upon my long observation of dogs and my knowledge of this particular animal, I'd create a pose that would depict Corky at his most characteristic behavior.

By this, I don't mean that I'd choose a pose from one of the photographs and copy it slavishly, for this would destroy all my intentions which are to produce a true *impression* of Corky, not an accurate rendering of his body. The only time that I would rely on the camera exclusively would be if Corky were not available or dead. In that case, I'd be obliged to base my observations on the photographic material. But this is always a poor second choice.

Then, I would proceed to *paint the portrait in my studio, and only when it was nearly finished* would I arrange another personal meeting with my sitter, at which time, I'd correct whatever wrong turns I'd taken.

This is the way I prefer to paint animals.

With horses, a more detailed observation is indicated since horses are less individualistic in appearance than dogs and tend to look pretty much alike but for minor markings.

Cats are excellent models and treat the entire matter of a portrait with the cool disdain of courtesans or aristocrats.

The approach toward painting animals is no different than that toward people. The same basic principles apply. It might be worthwhile to remember that an animal's coat must be handled broadly and not as individual hairs, and to try to show the inner dog as well as the outer animal. Otherwise, you'll end up with something resembling a hunter's trophy rather than the sweet, lovable pet that exists underneath.

A good book to consult is Eadweard Muybridge's *Animals in Motion* (Dover Publications, 1957).

Painting from Photographs

Painting from photographs is a perfectly acceptable practice, if—and this is a large if—*if you produce paintings, not colored photographs!*

The trouble with painting from photographs is that one is trying to attain a *three-dimensional* effect from a *two-dimensional* source. It's hard enough to paint a lifelike portrait with the living model before you. This becomes twice as difficult when you work from a *lifeless photograph*.

Painting from photographs can, in the hands of an inexperienced artist, become a trap. A black and white photograph gives clues to a subject's contours, but not to his coloring. A color photograph often gives the *wrong clues*, since color photography is seldom accurate as to exact color shadings and nuances. Thus, a fair-complexioned person can be made to appear florid or sallow, depending upon the laboratory technician's whims.

Another factor is that the camera distorts—in some instances, extensively—and this too can prove misleading. Additionally, the camera is a coldblooded, mechanical tool. In the hands of a great artist, it's capable of great artistic expression, but more often than not it's an instrument of banality and bad taste.

Painting from photographs—unless unavoidable such as if the subject were dead or not available—should be left to those so thoroughly experienced that they won't let the photographs cow them into producing an inferior portrait. I strongly advise all those who don't have to *not to paint from photographs*. I'll modify this statement somewhat. Use the camera as an adjunct: to check certain factors (proportions, contours, the folds of garments) but never, never do a portrait from a photograph *per se*, unless you have first painted a hundred portraits from life!

Despite their denials, professional portrait painters rely heavily on the camera. (They work on the painting extensively between sittings and make a big show of slapping paint while the model is present.) But these are *experienced* artists. A novice working from photographs (as I did) is asking for trouble. His portraits

tend to go too tight, too hot, too stiff and lifeless. They come to resemble tinted photographs, those unspeakable atrocities one sees in the windows of neighborhood photographers' stores. In the hands of a skilled campaigner, photographs can be a useful aid, since they cut down the hours of observation and drawing, but the older I get the more I frown upon this practice, even though I have used (and still do) the camera to advantage.

My objections against it are partially esthetic. As I grow more deeply involved in the psychology of painting, I view it as one of the last humanist experiences left to man, and I reject any mechanical contrivances that seek to impose upon this terrain. In his *Painting Portraits* (Watson-Guptill, 1971), Ray Kinstler speaks at length and most intelligently on the use of the camera in portraiture. It would be most helpful to the aspiring portraitist to refer to this excellent work, then make up his own mind as to how much he wants to involve himself in the practice. I can only offer my admittedly prejudiced views on the subject.

High Key and Low Key

There's a term used among artists when they're referring to the overall tone of a painting. This term is *key*. Basically, the key means the general *lightness or darkness of a painting*, right through all its tonal gradations.

When planning your portrait, you must also consider the key in which you will paint it—whether high or low. High means light, low means dark.

When is either used? Again, this is a matter of personal choice. However, it's a choice that should be established before the painting is commenced.

The old masters painted generally in a low key, the impressionists generally in a high key. So-called authorities proclaim that pastel inherently demands a high key. I say: "Nonsense! *There's no reason why pastel can't be painted in either high or low key.*" Dan Greene paints very good pastels in a low key as does Aaron Shikler.

What it boils down to, once more, is the most appropriate presentation of your artistic statement. If it suits your temperament and style to paint in a low key—by all means do so. Don't be misled by uninformed, arbitrary "experts" who have labeled pastel as "airy, fleeting, delicate, humble, fragile and fugitive." This is pure nonsense. Pastel is and can be a deep, robust, virile medium which can be painted in the lowest key one desires. It's true that it's sometimes hard to get good darks in certain manufactured crayons, but this too can be circumvented by making your own sticks, by a heavy application of fixative, etc. Where there's a will, there's a way, and don't let anyone tell you how to paint pastels, except well.

So don't be bullied into a key; select one to fit your needs. If you've decided on a palette for your painting and have elected to paint a high-key picture— go to the lighter shades of the colors in your palette. If it's a low-key effect you're after, use the darker shades of the colors. It's as simple as that. As for

using a high key for women and children and a low key for big, strong males as some books recommend— more nonsense! The only thing you must use is your head.

Composition

Composition is such an enormously significant factor in painting that I'll dwell on it very briefly, guided by the principle that all great truths are simple.

To those uninitiated, composition basically means the placement of the various shapes and forms in a painting. In the case of a portrait, it's the head, the figure, or figures.

To put it as simply as possible, the figure (or figures) should fit attractively and effectively within the confines of the four sides of the paper. There are ten-thousand or more rules concerning composition, none of which I'll go into here. I've neither the patience for nor the knowledge of mathematical rules when it comes to painting. My only guides are my brain and my eye and I go by the theory that if it looks good and feels right, it's good composition. And if it doesn't, it's not.

Are there rules for good composition in painting? You bet there are. I've seen dozen of diagrams analyzing paintings and describing *why* they are well-composed and why the eye travels to point A from point B through point C. I have no doubt that the writers of these books know their facts and are prepared to back them scientifically, but they still make me yawn. I just can't be bothered with charts, graphs, diagrams, and formulas. As I'm writing this, I see Rembrandt's *Head of Christ* (in reproduction, needless to say) in front of me. It's just a head plunked inside the canvas, but ah, what a head!

Am I saying that good composition isn't important? *I am not!* I only say that composition is not bound by rules or conventions. Degas proved this by breaking every known rule of composition and getting away with it magnificently. The best rule of good composition is that it should look right to the eye, and that it embellish rather than diminish the painting.

How is this done, you may well ask.

One, by studying paintings *that you admire* and noting the placement of heads, figures, objects, etc.

Two, by reading extensively of books on composition.

Three, by *planning* the portrait rather than by going on to paint it pell-mell. This way, you can make studies in line, in mass, and in light and shadow, which will project how the finished portrait will fit within the borders of the paper.

Four, by the use of an easily made gadget to frame your subject and to visualize how he will appear in the painting. To do this, take an ordinary picture mat and cut it this way. Now you are left with two L-shaped right angles. If you lay the short end of one on the long end of the other, you have a mat with an opening *whose size you control by sliding the L's together or apart*. Stand away from your subject, frame him in the opening, and slide the L's together or apart until you

get the effect you want. Now, simply record this effect on a piece of paper, and you have it.

There are, of course, certain rules of composition that artists generally follow. One is, that if the subject is facing, let us say, to his right, more space is left on the side toward which he is looking. Another rule is, that a subject's arms aren't cut off at the wrists. This is considered ugly and it may be; however, if *you* believe that *it will help your portrait* to cut off the hands—cut away! Burt Silverman has done it in his demonstration picture and it looks fine to me.

Good composition is basically a matter of good taste. If it looks right, it's probably well composed. I advise you to learn all that you can about composition by looking at *good* paintings. See how skilled artists placed their figures. Note how much space they left around the heads and bodies. Observe what they did with the hands. Mark how they employed chairs, tables, and other objects to help the general composition.

Watch, study, and file the information away in your brain. Then when you plan your next portrait, you've got a wealth of well-tested experience to draw on.

This then is yet another factor to consider when planning a portrait. Its composition. It's a most important factor and one that must be carefully thought out. A good thing to remember is that in a well-composed portrait, the composition is not apparent and in a badly composed one, it stands out like the well-known sore thumb.

Good composition is like good taste; it can't be learned overnight but must be acquired. To play safe until that time, borrow the compositions of those artists whom you most admire. Eventually, you'll learn to trust your own judgment in this area.

Planning the Mood

By now, you've contemplated and considered many aspects of the portrait that you're about to paint. At this time, you should think about the *mood* that you want your painting to project. The mood is a most important aspect of a portrait. It lends it character, and it helps create a sympathetic, receptive attitude in the viewer who senses the aura of the painting even before his eyes even begin to survey its various lines, tones, and forms.

How do you establish a mood for a portrait?

With light and shadow. A dark, somber painting usually evokes feelings of mystery, solemnity, sobriety. A light painting rouses feelings of gaiety, frivolity, fragility, lightheartedness.

With color. A portrait with lots of hot reds and pinks might represent sensuality; one with lavenders and violets might evoke nostalgia and sentimentality; one with yellows—joy and happiness.

With the pose. An executive standing erectly by his desk represents strength, vigor, determination. A girl sitting cross-legged, her arm around a puppy's neck, evokes warm and cozy sensations. A sailor looking

Framing the subject. *Take a picture mat and cut it into two L-shaped angles as shown in the diagram above. Stand away from your subject, hold the two L's in front of you by putting the short end of one over the long end of the other, and adjust the L's by sliding together or apart until you obtain the proper framing of your subject.*

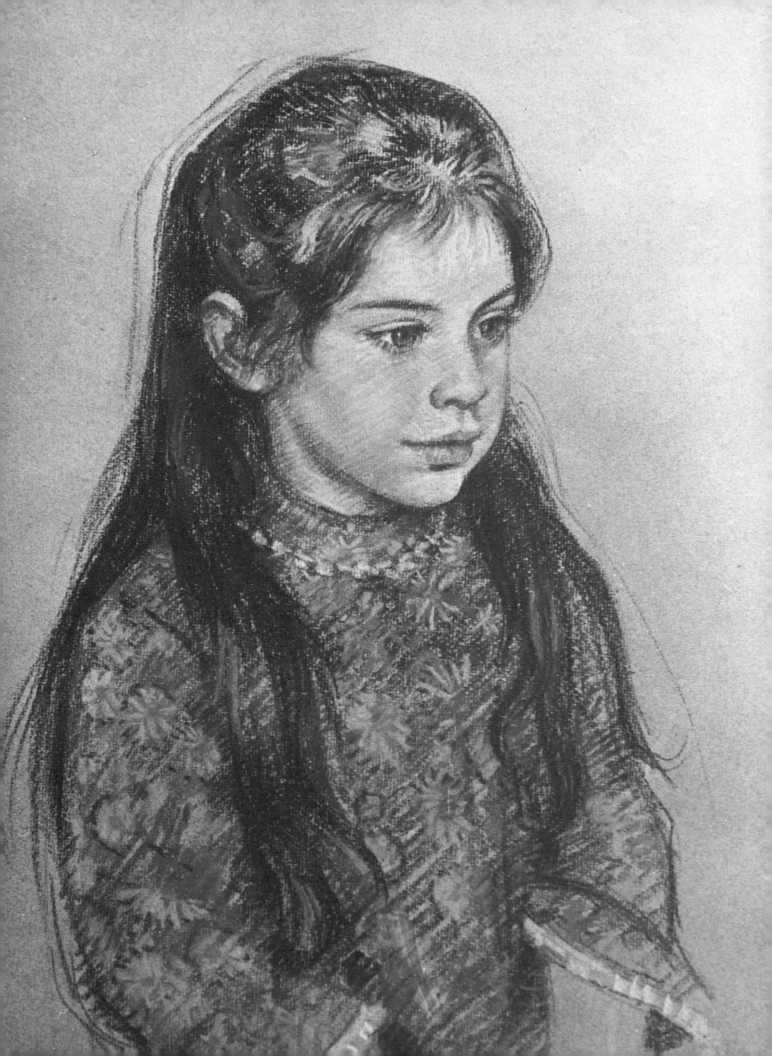

off into a cloudy horizon brings to mind adventure, daring, individualism.

I needn't go on, since everyone is familiar with these clichés which we've been conditioned from childhood to accept. I only want to stress how important it is for you to *establish the mood* before going on to paint the portrait. How you choose to express the mood is entirely within your province—but the mood must be clearly fixed in your mind *before* the actual painting begins.

Here, again, I'd advise you not to slip into the trap of a formula, but to objectively consider each portrait as an individual entity rather than as just another part of your total output. In order to win recognition, some portrait painters paint the same portrait over and over again, merely altering the features of the current sitter. This practice *may* make you fashionable and provide you with a lot of money, but it's artistically dishonest and unfair to the sitter who pays to get a work of art, not to serve as a stepping stone in an ambitious painter's career.

If the mood of every portrait is just like all the ones before, you're not seeking artistic truth but artistic notoriety.

Therefore, plan the mood of every portrait carefully and deliberately. Avoid patterns, formulas, and easy solutions. Just because a portrait worked out a certain way before, don't repeat the pattern but try something new and possibly better. One teacher I had in a leading art school insisted that there was only one way to paint—his way. If you digressed, he kicked you out of his class. He has produced hundreds if not thousands of copycats, but not one *artist* that I know of.

When planning the mood of a portrait, use your brain, your instinct, and your innate sense of rightness. Ask yourself: "What am I trying to portray? What do I hope to achieve?"

This way, you may err and stray off the path once in a while, but you won't become chained to the easy road that leads only to stagnation and mediocrity.

The Most Important Ingredient

Having passed through all the planning stages of the portrait, you're nearly ready to begin painting. You're probably a bit apprehensive at this stage and perhaps doubtful of your ability to do the job. Let me offer a few words of advice and encouragement.

When a stuffy teacher remarked to Renoir: "No doubt it's to amuse yourself that you are dabbling in paint?" that good man replied in all honesty: "Why, of course. And if it didn't amuse me, I beg you to believe that I wouldn't do it!" (From *The History of Impressionism* by John Rewald)

What a marvelous answer! What a healthy attitude!

Painting *should* be fun, never a burden. But nothing can be pleasurable if it's tinged with fear and timidity. Even if this is your first portrait, approach it with good cheer and with confidence in yourself. Painting is not for the timid and the faint of heart. *This is probably the most important lesson you can learn from this book!*

If you're inclined toward fussiness and finickiness, look in the mirror and repeat to yourself: "I will be bold! I will be daring! I will be forceful!" If you don't accept this credo, you'll spend the rest of your artistic life fumbling and nitpicking. Your portraits will be stilted, parochial, straitlaced. You'll come to despise painting and to resent your involvement with it.

So if you don't accept one other bit of advice I've given you, accept this one: *Be bold!*

You may turn out some lousy portraits, but it won't be because you haven't tried. Give yourself the same chance you'd give any human being who seeks only the opportunity to do his best. Psych yourself up if need be, and summon up every ounce of courage, will, and determination that's in you, then plunge in with every means at your command.

Plunging In

Now, you are psychologically ready to begin your portrait. You've armed yourself physically, mentally, and spiritually, and the moment of truth approaches.

A few preliminary steps remain before you can pick up the crayon and launch the actual process of creation. Let's consider these steps one at a time. I know that you're anxious to begin painting, and we'll get them out of the way quickly so that you can plunge in without any further delay.

Mariot *by Dorothy Colles, pastel on paper, 24" x 18". The free and rather sketchy treatment of the hair and body helps focus our attention on the center of interest—the face. The child's eyes directed at some vague point outside of our vision help create the aura of reflective introspection. The clever portrait painter uses his sitter's gaze to good advantage: the direct confrontation, the sidelong glance, the lowered gaze can all be utilized in portraying desired moods and attitudes. (Collection Mrs. Neil Tyler)*

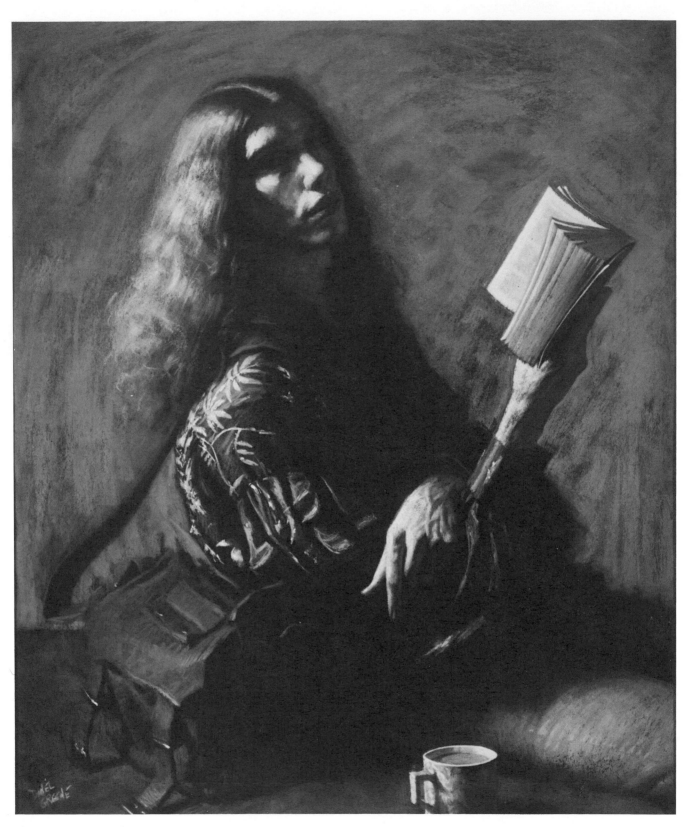

Model Resting by Daniel E. Greene, pastel on board, 32" x 40". In this beautifully rendered portrait of a long-haired youth, the artist used color with dramatic effect to portray a member of the "now" society. The gaudy blue of the model's shirt is characteristic of the new, primitive tastes of the younger generation. The artist departed from the usual portrait procedure in which the face and figure are accentuated, by painting inanimate objects such as the book and the cup of coffee with amazing fidelity. The subject's high cheekbones are sharply underlined with cool halftones, and patches of light are concentrated in those areas that project from the face—the nose, the upper lip, the forehead, and the upper cheekbone. The left hand is most carefully painted, but the arm behind it is lost in an indistinct blue to make the area recede. The hair is loosely treated and seems to float into the background. (Courtesy Markel Gallery)

Setting Up

In order to paint, you must have light. There are two kinds of light—natural and artificial. Which is better? No contest. Natural light is far the best; artificial light runs a poor second.

However, not everyone is privileged to be able to paint by natural light. Some artists must hold down jobs during the daylight hours; others don't have studios which face the outside.

Natural Light or Artificial Light?

To me, the worst natural light is better than the best artificial light. I hate to paint by artificial light because colors seem to acquire a false character and everything appears chintzy and gaudy.

If you can avoid it, don't paint by artificial light. If you can't, get yourself a fluorescent fixture with a so-called daylight lamp. It's the closest substitute for the real thing.

Most artists, given the choice, select a studio that provides a northern exposure. This light is less variable than that of the other exposures. It's also somewhat colder. Right-handed artists arrange the easel so that the light falls over the left shoulder—and vice versa. Usually, the easel remains in one place in the studio once the artist has found the most favorable location for it.

For drawing, rather than painting, artificial light is as good as natural. Since it can be more easily manipulated, it may even be better.

The best lighting is that which issues from directly above, as from a skylight. Painting outside can also be very pleasant, but not in direct sunlight which tends to dazzle your eyes and makes color selection rather difficult. Painting in light shade is preferable.

I've never painted by gaslight, but I've read that this is a most enjoyable experience. I've also read that Van Gogh affixed a row of candles to his hat and painted outdoors at night.

A factor not often considered is that the old masters painted pictures which were never intended to be seen by electric lights; and those painted by the impressionists were viewed by gaslight most of the time.

If you must paint by artificial light, check the painting in daylight and make whatever corrections you deem necessary. Or, if you can, arrange the final sitting during the day so that you can correct the colors to make them appear more true and lifelike.

Lighting Your Subject

When you're ready to begin painting, you'll have to arrange the light so that it'll illuminate your subject in the fashion most conducive to the effect you're after.

Light from a single source makes for the simplest and most effective portrait. Thus, if you have light falling on the subject from two opposite windows, cover one with a shade. By using draperies and shades, you can fairly well control natural light. As you know, light falling from above creates different shadow patterns than light coming from a side or from below. Do you want a dramatic effect? A dignified effect? A regal effect? A placid effect? Light helps to create the mood of a portrait. Play around with draperies, shades, umbrellas, and screens until you've learned to control the light. Try to simulate the so-called Rembrandt lighting in which the eyesockets fall into shadow and a good highlight strikes the forehead or cheek. Study the lighting in portraits you admire, then try to emulate the effect in your studio.

Mirrors and other shiny objects are also used to *bounce* the light and to reflect it onto whatever surface you want to illuminate.

Personally, I don't like manipulated light and always seek the simplest lighting possible, but here again you're free to probe and experiment in order to fulfill your personal requirements. I'll say that the best portraits are those that don't employ tricky or complex lighting.

Positioning Your Subject

The subject is now ready to be painted, and he awaits your instructions on where and how to pose. Most of your subjects will sit for their portraits. You, therefore, plunk him down in the chair which you've previously placed somewhere in the studio where the light is most desirable. He sits and awaits your orders.

Ask him to sit as comfortably as he can and walk around him so that you see him from every angle.

Somewhere along this route, you'll find the effect you're seeking. When you've fixed it firmly in your mind, ask him to stand up, then move the chair *so that the same effect is achieved when seen from your viewpoint before the easel*. Now, ask your subject if he feels comfortable in this pose or if it seems stiff and unnatural. If it doesn't feel right to him, make some small adjustments until it does. He must feel at ease, or else his face will assume a tense, strained expression that'll come through in the portrait.

Now take whatever props you've previously decided to use in the portrait (books, guns, eyeglasses, gloves, etc.) and fit them into position. Again, ask your sitter if the book, gun, etc., feels right and comfortable.

Now arrange whatever other props you'll need — tables, chairs, columns, lecterns, whatever. Dip into your chest of background draperies and put up the appropriate one or ones on the wall or screen behind the sitter. Check everything once more and ask if he feels comfortable, relaxed, undaunted. Does he? Good. As soon as you've arranged *yourself*, you'll be ready to begin painting.

A word about model stands. Some painters prefer to put their sitters up on a pedestal, literally, not in the figurative sense. Model stands allow the subject to sit or stand a foot or so off the floor, thus giving the painter a somewhat higher view.

Positioning Yourself

Now that you've positioned the subject, it's time to position yourself.

Take your place behind your easel and make sure that you can comfortably see the paper, the subject, the crayons, and other tools. You can work either sitting or standing, however you prefer. Have your pastels, erasers, fixative, etc., laid out on a table within easy reach. See to it that the light falls on your paper and your crayons. Make room so that you can step backward, sideways, or frontward without knocking anything over. Leave plenty of room on the table to quickly put down and pick up crayons, rags, stumps, etc. Have everything at hand and easily available. Nail a ridge around the table, if necessary, so that the crayons won't roll off and break on the floor. Put the crayons you're using in one place so that you don't have to go groping around for them. Keep boxes of extra crayons handy in case the ones you're using break at the most critical time (they always do). Remember where you put down everything that you're using so that you won't have to go frantically searching for it later. Don't leave things standing where they may be knocked over in the heat of artistic gestation. Make sure there's someone to answer the doorbell or telephone so that you won't be disturbed. Play soft music if you and the sitter don't clash in your musical tastes. Arrange to have water, coffee, tea, cigarets, ashtrays, matches, booze, or whatever handy so that you don't waste valuable painting time looking for same. Hang a mirror close by so that the subject can comb his hair or smooth his tie if he feels somewhat insecure during the break. Have a washroom available.

Positioning Your Paper

The painting surfaces we've discussed include paper, board, panel, canvas, or similar material that's stretched on painting stretchers.

Pastel paper in its unmounted form offers the most satisfactory results if *six or more sheets are placed beneath the topmost one so that there's a nice give and bounce to the surface*. These sheets can then be tacked, taped, or clipped to a piece of wood or a stiff cardboard, and fitted into the easel. Since pastel breaks and powders, many pastellists tilt *the top of the paper somewhat forward* so that these granules will fall to the floor instead of coming to rest on the paper itself.

I like to work with the *bottom* of the paper tilted forward. If you'd ask me why, I couldn't tell you the reason.

Pastel board and panels which have a rigid back don't require a stiff board underneath; but I use one anyway to avoid possible buckling. Canvas is, by choice, flexible and is used on stretchers, as is.

I like to place the paper so that the eyes of the portrait fall just below my own eye level. Others place the paper higher or lower.

However you position your paper, make sure that it stays firm and doesn't wobble. There's nothing more annoying than having your paper shimmy and shake just as you're trying to enter the gates of artistic heaven. A good, solid easel is most helpful.

How Far Away Between the Subject and You?

The distance you maintain from your subject is again a matter of personal choice. A lot depends on the sharpness of your vision. I see well enough, but I like to work close, as close as the subject will tolerate without growing nervous about my rather piercing eyes.

I've also seen photos of portrait painters standing at what seemed ten yards from the sitter; therefore, choose the distance that seems most comfortable for you.

Some artists use a reducing glass through which they periodically scan the model and the painting. Others hold a mirror to the painting to check whether their proportions are right when viewed from a reverse angle.

I believe that this covers everything leading up to the actual portrait itself.

You can now begin to paint.

Alice by Dorothy Colles, pastel on paper, 20" x 16". This is a fine example of the pointillist technique in which the artist used strokes rather than dots to paint the planes of the face, arms, and areas of the dress. Note how the strokes follow the natural shapes of the forehead, cheeks, and upper arms. In the hair and in areas of the dress, the artist blended in order to draw the viewer's eye to the adjourning areas, where the strokes are broken and more arresting. (Collection Mrs. Betty Kirk Owen)

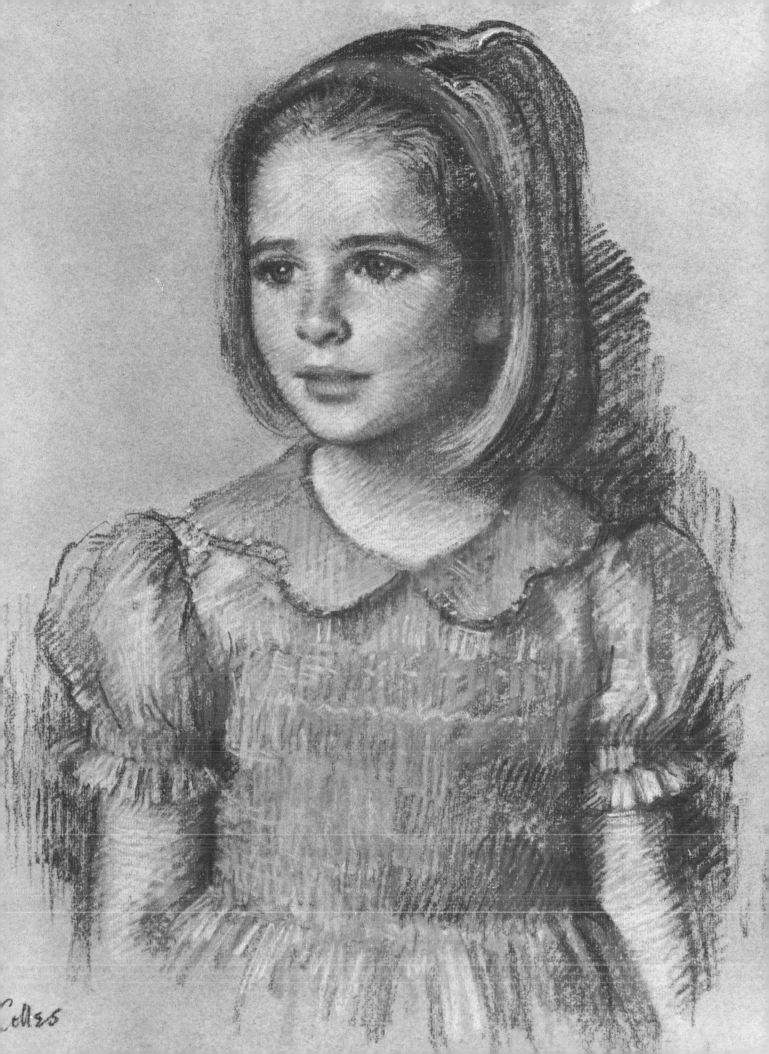

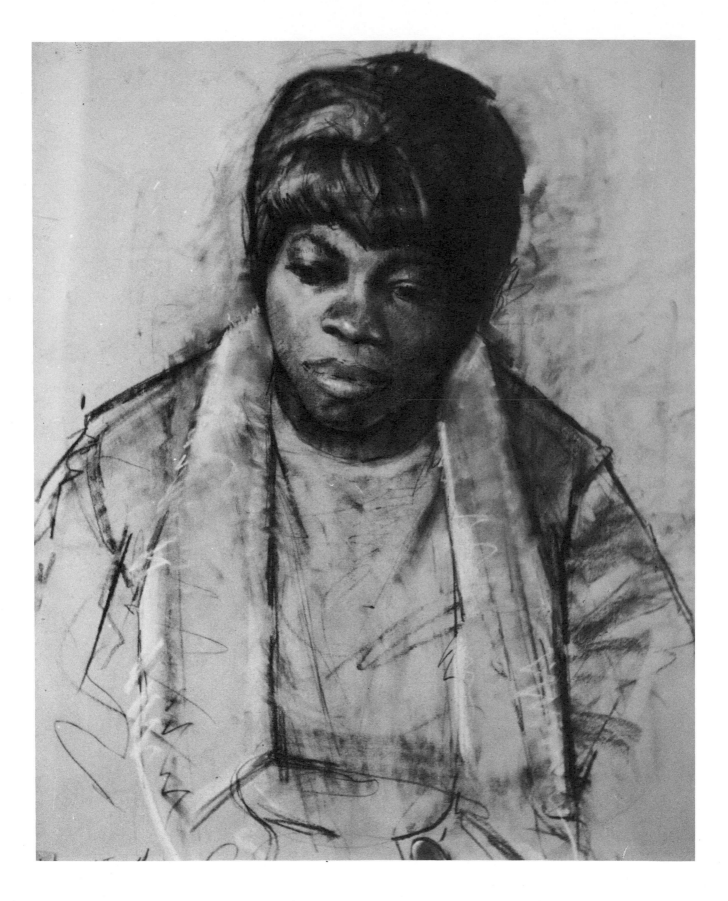

Daphne *by Thomas Edwards, pastel on paper, 22" x 18". In this portrait, a combination of loose and tight technique is used: the outlines are rather sharply indicated, but the features are blended and soft. The artist has stroked a number* *of broken lines over rubbed areas—as in the hair and parts of the body—to lend strength and direction. Note how darkly the so-called whites of the eyes are painted—almost equal in value to the rest of the face. (Courtesy Mr. J. Richards)*

Painting the Portrait

If you've carefully absorbed all that's come before, you should be physically and emotionally ready to begin a portrait. Likely as not, your subject sits before you stiff as a ramrod, with a tense smile or a worried grimace fixed on his face. If you think that *you're* nervous, put yourself in *his* place. This is probably his first portrait and he doesn't quite know how to react. He's concerned that he hasn't shaved closely enough, that his tie is stained, or perhaps that his profile isn't all that it should be. If you've ever caught sight of yourself unexpectedly in a three-way mirror while trying on a coat in a store, you can sympathize with his discomfort and apprehension.

Relaxing the Subject

The first thing you must do is relax him. Disarm him with some idle chatter. Discuss a subject you think may interest you both and transform him from a robot into the interesting human being he probably is. No one, regardless how tense or austere, fails to respond to stimulating conversation.

Keep him talking and animated and your job will prove infinitely more pleasant and interesting. It'll also take attention away from *your* nervousness, since nothing will so distract and worry a subject as to see the artist who appears fumbling and uncertain.

There's absolutely no need for your subject to sit like an embalmed corpse. By now, you've looked at him and—hopefully—into him, and you have a pretty fair concept of what he looks like and what he is. So let him move or stretch when he feels the need. And let him take frequent breaks.

Drawing the Outline

There's a school of artists, hopefully declining, that demands a complete outline before going on to paint the portrait. It's their contention that if the contours are drawn exactly, the rest will automatically fall into place. I'd be the last to argue against good drawing as an integral part of a portrait; however, many subtle dangers can result from a precise preliminary outline.

The masters were nearly all superb draftsmen. Yet a detailed study of their output reveals that toward the end of their lives, when their skills and understanding had reached the height of development and maturity, they invariably tended toward a loose, free style of painting. As their talents blossomed, they gravitated from the linear toward the tonal approach. In the mature work of such accomplished painters of the human form as Rembrandt, Degas, Renoir, it's difficult to find a precise outline. A lifetime of acquired knowledge and experience freed them from the tyranny of the outline and impelled them to employ color, tone, line, and form with verve—almost wild abandon.

Rather than primp and fuss and scratch in every wart and wrinkle, let's consider the subject before us as a pyramid of masses, lights, halftones, and shadows. A precise preliminary outline—in the hands of anyone but a completely realized artist—often leads to a finished portrait in which the subject seems to have been snipped out of paper, then pasted to the background. Obsession with the outline and with precise detail tends to limit, to stultify, to smother the aspiring artist and to enslave him to a kind of blueprint. Of course, it's perfectly possible to prepare a completely detailed outline, then obliterate it in the later stages of the painting; but if the outline will be obliterated in the end, why go to such elaborate lengths in the first place?

It's much easier and more productive to indicate an outline with several appropriate, but *loose* strokes which simply serve as a *guide* for the completed portrait, not a sharp edge to be preserved at all costs. In conceiving an outline, you must pay particular attention to the *total* form before you. You must ask yourself: is the head large or small in comparison to the torso? Is the head set on a long neck or does it seem to squat on the shoulders? Are the shoulders broad, narrow, rounded, stooped, or square? Where are the sweeping curves and angles within the form?

At this stage, you must hold back all the psychological insight you've acquired into the subject and think of him as an object composed of blocks, cones, cylinders, angles, curves, lights and shadows. Narrow your eyes so that your vision grows blurred. If you're

near-sighted, remove your glasses. Now look at your subject. His features have momentarily receded into the skull and you see him as a vaguely defined coalition of masses.

Perhaps the head has fused with the shoulders and arms and partly faded into the shadows of the background. The hands are patches of light set against darker clothing. There's no individual head, neck, torso, arms, legs but instead a total shape, wide here, narrow there, jutting here, curving there. In this vague blur, the hairline grows indistinct, the eyelashes are obliterated, the sharp edges, which we think we see, vanish. This is how you should see and paint your subject during those critical early stages! Later, there will be ample opportunity to rediscover some of the lost details.

Now, pick up a piece of charcoal or a half-hard pastel stick which is somewhat darker in value than your paper. I like umber for this purpose. Holding it loosely, indicate roughly the angles, curves, and general contours of the subject. Using the point of the stick, indicate the linear outline. Using the broad side, block in the shadows solidly. Then, using the same stick, roughly strike in the halftones, letting the surface of the paper show between the lines. Thus, the shadows are solid and the halftones are what might be called broken lines. For now, leave the light parts completely untouched, just bare paper.

If you'll again look through dimmed eyes, you'll see that the shadow doesn't stop abruptly at the head, but seems to drift into the background and into the other parts of the body. Good! Handle it just that way in the painting. Let the shadow areas of the face, neck, body, and arms flow into the background without marking off where each part begins or ends. Remember, we're not made up of bits and pieces, but of a whole in which the anklebone is connected to the shinbone, the shinbone is connected to the kneebone, and so on. And the flesh that covers us flows from limb to torso to skull, forming a unified continuity composed of various interesting angles and curves.

Therefore, when outlining the features of the face, don't think of the nose as something pasted on as an afterthought to allow us to breathe, but rather as an extension of the cheeks—a form that juts out, then flows back into the other side of the face. The ears are the closest to being appendages which, in some unfortunate cases, seem to run counter to the rest of the skull. But even they, in most instances, lie flatly and comfortably alongside the skull. The eyes and mouth protrude or recede least of all the features. The eyes dip slightly into the mass of the skull and create wonderful shadows when lighted from above.

Study the eyes in Rembrandt's portraits. They lie totally in half-shade, with just a hint of the inner light. The whites of the eye are never white, but are the color and the value of the rest of the face. You can't count the eyelashes; nor are the pupils outlined like polka dots. But what magnificent eyes they are!

The mouth, in the hands of a master, is a dark slash, not a precisely outlined cupid's bow.

Rarely are edges sharply or precisely defined in the faces of the world's greatest portraits; instead, edges are modified with halftones so that they seem to drift naturally and unobtrusively into the areas that surround them. When Rembrandt paints an ear, you don't necessarily see, but rather *sense* the convolutions within it. His hands and fingers are among the finest ever painted, but a closer look will indicate how loosely and boldly they've been treated.

Therefore, by all means prepare an outline, but don't render an architectural blueprint. Rather, give yourself a series of guidelines to make the next stage easier. An outline is just that, a signpost designed to lead you to your ultimate destination.

Following the Natural Contours

A note before going into the second stage of the painting, in which I'll show how to further advance your portrait in the three pastel methods indicated in Chapter 7: the pointillist, the painterly, and the rubbing-in techniques.

From the earliest times, artists who specialize in painting the human form have sought means to achieve three-dimensional effects while working in a two-dimensional medium. A useful trick that's come down from the masters is to apply the strokes in such a way as *to follow the natural* contours of the body, the way a bracelet wraps around a wrist.

Degas used this effect extensively in his pastels, as in his frequently reproduced *A Woman Having Her Hair Combed*, which hangs in New York's Metropolitan Museum of Art. (However, it's only fair to point out that, toward the end of his life, Degas consciously ran his strokes *in opposition to the natural contours* to achieve certain discordant rhythms that he sought in his never-ending search for beauty.)

Pastel offers an excellent opportunity to implement this particular technique. Pastellists employ their strokes to follow the contours as the most natural means of depicting the various angles and planes of the human face and body. It's a practice worth the study and consideration of every aspiring portrait artist.

Pointillist Method

You now have an outline before you, giving an indication of the contours, the form, the lights and shadows defining your subject. You're ready to start laying in the masses, to commence underpainting the portrait.

Let's assume that your subject is a girl with a fair complexion, blond hair, and blue eyes.

You've prepared the outline, indicating the general shape and forms of her head and upper body, and you've treated the shadows as one continuing mass. You've marked the halftones with broken lines of the crayon and left the light areas blank. You've roughly blocked in such shadow areas as the eye sockets, the area between the lips, the insides of the ear, the area under the jaw, and perhaps the hollow under the cheek.

For the pointillist method which may be the most difficult to carry off successfully, select six hard

or semihard sticks. Since the subject is fair, you'll paint her in high key, in light, airy colors. The colors you might need are flesh ochre, raw umber, cobalt blue, yellow ochre, olive green and burnt umber, all middle shades.

Begin to stroke in the colors, using the sticks alternately, being guided by your eye, by instinct, by feel, and by inspiration. Begin laying in the colors with the point of the stick; apply dots or short, vivid strokes until you've filled in the halftone area. Select one darker stick to redefine the shadow areas, perhaps burnt umber or burnt sienna, second darkest shade. Study your subject's face to see where there's a spurt of warm color, perhaps in the cheeks, in the lobes of the ears, on the bridge of the nose, in the lips. In those places, touch in a stroke of flesh ochre, middle shade. Now and then, working simultaneously on all parts of the face, you'll detect cool bluish, greenish, or grayish accents along the upper lip, in the temples, under the cheekbones, or along the chin, and you'll stroke in appropriate spots of blue or green. As you study the flesh color, you'll notice that it's actually not rosy, but more toward the amber and ivory hues. Remember, most artists—particularly beginners—tend to paint flesh too hot, too pink and red.

Now, you'll turn toward the shadows and see that they're lighter and cooler than you've assumed. Stroke or dot in greens and blues among the hot umber or sienna so that the area loses some of its sameness and seems to acquire a kind of vibrancy and snap. Occasionally, let some of the paper show through to break up the monotony. And make sure to introduce some strokes of the other colors into each part of the portrait, both shadow and halftone, in order to draw the elements together and lend a kind of cohesiveness to the whole. If the shadow is particularly dark, use the darker shades of the other colors.

Now you're ready for the light areas. Study your subject closely to establish the highlights upon her form. Perhaps there's a highlight on her forehead, another on the tip of her nose, a third on her chin or above the cheekbone. Study these highlights closely. They're not, in most cases, as bright as you may assume; they may only appear so in contrast with the other areas. Subdue your urge to strike them with pure white! To see how far from white they really are, hold a piece of white paper up to your eye and measure the areas against the highlight. See how much lighter the paper is?

Treat these light areas with the same combination of colors you've been using, but work more toward the pale tints of these colors. For example, if you've used yellow ochre 6 (in the Rembrandt line of pastels) for the overall painting, try yellow ochre 3 for the highlight.

Now, the hair. Remember to treat the hair as part of the total form. Don't give it a color too far removed from the others—unless the lady happens to have a particularly hideous dye job. In nature, all colors assigned to the human race are pleasing and complementary. In the case of our fair-haired lady, treat the hair color as an extension of the flesh and proceed accordingly. Remember, a single hair is like a single drop of water in the ocean. It can't be rendered individually, but must be treated as part of the whole.

Now that your light areas are established, work the dots or strokes into the background, remembering at all times to let the head drift into the background gradually, rather than precipitating a sudden division. *At no time must you form a distinct line between two areas*, but rather do it in a broken or graduated manner which will synthesize the two areas and establish a sympathetic relationship between them. The same principle applies to the backgrounds in the other two techniques, which I'll describe later in this chapter.

In the pointillist technique, as I've mentioned, each area acquires some of the other colors used elsewhere in the painting. The color is broken up chromatically, in a kind of stained-glass window effect, so that when viewed from a distance, all the areas seem to fall into place in a pleasing and interesting manner.

A portrait painted in the pointillist method might have red touches appear in the blue area, green strokes in the pink, yellow dots in the violet, and so on.

A great deal of visual knowledge and experience is required to paint in this manner, and it's not one usually adopted by beginners. At the end of his life, Degas became a kind of unregimented pointillist, although he's not normally associated with this school of painting. Seurat, Signac, and the American Childe Hassam were noted pointillists, as were Bonnard and Vuillard, to some lesser degree.

Painterly Method

If you've chosen to paint the portrait in the painterly or building-up method, rather than the pointillist method, you proceed to the second stage in the following way, after drawing your outline. You'll use soft pastels, which are more adaptable to the fluid or painterly style. You won't allow the underlying surface to show through as you would in the pointillist method, but rather use a heavy impasto to build up your portrait in an effect closely approximating the brushstrokes in an oil painting. The painterly method is essentially a technique based on tones which build up to a fluid, opaque finish. Many pastellists manage to achieve this effect despite the assumed limitations of the medium.

Take up a stick approximating the subject's medium tone, and using the side, lay in color heavily so that the entire halftone area is covered in a fairly thick impasto. Don't worry too much about features and details, but rather fill in with appropriate hues the general areas of the face, background, clothing, etc. Go over the entire portrait thickly, in long, sweeping strokes that follow the general form, bridging the gaps between shadow and light with smoothly graduated halftones. One of the characteristics of this method is that great portions of the painting are covered in a single stroke, in contrast with the pointillist technique, which treats a comparatively small area at a time.

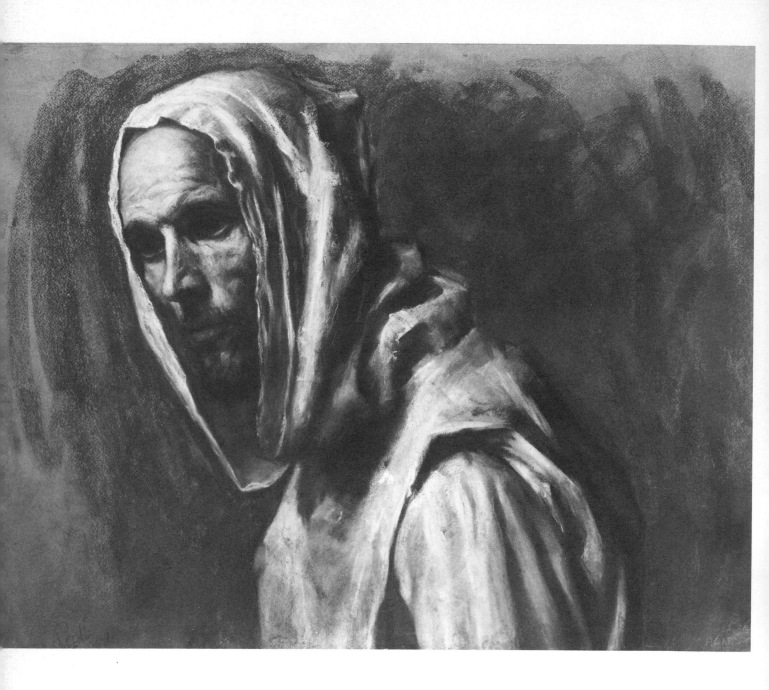

The White Monk (Above) by Daniel E. Greene, pastel on paper, 20" x 28". The artist used pastel in a fluid manner to paint the long, sweeping curves of material in the cowl. He has thrown the eyes into shadow in the so-called Rembrandt lighting and concentrated the lightest tones in the forehead and on the nose. The cheeks, lips, and nostrils are subtly modeled. Several strong, broken accents are stroked in beneath the subject's left eye, on the upper lip, and on the ridge of the brow. Although the eyes are in shadow, they vividly portray the subject's searching, intense gaze. The rough strokes of color in the background serve to soften and somewhat veil the stark lightness of the robe. (Collection Mr. Charles Plohn)

Man with a Sword (Right) by Daniel E. Greene, pastel on paper, 29" x 21". The subject's angular, cadaverous face lends itself admirably to the artist's virile, vigorous style. The extraordinarily deep cheekbones form a dramatic contrast with the light areas of the forehead and upper cheeks. The artist has wisely focused the spotlight on the upper part of the face and left the rest of the figure in comparative shadow so that the eye darts immediately to the important areas of the portrait. The crook of the left eyebrow, the rigid lock of the mouth, and the hard cast of the sucked-in cheek are the portraitist's ways of providing insights into the subject's character. Contrast these incisive touches with the typical "mug shot" in which the sitter looks out vapidly from the canvas and no rapport is established between subject and viewer. (Collection Mr. Charles Plohn)

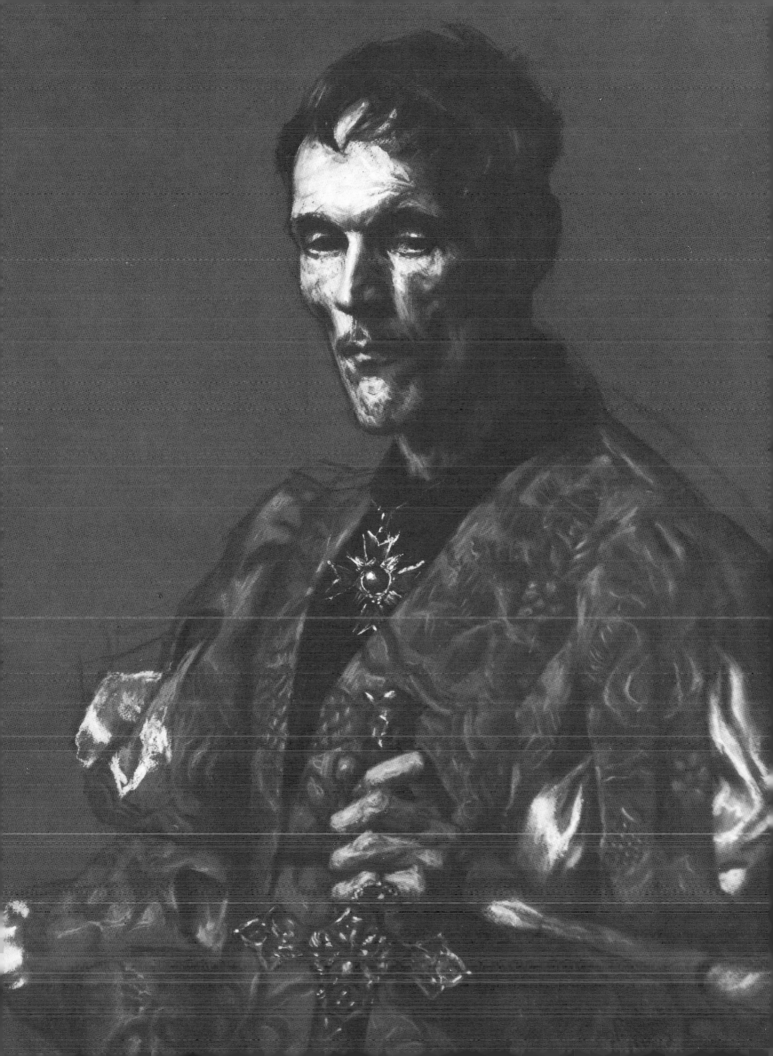

If your subject is a brown-skinned man with black hair and brown eyes, you'll use a rich burnt sienna, medium shade, for the medium tone and you'll strike in the shadows in a warm, dark umber, second darkest shade, touching here and there with yellow ochre or raw umber, medium shade. A pale ultramarine blue, second lightest shade, touched in along the cheeks, lips, and temples will enliven the lighter area of dark skin. Construct the nose in strong, distinct halftones and render the entire head in bold, plastic accents that will achieve the sculptured, three-dimensional effect that's the mark of this technique. Employ the black pastel stick to block in the hair, but not until you've underpainted with umber to cut down the harshness of the black. Or, substitute the darkest ultramarine crayon for the black altogether. Mixed with dark umber or caput mortuum, it will produce a black effect.

Strike in the pupils of the eye with umber, darkest shade, and modify some of the overall hot effects with ultramarine blue, middle shade.

When you've filled in the middletone and shadow areas, strike thickly into the highlights with a yellow umber or a pale blue, second lightest shades. Paint everything thickly and richly so that each area glows and scintillates with color.

In the painterly technique, it's not as vital to blend the various areas of light, halftone, and shadow. One charm of the technique is the boldness that marks each value as a strong and distinct component of the total painting.

Painting in this method is less exacting than the more controlled pointillism, and is favored by those with impatient, quicksilver personalities. This is the loosest and least confining of the three pastel techniques and, when executed with vigor and audacity, best demonstrates an artist's virtuosity and sureness of hand.

In contrast to the pointillist method in which the background vibrates with all the colors, the background executed in the painterly method demands a more subdued, less variable treatment. This is a method which lends itself esthetically to a dark, rather somber background, preferably of one hue, with subtle variations of light and shadow.

The painterly method is born of the old master portraits of the sixteenth centuries, in which the light was mainly directed at the face and hands of the subject, while the rest of the figure floated in a kind of veiled, amorphous mist which hinted at more detail than it indicated.

This kind of background must never be dull or flat or thin, but rather deep, lush, and satisfying to the eye and to the senses. It's said that when you gaze long enough into Rembrandt's backgrounds, you become intoxicated. You should be able to lose yourself in this background and let it conjure up for you the sensation of night, of mystery, and of enchantment.

How is this background achieved?

Basically, by going over and over the surface until it acquires a kind of rich patina like a well-polished wooden table or a length of old plush tapestry.

In practical terms, take a soft stick of caput mortuum—the darkest shade—then stroke in lavishly until the entire area is covered thickly. Now, go over it with olive green, the darkest shade, and raw umber, the darkest shade, with a few touches of raw umber, middle shade.

Use nothing lighter in your background. These sticks will suffice, as you don't want to go any lighter in value.

A vital point in painting this kind of background is the proper placement of the lighter areas. I'd advise you to employ historical precedent and either begin with your darkest area at the top of your portrait, working gradually down to the lighter; or that you go darkest along all the edges and reserve the lighter areas so that they fall around and behind the head and shoulders of your subject.

In any case, there should be only minimal differences between the high and low values, so that the eye senses rather than sees which part of the background is the lighter. This helps establish the mood of mystery and romanticism that's desired here.

The backgrounds in the portraits of Rembrandt, Velásquez, and Sargent, even though these artists worked essentially in oil are good examples of the backgrounds appropriate to this method.

The other alternative to the dark and somber background in the painterly technique is *no background at all;* that is, you employ the color of the paper itself to serve as the background for the painted head or figure. In my opinion, a light background, completely filled in, vitiates the effect of the painterly method.

The third major pastel technique is the rubbing-in method, chiefly employed by the earliest pastellists, such as Rosalba Carriera, Maurice Quentin de La Tour, and Jean Liotard, who painted superb (if somewhat finicky) portraits of courtiers.

In this technique, all strokes of the stick are blended to produce a smooth, pleasing finish that lent itself admirably to rendering the silks, satins, and smooth-powdered complexions of the ladies and gentlemen of the court of Louis XV. The effect is very different from the pointillist and painterly methods.

Although it's fallen into ill repute in our era of sketchy half-finished portraits, there's something to be said for this method when it's properly handled and controlled. It's the technique most commonly associated with pastel by those not too familiar with the fullest potential of the medium.

Let's assume that you're painting a portrait of a young girl with a rosy complexion, green eyes, and pale auburn hair. Her skin is youthfully soft and fine and contains the delicate tints that we associate with portraits of English ladies by Lawrence and Gainsborough.

Over the preliminary outline and indication of the light, shadow, and halftone areas, begin the second stage by laying in the halftone areas with a soft stick, for example, a flesh ochre, third highest shade. Then take your favorite finger and rub the area smooth, going from halftone into and over the shadow areas and across the light areas, achieving an evenly gradated

effect in which all three areas are pleasingly and tastefully homogenized. Add appropriate lights and accents in dabs of pale lemon yellow, second lightest shade, which you once more rub into the adjoining areas. At all times, the effect is airy and ephemeral, gracious and unobtrusive.

Eyebrows, nostrils, the slash of the mouth, the shadow below the chin are lightly indicated with a burnt sienna, middle shade, then once more rubbed in and smoothed out. Add cobalt blue, third lightest shade, to strive for the cool, ivory effect at the temples, the brow, the young lady's neck and throat areas. The hair is lightly indicated with a burnt sienna, third lightest shade, then rubbed so that it flows gently and naturally into the creamy patina of the forehead. Touch umber, middle shade, gently to the iris and merely hint at the eyelashes. The corneas of the eyes aren't handled separately, but related to the flesh area, in the value of the highlighted cheekbone, let's say. The highlights can go closer to white than in the other techniques; you can use highlights of the palest ochre, since they won't be left alone, but smoothed into the other areas.

A few more bold strokes of the soft stick are employed for the girl's dress. Don't stop to fuss with wrinkles and folds, but merely indicate the big, noticeable breaks in the material like those at the juncture of the arm and body, or at the elbow. Again, smooth in a neutral green, gray, or blue to bridge the gap between the neckline and throat. There's no severe break there, merely a change in hue that makes the transition from cloth to flesh a gradual and gratifying visual experience.

A kind of misty veil must seem to hover over the entire painting. This shouldn't indicate weakness of execution, but rather lend a poignantly appealing, even dreamlike quality to the portrait.

The background should be light, as opposed to the other two techniques in which we rendered it dark and deeply penetrating or broken in color. For this painting, select a light toned surface, and play with various tints of pink, blue-green, and violet to create a cloud-like, Elysian atmosphere in which to present your pretty, young sitter.

Rubbing-In Method

The rubbing-in method calls for a background treatment which differs from that used in the other two techniques. In the pointillist method, you'll recall, we let our background vibrate with colors which lent it a kind of nervous, throbbing, electric quality. In the painterly method, we let the background go dark, achieving a Gothic, nocturnal inscrutability. The rubbing-in method signifies a kind of *joie de vivre* in which the sun is always shining and the lion lies down with the lamb. Boucher and Watteau captured the essence of this expression in their charming court and pastoral scenes.

In this method, the colors are pleasing and delicate and a light background is almost mandatory. In value, the background can go as light as the middletones of the subject, but not quite as light as the highlights, since this could minimize the strength of the main elements, the face and figure.

Take soft sticks of viridian, blue violet, and cobalt— all third lightest shades—and spot them into the background area. Now rub these colors together so that they fuse into each other in a pleasing and harmonious arrangement. Stroke, then rub some mouse gray, third lightest shade, into the general background. When the whole area is covered, stand back and study the portrait. Does the background seem too strident or is it properly unobtrusive? If it's too aggressive in places or too much inclined toward any one hue, subdue it with a contrasting color.

Try to place the cool colors against the warm areas of the face and figure and vice-versa, so that each area gains from its proximity to a contrasting warm or cool hue. If you stroke and rub in such a way that the background remains just that, a *background*, you've created a proper setting in which to present your main element of interest: the subject.

A point to remember is that warm colors—reds, pinks, oranges, and orange-yellows—tend to advance, while the cool colors—blues, greens, limes, and greenish yellows—tend to recede.

Refining the Portrait

The final stage of your portrait, like the first stage, is essentially applicable to all three techniques: pointillist, painterly, or rubbing in. You'll proceed to refine, to correlate, to finish your painting.

You do this by unifying the elements and assigning proper importance to them: by adopting a loose approach and exercising selective focus; by cooling down areas that are too warm and warming up areas that are too cool; by emphasizing some edges and by losing other edges; by correcting poor drawing, composition, colors, values. I'll touch on these factors in the following paragraphs. The early stages of your painting, while equally important, are seen by no one except you. Now you're preparing the picture for public view. At this final stage, you must be particularly alert and attentive. It's now that your portrait must come to life.

Unifying the Elements

In this final stage, you're concerned with unifying the elements to assure a totally cohesive effect, not a collection of disparate details that tire the viewer's eye as it darts from one spot to another, seeking to glut itself on tidbits offered up indiscriminately. This is a fault of many painters, who serve up a dazzling mélange of colors and textures and details, a sensation comparable to having a chef's salad hurled at you so that you don't know which way to duck to avoid being hit by something. In this type of painting, a lapdog's silky coat is painted with the same care as a human nose or the buttons on a coat, and the eye goes mad seeking some place to rest. It's wasteful to give every element of your portrait equal importance and

impact. It's also cheap and presumptuous. The artist seems to be saying: "Look at me, look at me, I'm a genius! I can render a belt buckle as beautifully as a silk fan, so take all the time you need to pay homage to my splendor!"

Rembrandt could render a lace collar as well as any man born, yet in his infinite genius he knew how to subdue details and guide our attention to the vital areas of the portrait: the face, the hands, the one or two significant highlights.

It really doesn't matter that you can render a slice of Camembert cheese so effectively that flies will light upon it; it only impresses those deluded souls who appreciate the *craft* of painting and remain blissfully unaware of the *art*.

How do you unify the elements? First, by thinking of most of them as props, as a foundation for the monument (the face and/or hands) can't stand without its foundation, but how much time should be wasted looking at the base? Second, you unify the elements by adhering to the principle that the face and body are all part of a whole, rather than a collection of assorted nuts and bolts. In the pastel portrait, we do this by treating the various parts and masses as elements of light and shadow, rather than as separate entities. If a face and a neck and an arm are in shadow, this shadow remains similar in tone throughout the entire figure, rather than red in a red-sleeved arm and pink in a ruddy face and so on. Shadows in painting don't look too much the color of the object but remain essentially shadows—dark areas—even if they are flesh or material. Shadow is shadow, regardless of the color beneath it. Subtle differences do exist, but for the purpose of unifying the elements, we minimize these differences.

The same principle of unification exists in the light areas. We may retain the value of the various elements, we change only their hue. This means, not marking off sharp differences between heads, necks, arms, torsos, etc., but thinking of them as light areas, *alike in tone and only different in hue.* You can solemnize this marriage by running a neutral shade such as olive green, medium shade, over the whole portrait so that all parts blend and flow into one another to some degree.

Loose or Tight Approach

Unless you're executing a *trompe l'oeil* painting in which a conscious effort is made to deceive the eye into thinking that the picture is the real thing, too much attention given to fingernails, eyelashes, earrings, reflections in irises, and so forth, becomes a deadly and ponderous bore. It's like a meal composed entirely of chocolate mousse.

Painting tightly like this means providing fairly precise outlines for every part of the painting, then filling in the areas with the actual color of the object. Painting loosely means composing in masses, running colors into each other when desirable, and maintaining a lively, fluid approach to the work, the right approach for pastel.

A good example of tight painting was the paint-by-the-number craze so popular a few years ago. This execrable practice, happily now on the wane, provided vials of raw, crude colors for arbitrarily assigned portions of the painting, each sharply outlined. The results, needless to say, were rigid and lifeless.

Even when a master of tight painting such as Andrew Wyeth paints a portrait, his ability to produce a brooding, deeply evocative mood overrides the attention he's paid to detail. This is the method that Wyeth has chosen to achieve his goals and he pursues it with brilliance and with inspiration. But few of us are Wyeths, and we must walk an easier path—the path of broad, loose painting—one marked and surveyed for us by such giants as Velásquez, Goya, and of course, Rembrandt himself.

Selective Focus

Therefore, seek to *paint* a portrait rather than *render* it. Almost every experienced professional portrait painter can probably achieve a photographic effect. The fact that few of us seek this effect is evidence that we don't consider a slavish reproduction of the subject before us desirable. We practice selective focus. That is, by manipulating lights, contrasts, and degree of finish, we draw attention to what we consider the vital elements of the portrait, keeping in mind the total goal, a painting that provides an insight into the subject beyond mere externals.

You do this by selecting the parts of the portrait to which you wish to draw attention, let's say, the subject's eyes, and painting them with more care, more finish, more emphasis than the other parts. Or you can throw a kind of spotlight on it, illuminating the area with lighter colors so that you focus the viewer's attention upon it.

For example, if it's hands that you wish to emphasize, paint them with extra attention to detail (veins, nails, etc.), or spotlight them by painting them several degrees lighter than the surrounding areas. In the pastel portrait, this is done with half-hard pastel shades which permit finer detail than the soft sticks. Choose colors that are the lighter shade of those used underneath: for example, a flesh ochre, lightest shade, over a flesh ochre, middle shade, and so on.

You can also go somewhat tighter in these spotlighted areas by sharpening edges and adding more detail. Another trick is not only to lighten the desired area of interest, but to darken the areas that surround it, for even greater contrast.

So don't go over your portrait with a magnifying glass; don't polish every square inch of it to gleaming perfection. Rather, consider the total picture; focus on the areas where you want to rivet the viewer's attention and interest, and let the rest serve to support, rather than hinder your effort.

Put yourself in the position of a guide leading a group of tourists through a museum that contains thousands of paintings, including *some* masterpieces. Your time is limited, yet you honestly want to give your clients their money's worth. What do you do? If you're clever

Mrs. Diana O'Hagan by Helen Wilson, pastel on paper, 22" x 17". Broken patches of tone and color, blended in places, make up this lively, vibrant portrait of a pleasant-faced young woman. The artist has left the surface showing through in areas of the sweater and background. The movement of the strokes is almost exclusively vertical. The contour lines are soft and blended except for parts of the hair and the shirt collar. (Collection Mr. Saunders)

Sir John Reade, Bart *(Left) by Rosalba Carriera, pastel on paper, 22¾" x 18¼". Rosalba Carriera rubbed and rubbed her portraits until they nearly went up in smoke; but in all fairness to her, she was fulfilling one of the portrait artist's basic functions—giving the customer what he wanted. Her times demanded soft, pretty, fluffy portraits and Carriera complied, but her skill in the medium negates some of the apparent lacks of strength inherent in her portraits. For all this, there's great, delicate beauty throughout and the treatment is charmingly loose, free, and gracious. (Courtesy National Gallery of Art, Samuel H. Kress Collection)*

Portrait of Marguerite Pouget (Madame Chardin) *(Above) by Jean Baptiste Siméon Chardin, pastel on paper, 18" x 15". An honest and deeply emotional portrait of the artist's wife by one of history's foremost pastellists. The handling is loose, but the forms are solid, and you can almost sense the sure and knowledgeable hand of an experienced, mature portrait painter. Note how freely Chardin has painted the eyes, which turn with the planes of the face and express the inner character of his sweet-faced wife. I sense the deep love and respect that the artist felt for his lady, in this strong, deeply romantic and skillfully rendered eighteenth-century pastel masterpiece. (Courtesy Art Institute of Chicago, Joseph and Helen Regenstein Foundation Collection)*

and resourceful, you arrange your tour so that your group sees only the major works and merely flits by the mediocrities. Otherwise, by the time they've reached the Mona Lisa, they're too pooped and bleary-eyed from gaping at shepherdesses, fauns, and clowns to appreciate her beauty.

A successful portrait can be likened to such a journey. You quickly reach the main attraction, while skimming across the nonessentials.

Playing Down Nonessentials

The trick, then, is to play down the assorted arms, elbows, collarbones, bosoms, cleavages, watch chains, elk's teeth, and to fix your artistic spotlight on faces, which is what a portrait is all about.

How do you do this? By simply losing or blurring edges between areas, by toning down the light falling upon them, by painting them as loosely as possible so that they cease to demand our attention. Don't dwell on these areas, but rather suggest them. Run a neutral-toned crayon (such as olive green or mouse gray) over them so that they retreat to the back of the room where they belong.

Does this mean that you should treat the less important passages carelessly or superficially? Absolutely not. Every inch of Rembrandt's paintings has been given his tender, loving care, even when detail disappears into shadow. In order to conceal three-quarters of an arm in shadow as he did, you must know exactly how this arm looks, feels, bends, and lies; otherwise it'll appear to have popped out of the darkness with a life of its own, entirely independent of the socket that binds it to the body.

The knee, as a wag once observed, is a joint, not an entertainment. To you and to your sitter, your respective knees represent vital equipment that enable you to perform certain necessary actions, and make walking, running, and praying easier and more comfortable. But they mean little in a portrait. However, the viewer should feel sure that the subject's knee in the painting is a perfectly operating part, fully capable of all its functions, even though it's *not* shown in scrupulous detail.

I must stress that I have no desire to bully you into painting Rembrandtesque portraits. I only want to point out that proper emphasis is a most vital ingredient of the effective portrait. So even if you clearly show every inch of the subject's checkerboard vest and Red Cross pin, always keep in mind *what's important and what isn't.*

To sum up, the final stage of the portrait represents the opportunity to *selectively* emphasize and de-emphasize; to insert or reject elements according to their importance; to correct errors; to inject dramatic appeal; to bring the painting together; and hopefully, to scale the heights of inspiration.

You can do this by the methods I've outlined: by graying down unimportant areas; by strengthening or spotlighting important areas; by suggesting, rather than rendering with care those parts you don't wish to stand out.

Cooling and Warming Colors

If the painting seems too hot at this stage, that is, too much inclined toward the reddish or yellowish, cool it! Using a pale olive or blue stick, doodle over the painting, touching here and there until the reds and yellows cease to shout and an aura of respectable coolness settles over it. A stick of moss green, olive green, or cobalt blue, middle shade, is excellent for this task.

On the other hand, if this painting is too cool, that is, too gray and torpid looking, liven it up with cadmium yellow deep, yellow ochre, or flesh ochre, again middle shades. Play the stick lightly over all the areas without worrying too much about where the chin ends and the tie begins. It'll all fall into place if the stew isn't overcooked; that is, if you don't overdo it. If you go too hot again, cool it down once more with blues or greens.

Keeping or Losing Edges

Now, despite my long polemic about soft edges, select just a *few* edges and sharpen them. Remember, I said a few! Perhaps a nostril, an eyelid, the slash between the lips. The best stick for this is a rich burnt umber, darkest shade, or a caput mortuum, darkest shade. With these sticks, you can draw a good, heavy, juicy line that will lend strength to your painting.

Don't go overboard. Even to this day, and after years of painting, I must restrain myself in the final stages of the portrait, since I always tend to overwork a painting. I've had to curb this urge over the years like an alcoholic fighting the tendency to drink. If there were an Alcoholics Anonymous for the painter who keeps overrefining his product, I'd be on the telephone to them at least four times a year.

Now, stand back and again blur your vision. Look at your portrait, then at your subject, then back at the portrait again. Have you caught the main sweep and thrust of the shape before you? Are your essential masses correct as to form, light, shadow? Are all the proportions right? Are your highlights too high? They probably are. Tone them down a bit with gray or raw umber. Did you work around the eyes too much or do they seem to flow naturally into the skull? Run the olive stick over them a few times so that they aren't so fussy and mechanical. Is the hairline so precise that the subject seems to be wearing a wig? Scumble some ochre back and forth over the hairline so that the flesh and hair become more closely integrated. Does the mouth seem too red, as if it's pasted on? Run your finger over it so that lip blends with flesh. After all, what's a lip except flesh with an extra suffusion of blood?

Did you draw the holes and flutings of the ear too carefully? Lose them into the hair and background. How? Either by a rub of the finger so that the whole area fuses together, or by running a neutral stick over it a few times, an olive green or a mouse gray, medium shade. Maybe a spot of shadow under the jaw would add a note of emphasis. Strike in boldly with a chunk of caput mortuum. Does the dress push its

robin blue too aggressively into your eyes? Scumble some mouse gray over it.

This is the time to refine, to define, to confine. This is the moment of truth because, by now, your sitter is on pins and needles, squirming to see the reflection of his glory. Perhaps the relatives are huddled in the back of the room, ready to be delighted and astounded.

The Final Look

Now is the time for the final self-examination. Ask yourself if you've done all that you possibly can to paint a good portrait. *Well, have you?* The beauty of pastel is that it can be quickly corrected without elaborate manipulation.

Is the arm drawn badly? Don't despair. Draw the line over again *without correcting the earlier contour!* You'd be surprised how many great artists go off in their drawing. Degas' pastels show two or three lines drawn one over the other without shame or embarrassment. The great master wasn't afraid to correct a painting, even in its final stages. And the amazing part of it is that these corrections often add charm to the painting! As I'm writing this, I'm looking at a reproduction of Degas' *Two Dancers*, a masterful pastel that hangs in the Museum of Fine Arts in Boston. The legs of the nearest dancer show not one, but at least two or three obvious corrections!

Degas' goal was truth and he was humble enough *not* to feel the need to conceal his mistakes. Are you?

At this stage, accept this credo as one for which you'd gladly lay down your artistic life: *"I will be bold!"* Don't stop now to tinker around, but strike a course and pursue it. Has something gone wrong? Do it over. It's never too late. Your portrait won't suffer for it. It may, in fact, gain a certain strength that it didn't possess before. Redraw your lines, if necessary, with firmness and conviction. Add or subtract colors without hesitation. This is not the time to lose your nerve. Act as if *you* are the master of your painting, not the other way around. Even if you're off a little, a certain crudeness may not always be a detriment. Look at some of the portraits by Cézanne or Van Gogh.

So, go to it and finish the damn picture! Rub in, dot, smear, scrape, stroke, scumble. Throw in an incongruous color or two. Slap the paper with a piece of rag if you feel like it. What if the nose is an eighth of an inch off? It's far worse if it's the proper length, but it looks more like a canoe than a nose. Does the portrait sing to you? Does it breathe life and blood and guts? If it does, you've achieved the possible. You've won.

Does the Portrait Look Like the Sitter?

Now comes a most ticklish question. Does your portrait resemble your sitter? Hopefully, it does. But even if it doesn't, perhaps it's a fine work of art anyhow. Does anyone really care what the fat man in Rembrandt's portrait actually looked like? We feel

Pattern of facial features. *Think of a triangle composed of an imaginary line drawn from the edge of the mouth, under the lower lip, to the other edge of the mouth, up the edge of the other eyebrow, and across the eyebrows to the beginning point. Within this triangle, all your subject's features are contained.*

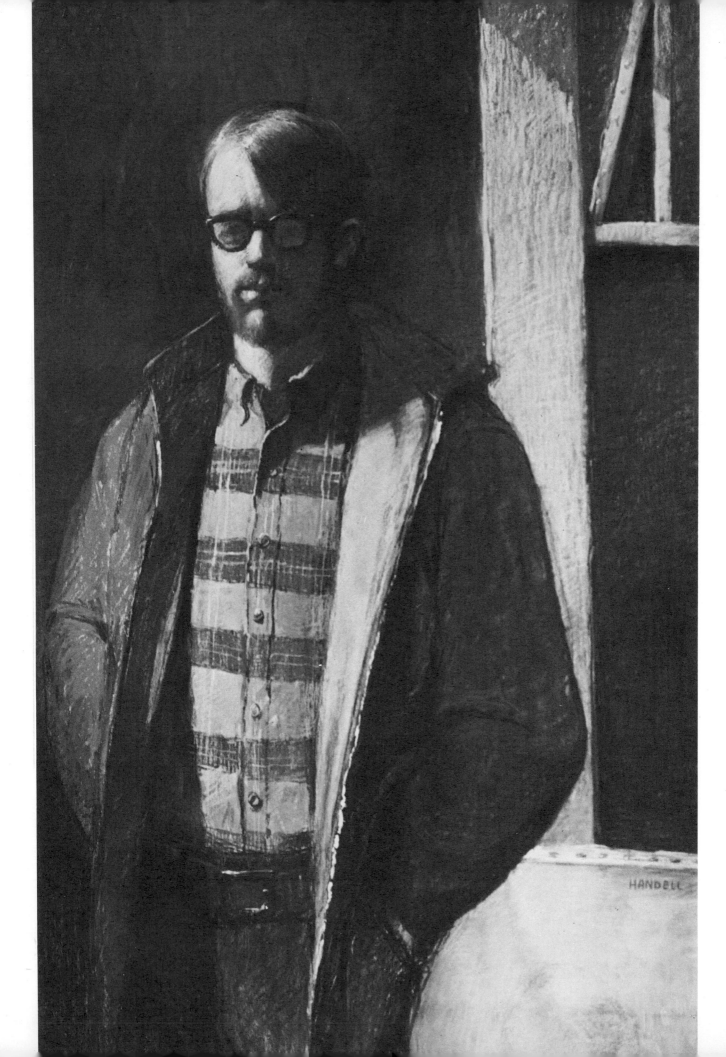

privileged merely to look at the master's interpretation of his face and form.

Sure, you want it to look like your subject, and in time, you'll learn to achieve a resemblance. But is it more important that you learn to capture Uncle Joe's ruddy jowls or that you create a work of art? Uncle Joe will go to his reward, but art lives forever.

Still, resemblance *is* something to consider.

Basically, a likeness is a matter of proportions. It's relegated to drawing and requires minute observation as well as general contemplation of your subject.

First, squint down and get an *overall* sense of your subject's proportions: the size of the head in relation to the torso; the length of the arms; the respective length of forearms, upper arms, neck, shoulders, all in relation to each other. Form a kind of mental image of your subject. Is he squat, elongated, round, squarish, erect, or hunched? Then, get down to the smaller areas: the nose, chin, eyes, mouth, fingers, etc.

Now having gained a kind of overall concept, check it against your portrait. Have you got him down in *general* proportions? Even at this stage, it isn't too late to correct things. Pastel is a wonderful medium in that it can be corrected almost endlessly. If the general proportions are correct, the rest will be easier.

Don't look at the inner proportions, the eyes, nose, mouth, etc., without considering their relation to the rest of the face. If the outward proportions are correct, the features can be adjusted to fit correctly within them. If Uncle Joe is built on the general lines of a bulldog and you've caught this *effect*, you can go on to fix the length of his nose or the breadth of his mouth. Force yourself to see one thing in relation to another, to compare eyes to nose to ears to mouth to chin. They all form a kind of pattern, if you look closely enough.

Think of an imaginary line drawn from the edge of one eyebrow down to the edge of the mouth, under the lower lip to the other edge of the mouth, up to the edge of the other eyebrow, and across the eyebrows to the starting place. Within this triangle, all of the person's features, excluding the ears, are contained. Now set this imaginary triangle within the context of the face. Once you have this properly placed, it's merely a matter of relating the various components to each other. You can, if you wish, compose smaller imaginary triangles within the bigger. A nose is a triangle, isn't it? Place it within the other. The mouth and upper lip can be considered a kind of triangle. Place it where it should be. Now gauge the width of the eyes from outer edge to outer edge, and place them.

If you've taken these steps in proper progression, you should be fairly close to a likeness of your subject.

In any case, don't let the job of getting a likeness overwhelm you. Resemblance is something that comes with practice. It's merely a matter of looking and looking again and mentally checking one feature in relation to the other. Never look at a nose as an isolated thing—no matter how large or ungainly it may be. A nose is a nose is a nose, to paraphrase Gertrude Stein, but it's still a part of a complex arrangement of forms and must be given its rightful place in the total, overall picture.

Look and draw and look some more. You'll learn how to achieve resemblance, just as surely as God made little green apples.

The Student by Albert Handell, pastel on board, 24" x 16". There's something El Greco-like in the elongated figure of the student. Here, the pastel has been rather loosely applied so that the underlying surface shows through in the trousers and in the right sleeve. The left sleeve, on the other hand, is blended. There's a rough, unfinished quality about the portrait which lends it a kind of free and open feeling. Although we don't see the subject's features clearly, there's no mistaking who he is and how he reacts to the act of posing in particular, and to his surroundings in general. This rather rough technique, by the way, works especially well with a youthful subject. (Courtesy Eileen Kuhlick Gallery)

Portrait of a Young Girl *by Robert Brackman, pastel on paper, 12" x 14". This is a penetrating study of a young girl by a modern American master, this loosely handled and rather sketchily rendered portrait provides deep insight into the dreamy, tender world of a growing child. The eyes speak wonders; the rather melancholy expression gives clues to the workings of youthful minds which, contrary to what most grownups think, incline toward moody introspection.*

Some Technical Tips

Now that I've presented and discussed many of the various techniques in painting portraits in the previous chapters, I'd like to touch on some of them again very briefly.

Degree of Finish

Judging how far to go in any particular painting is a most important decision that torments even experienced painters throughout their careers. It's not unusual that a single painter's total output should include works that range all the way from polished to crude finishes. Usually, a painter's work becomes less polished, more "unfinished" and loose-looking as he grows older—but not always. Renoir and Pissarro jumped back and forth, from "finished" to "unfinished" and back. How far you elect to go in your own paintings will have to be weighed between your sense of propriety and your sense of rebelliousness, to put it in the most simplistic terms.

The puritanical conscience tugs at one to keep working and working on a painting; the devil-may-care attitude that reposes within us all says: *"To blazes with it! Let it stand as is."*

Until the artist finds his spiritual peace, these forces keep pulling him apart and disturbing his sense of self-satisfaction. He never really knows whether he has gone far enough, or too far.

What can be done to resolve this situation? If I told you that you should go just far enough to accomplish what you've set out to do and not a step further, you'd say that I was begging the question, and you'd be right.

But the best guidance I can offer you is the same advice doctors offer dieters: to stop eating just before they become full. In our case this can be paraphrased: to stop painting *just before the portrait is finished.*

One thing that's factual is that most inexperienced artists *overwork* rather than *underwork* their paintings.

Border-to-Border or Vignette?

Should you cover the entire painting surface or concentrate on the sitter, letting your strokes "fade out" around him, leaving the surrounding paper untouched?

This is a matter I've already discussed before, but in order to solidify my own views on the subject, I spoke to other pastel painters about it. The consensus was that there is no hard and fast rule concerning either method. The artists all said that they followed their instincts in determining a course of action.

When to use vignette or border-to-border? The best solution is to paint portraits in each manner until some personal response evokes a predilection toward one or the other. I have seen excellent portraits by artists in both vignette or border-to-border finishes, so why feel constrained and follow a single way of working?

Building an Impasto

Since the physical limitations of pastel partly determine the decision of how far to go in a painting, I'd like to touch on the aspect of impastos—thick buildups of color.

There are professional pastellists who say that you can build just so much pastel impasto before it refuses to accept anymore color. There are equally experienced pastellists who say you can keep piling up pastel impastos almost indefinitely.

Which shall you believe? Neither. Believe your own hand. Pile on the impastos till you yourself are convinced that you've reached the end of the line. That's the only way you'll ever find out how much pastel the paper can take. The rougher sandpaper and marble dust surfaces will accept more impasto than the fiber and velour surfaces.

Using the Surface Color

Technically, you can paint a pastel of the sea using only a white crayon. If the paper surface is a blue, you can indicate clouds and whitecaps with the white and come up with, at least, a recognizable seascape.

I know of one quick-sketch artist (one of those guys who does ½-hour portraits at fairs or in hotel lobbies) who uses a flesh-colored paper as his base, and merely puts down an outline of the features and a few color

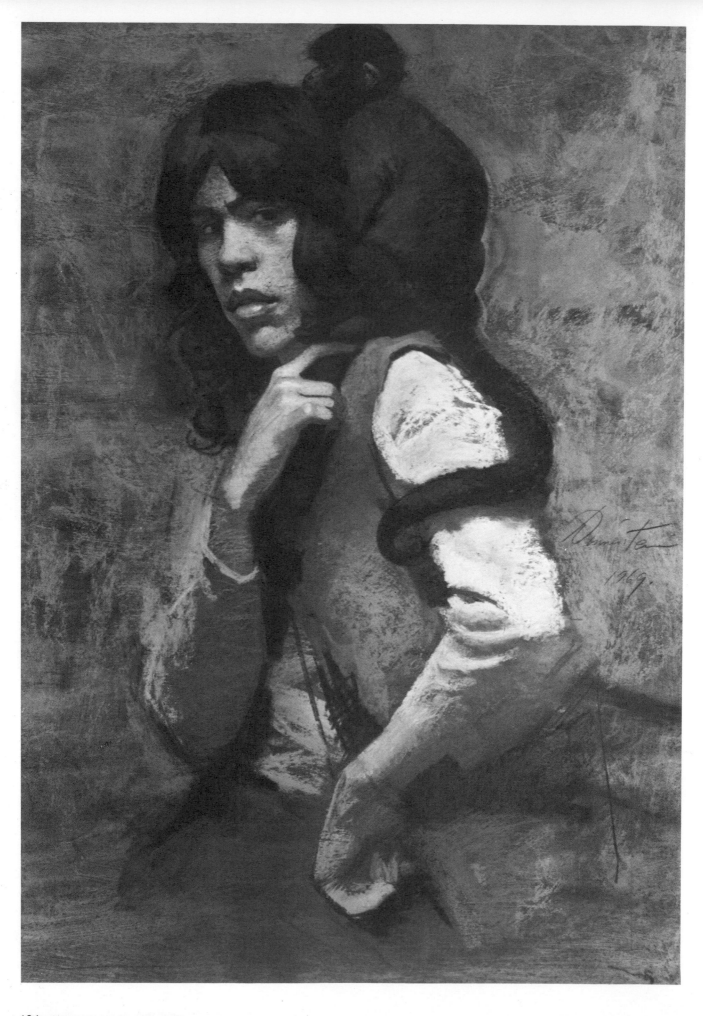

accents, and his sitters never catch on how little work he has performed.

These are extreme uses of surface color. But using the surface color in pastel is an old and established practice of which you needn't feel in any way ashamed. If it fits in with your way of working, don't hesitate to use it.

Even if you pick a few lights out of a dark brown sheet and this does the job, it's perfectly acceptable. Don't let your conscience plague you—there are artists today who pick up ten thousand dollars for sixty square feet of white house paint with two black lines smeared diagonally across it.

Using Fixative in the Intermediary Stages

There are those who never use fixative in pastel painting, and those who blow or spray it on in torrents. I am referring now to fixative as used in the intermediary stages of the portrait.

To spray or not to spray, that is the question.

Fixative permits a heavy buildup of impasto. *Spray-and-paint, spray-and-paint* is the way it works out. Degas, as I've already mentioned, used fixative copiously. The old boy literally painted with the stuff, occasionally working into it with a stiff brush. If it was good enough for Degas, it's good enough for me.

There is no esthetic reason for *not* using fixative. If you want to—use it. But don't use it just because it's there. *Have a reason* to do so.

Fixative is like rags, stumps, razor blades, sponges, etc.—merely another tool to help achieve a good painting. As to the argument that it alters the character of pastel—that's sheer baloney. Pastel *has* no inherent character, except what *you* make of it. Pastel, oils, crayons, watercolor or acrylics are merely instruments with which an artist makes his personal statement.

Combining Pastel with Acrylics

A blend of pastel and acrylic is entirely feasible. Acrylics can be used for the foundation, and a pastel can be applied over it without any difficulties whatsoever. When I spoke of toning papers in an earlier chapter, I mentioned that this toning can be done with acrylics.

But painting with acrylics *over* pastel seems to be a perfectly idiotic gesture since it completely obliterates the pastel. Therefore, what possible purpose would it serve?

Combining Pastel with Watercolor, Tempera, Casein, or Gouache

Pastel is perfectly acceptable to use with watercolor, tempera, gouache, or casein. Any of these mediums can be used to tone a pastel surface or to underpaint portions of the painting which will later be finished in pastel.

In illustration particularly where speed so often counts, artists apply pastel over these aqueous mediums to correct errors or to establish color accents.

Combining Pastel with Charcoal, Ink, or Pencil

Pastel also goes well with nearly every medium that isn't oily or greasy in character: charcoal, ink, pencil (non-greasy). All kinds of interesting possibilities exist and you should explore them all in your leisure moments to gain a deeper insight into the medium.

Advantages of Combining Mediums

We know that it's possible, but is it advisable to combine pastel with other mediums?

My personal feeling is—no. It's my heartfelt conviction that when you paint with pastel, you should paint with pastel. My objections to the practice of combining mediums are based on the premise that it's like using a crutch, and I prefer to walk on my own two legs. Why seek two tools when you can obtain the same effect with one? Even Degas stopped painting on monotype sheets after a while, pushing pastel itself to, and even beyond, its alleged limitations.

I believe that a pastellist should stop looking for quick, easy solutions and for miracles, and instead, concentrate on exploring the fullest potential of the medium. This imposes a discipline upon the artist and forces him to draw upon inherent strengths and resources that would otherwise remain untapped.

I also believe that an artist should early in his career decide the medium that best expresses his statement, and to stick to this medium. Instead of flitting from oils to watercolors to tempera to pastel, accept a commitment to one medium and push it for all it's worth.

If you want to mix pastel with other mediums, by all means do so. But first consider if you couldn't get the job done as well with pastel only. If you find that you cannot, then by all means mix away, but you'll never plumb the fullest potential of pastel by taking this compromising side road.

Carlos with Monkey by Harvey Dinnerstein, pastel on board, 29" x 21". Certainly a different approach in the light of modern times, but a familiar device in older days when pets—dogs, cats, monkeys, and birds—were frequently used in portrait paintings. Note the clever compositional use of the monkey. Cover it with your hand and see how the picture loses its balance. By concentrating the lightest tone on the youth's upper left sleeve, the artist forces the rest of the figure into the background and provides the effect of depth. (Courtesy Kenmore Galleries)

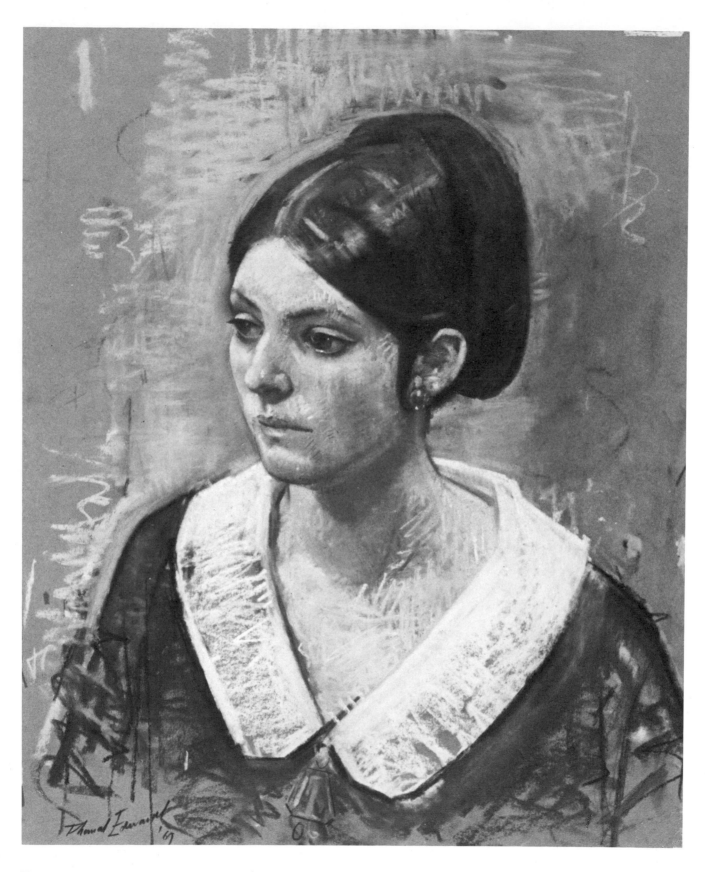

Elizabeth Maria by Thomas Edwards, pastel on paper, 24" x 30". This portrait was painted in a high key and moderately blended, with several vigorous, sharp strokes to lend strength and authority. Here, we have a downward view—the artist was obviously standing, the model was sitting. The level at which the painter works in relation to the sitter is a very important consideration in planning a portrait. An instance is if the subject were somewhat long in the nose and small in the chin, the downward view accentuates these faults while an upward view minimizes them.

Fixing, Matting, Framing

You've completed your portrait. It sits there—a thing of joy and beauty breathing life and excitement on the easel. Now the question hangs in the air—to fix or not to fix?

As many pastellists as there are, that's how many varying opinions exist as to whether or not to fix the finished pastel. (I'm referring to the *final* fixing now, not to the intermediary fixing which is covered by others layers of pastel.)

Let's take a little poll.

Professor Doerner in *The Materials of the Artist and Their Use in Painting* gives a qualifying nay.

Ralph Mayer gives a more determined nay in *The Artist's Handbook of Materials and Techniques.*

Henry Tonks, writing in the *Encyclopaedia Britannica,* says a definite nay.

Richmond and Littlejohns, authors of *Fundamentals of Pastel Painting*, give a hearty nay.

Stephen Csoka, in *Pastel Painting: Modern Techniques,* is noncommittal.

Jack Merriott, an English artist and writer on pastel says yea, but he offers a rather revolutionary fixing system of his own. In his book called *Drawing and Painting in Pastel,* he gives the reader the following instructions. First, apply wallpaper or library paste to a sheet of wrapping paper and glue paper to mat. Then place the pastel painting face down on a sheet of glass and tape it in several places to keep it from sliding. Next, apply the paste to the back of the pastel. Remove the tapes and place the side of the mat without the wrapping paper to the back of the pastel. Press the mat until it sticks to the pastel, then lift off. The pastel has been fixed from the back.

Elinor Sears is noncommittal in *Pastel Painting Step by Step.*

Ernest Savage, author of *Pastel for Beginners*, gives a yea *and* a nay.

I say, in this book, an emphatic nay.

Where does all this leave us? Nowhere. It just goes to show that fixative is there for you to use or not use as *you* see fit. However, the best way for you to decide whether to fix your paintings is to be ready to sacrifice a few pictures by blowing or spraying fixative over them, then appraising the results.

There are various kinds of fixative, none of them perfect. There are the ready-made fixatives that you can blow on with a mouth atomizer or spray on, and those that you can prepare on your own. Ralph Mayer gives the formula for a pastel fixative in his *The Artist's Handbook,* as does Professor Doerner in his *The Materials of the Artist.*

Prof. Doerner gives five formulas: (1) damar (the whitest possible), 2% dissolved in benzene, (2) 2% mastic resin dissolved in ether, perhaps thinned with alcohol, (3) Venice turpentine, 2% dissolved in alcohol (genuine Venice turpentine remains clear in alcohol), (4) 2% white colophony dissolved in benzene, ether, or alcohol, (5) Zapon varnish, strongly thinned with ether. Prof. Doerner suggests that the first formula is best. Ralph Mayer suggests the following. Soak ½ oz. of casein in about 4 oz. of water for six hours. Add ¼ teaspoon of pure, not household, ammonia until the casein dissolves. Add ½ pint of pure alcohol and mix well. Add enough water to bring to quart and filter before bottling. A fine, white precipitate may settle on standing, in which case the liquid can be poured off later. Most reputable art materials manufacturers make up pastel fixatives, usually in spray cans. I assume that these are as good as the product can be. In one area the experts do agree—that if you do use fixative, that you use it sparingly. When you blow or spray on fixative, stand well away from the painting so that the drops don't fall onto the painting surface.

Degas had a fixative prepared for him by an Italian painter, Chialiva, but the formula for the concoction died with its originator.

To fix or not to fix. Experiment, then decide.

Why Mats for Pastel?

The consensus seems to be that pastel paintings should be matted. There are two reasons given for the practice: one esthetic, the other pragmatic.

Let's take these up in sequence.

First of all, those who know and appreciate pastel contend that it looks better if there's a mat over and around the painting and under the frame. I tend to agree with this contention, but I wouldn't insist upon it as an absolute rule.

Frankly, I don't like to do the job of matting, mounting or framing my own pastels. This is a job best left to the expert—the framer. After all, *he* doesn't paint pastels, so why should *I* frame them?

However, if you do elect to mount, mat or even frame your own pastels, Mr. Mayer offers some suggestions: Lay the pastel face down on smooth, shiny paper or cardboard. Dampen the back with a sponge, and blot dry around the edges, leaving ½″ margin. Apply paste or gummed paper to it. Place the pastel painting face up on the mount which should be somewhat larger than the paper. Cover with a sheet of smooth paper, rub flat with the hand, and cover with heavy weights until dry.

There's an excellent book on mats and frames by Frederic Taubes called *Better Frames for Your Pictures*.

The second reason for using mats with pastel paintings is that they keep the surface of the painting from touching the glass and possibly, smearing.

Mats come in various colors and materials, in addition to paper. They can be of burlap, silk, cork, or what have you. They come in various sizes and thicknesses. There's a so-called museum mat, which is made of pure rag paper. If you're prepared to cut them yourself, there are special mat cutters made for this purpose.

Even if you give your paintings over to a framer, you should help select color and texture of the mat, and decide on the size of its borders.

Framing of Pastels

After you've decided on a mat, it's time to choose a frame for the painting. The function of framing a pastel painting is to keep the painting clean, safe from rubbing, and protected from dampness, mold, and accidents. Here, again, the array of framing materials is almost endless and you're limited only by your taste and by the state of your pocketbook. Frames can run into fortunes and early in my career I had the humiliating experience of having a client select a frame that was more expensive than my fee for the portrait itself.

I must confess that I do my best not to get drawn into the turmoil surrounding the selection of a frame. Women particularly have very definite opinions regarding frames and I am more or less indifferent about them. I leave the framing decisions regarding my own paintings to my wife.

In the case of pastel paintings, a frame is especially important, since the glass that's held by the frame prevents the picture from smearing and being damaged. The usual way is to arrange the frame so that the painting never touches the glass itself through the use of mats and/or pieces of cork between picture and glass at the corners where they won't show, and to protect the back of the painting with a rigid backing of some sort.

There is a perfectly acceptable method called passe-partout which consists of placing the painting, sans mat, but with a cardboard backing the same size flush against a piece of glass equal in size. The edges are then taped all around with a special passe-partout tape to keep out dirt and dust, and to keep the painting from shifting.

If you wish to keep your pastel paintings comparatively safe without framing, it's advised that you lay a sheet of acetate or waxed paper over them and store them one over another in some flat area big enough to accommodate the paintings without folding. Never roll pastel paintings since they will rub and smear. Oil pastel paintings, on the other hand, need little protection since this color will neither flake off nor smear.

Since even framed paintings can be severely damaged by dampness, experts advise that they be hung in dry places, and that pieces of cork be placed between the frame and wall to minimize the perils arising from moisture.

Those wishing to frame their own pastels can learn the various ways of doing this from Mr. Taubes, or from other books on the subject.

A conventional way is to lay the frame, face down, and drop the glass into the frame. Paste, nail, or tape some cork or wooden wedges at the corners (where they won't show), drop in the mat and paste or tack it to the frame. Drop in the painting and attach to one side (top or bottom) of the mat, then insert a mounting paper (100% rag) in back which you tape or glue to the frame. Next, lay a sheet of wrapping paper over the mounting board and tape it all around. (Some experts advise against the use of this final covering, since they claim it attracts dampness, while others assert that it's a harmless practice.) Basically, this is a way of framing pastels. There are, of course, other ways of doing it. I suggest that you guide yourself with the advice of acknowledged experts such as Hal Reinhardt and Ed Rogers *(How to Make Your Own Frames)* or Mr. Taubes.

Plain or Glareproof Glass?

Pastel paintings require glass and there are two kinds to choose from—plain and non-reflective, or glareproof, glass.

Plain glass casts a reflection and must, therefore, be hung in such a way that no direct light falls upon it. Glareproof glass makes it appear that no glass is there, but as if a kind of veil hangs over the painting. Its dull, matt appearance gives the pastel painting a strange kind of plastic look resembling lamination.

Which is preferable? In most instances, I'd opt for plain glass despite its deficiencies. Plain glass makes a pastel look like a pastel, not like some strange hybrid. Glareproof glass glamorizes a painting and gives it an exotic look, but it also deprives a pastel of some of its textural, grainy beauty.

But occasionally, a glareproof glass offers a most intriguing effect, particularly over seascapes or oil pastels. Aaron Shikler tells me that some glareproof glass tends to act as a magnet and pull the pastel granules off the paper.

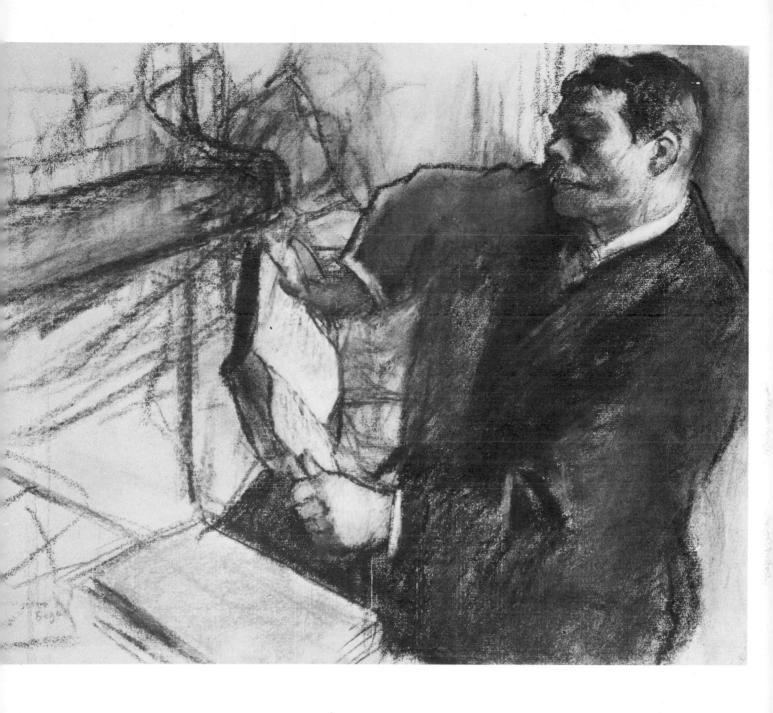

Pagans and Degas' Father *(Sketch) by Hilaire-Germain-Edgar Degas, pastel on paper, 18⅞" x 24¼". If you are terribly concerned about precise outlines and anatomical details, feast your eyes on this lovely little gem by the greatest pastellist of all time. Does he concern himself with the color of the man's iris? How much time and worry did the artist expend getting the curve of his mustache just so? But does this seemingly slapdash rub and scrub, scribble and dabble approach work? If you have any doubts, try to duplicate it (Courtesy Philadelphia Museum of Art, Mr. and Mrs. Carroll S. Tyson Collection)*

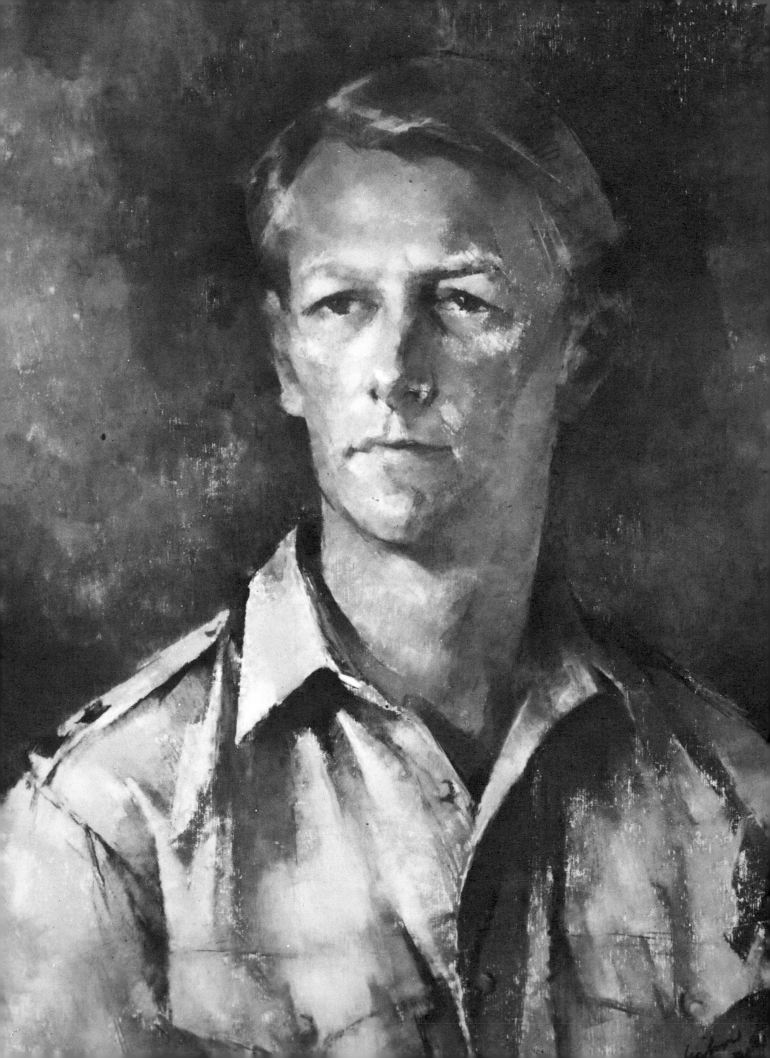

Preservation of Pastels

I've already mentioned that dampness is the pastel painting's worst enemy. But there are other villains. Mold is one of the most deadly. Ralph Mayer suggests that this can be prevented by mold-proofing the paper in advance of painting by adding fungicide to it during its manufacture. Fungicide can also be added if you manufacture your own crayons, as we have already discussed in the earlier chapters. However, since most artists use prepared crayons and surfaces, other means of combating mold must be employed in most instances.

If mold does occur, there are several ways in which you can destroy or stop it. You can expose the painting (minus glass) to strong sunlight or fresh air, which may do the job. Elinor Sears describes a treatment for mildew and the so-called "ultramarine disease" in some detail. To cure "mildew," pick off the mold wih a soft camel's hair brush previously dipped in pure grain alcohol. If spores are deep, scrape off with a razor blade, then touch over with a brush dipped in alcohol. According to the author, ultramarine occasionally causes a whitish film to form over the pastel painting. To cure this condition, she advises the same treatment as for mildew (scraping with brush or razor), rehanging in a drier location, and placing cork wedges between the frame and wall.

I would advise that you consult a competent art restorer should this condition affect your pastel paintings.

Mr. Mayer also discusses methods of restoring pastel, in *The Artist's Handbook*. Dust may be removed with a blast of air from a fan or lightly rubbed over with a sheet of paper thinly covered with a well-dried film of rubber cement. Tears can be stripped by cutting a patch of paper of the same thickness and texture and gluing these patches to the tear from the back, then repainting. Cleaning and bleaching of pastel paintings is a much more complex operation that requires an expertise far beyond that of the average artist.

If you need to restore your pastels extensively, contact your local museum for the names of competent art restorers, or if you live in a large metropolitan area, you can usually find their names in the classified telephone directory.

Major Peter R. Dawson, Royal Marines *by Helen Wilson, pastel on paper, 19" x 26". Painted basically in planes and fairly much blended so that it has acquired the smooth, fluid appearance of an oil or watercolor. The few rough spots are just below and above the left eye and in small accents in the shirt. The surface of the fine-grained paper is covered except for a spot here and there in the background. This portrait is painted in a rather even key, with few really distinct shadows or highlights. The total approach can be described as placid and refined. (Collection Major Peter R. Dawson)*

Demonstrations

DANIEL GREENE
PAINTS A PORTRAIT
OF JANICE

Daniel Greene is a prominent, extremely skilled, and highly successful artist and teacher, who works both in oils and pastel. A member of the National Academy, where he also currently teaches, his works can be seen in the United States Senate, in the Pentagon, in the Smithsonian, and in any number of important educational, financial, and cultural institutions.

Winner of such prestigious prizes as the Emily Lowe Award, the American Watercolor Society Medal of Merit, and the Audubon Artists' Medal of Honor, Dan Greene has painted portraits of Mrs. Eleanor Roosevelt, such notable political figures as Herbert Lehman and George Romney, and astronaut Walter Schirra.

Greene has explored every means of using pastel. He's one of the most expert and innovative practitioners of the craft of pastel painting, a knowledge which he can articulate with deep insight and lucidity.

He employs soft and hard pastels to achieve his masterful portraits and he paints on paper, on boards, and occasionally on pastel canvas. He also likes to make his own pastels and to experiment with pastel surfaces. Since he employs the traditional methods of working from dark to light and from hard to soft, he's constantly on the search for crayons that are dark enough and soft enough. To achieve this, he selects sticks from many brands of pastel. To paint a pastel picture, Greene draws from a personal assortment that includes hundreds of tints and shades.

For the portrait of Janice, Greene chose a dark green Canson Mi-Tientes paper which he felt would effectively set off the sitter's dark hair and rather cool, pale skin.

Step One *After studying the big masses of darks and lights and observing the sitter's most important characteristics from all sides, Greene decided to do a three-quarters-view portrait, one which in his opinion would best display Janice's features. First, he measures with the span of his fingers the space between the top of the paper and the place where the top of the head begins, and marks off the spot. He then visualizes the portrait so that the left eye and cheekbone would fall approximately into the center of the paper, measuring from side to* *side. He selects three hard crayons, in the cocoa brown, Van Dyke brown, and burnt umber colors, and a soft burnt umber for the initial outline. He sharpens the hard crayons and, beginning with the earlier mark at the top of the paper, he divides the face into three parts—the top one from the hairline to the eyebrows, the middle one from the eyebrows to the bottom of the nose, the third from the bottom of the nose to the bottom of the chin. He has now established the placement of features.*

Step Two *Now, Greene separates the center part in half again and, using the burnt umber, draws in the eyes so that the bottoms are above the middle of the center part of the face. He then divides the bottom part of the face and draws the bottom of the lower lip in the middle of it. So far, he has drawn only horizontal lines. All these measurements are a reference in addition to being natural observation. He then begins to develop the nose and draws first the bridge, then the slant of the nose—after which he checks the nose against a* *straight vertical line to see if it's correct. He then forms the complete eyes, drawing the visible left eye first and checking that its corner hits the nose where it's supposed to. He then works on the other eye, on the principle that all matching parts of the face should be drawn simultaneously as physically possible. Then, dropping a set of invisible plumb lines from the eyebrows to the nostrils, he draws the shadow on the cheek, under the chin. At this stage, he draws only within the outer contour of the head, working, as it were, from inside out.*

Step Three *In this stage, Greene indicates the shadows in a loose and rough treatment, still drawing rather than painting, and seeking to find and affirm the large forms and masses.*

He has drawn in the darks of the hair framing the face, and has corrected and pulled together such features as the nose, the jawline, and the model's rather long neckline.

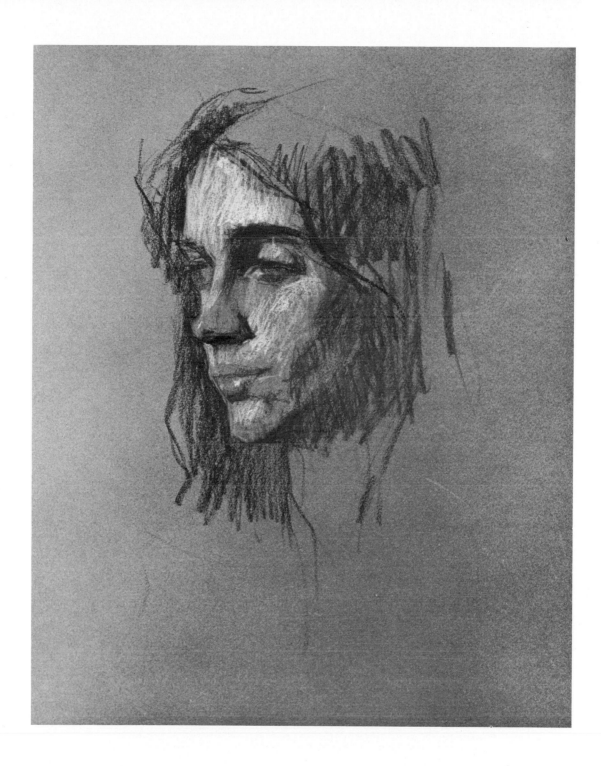

Step Four *For the first time, Greene fills in the head's lighter areas with color. At this stage, he's seeking to establish the contrast in values between the light and dark areas of the portrait. For this step, he employs the full range of colors. Working from dark to light, Greene tentatively picks out the light sections of the face, keeping the strokes light and loose with the underlying paper surface always showing. Greene uses the side of the pastel to stroke in the colors and as he paints, he corrects the drawing, painting in a rather non-assertive fashion, leaving room for subsequent refinement of colors, values, and contours. At this stage, Greene looks for the obvious, the easily discernible colors (such as the lips) and he strikes them in boldly and directly. These colorful touches serve as a kind of checkpoint, against which he measures the other colors of the portrait. At all times, Greene keeps the concept of a balance of warm and cool colors within each value in back of his mind, and he strives to maintain such a balance when he strikes in with additional hues. The portrait, at this stage, has begun to acquire the three-dimensional form it will possess in its completed form. This is evident from such touches as the first highlights on the nose and lips, the roundness rendered the model's left eyelid and the contour of the lips established on the partially seen right side of the model's face.*

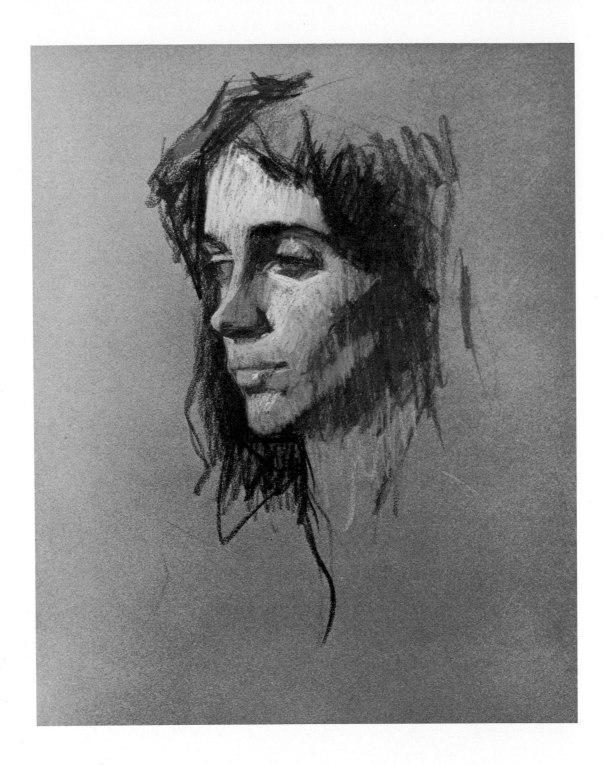

Step Five *At this time, Greene checks the basic proportions of the face by going back to his original concept of separating the head into three basic divisions. Having done so, he redraws the head in more detailed fashion, using a dark brown crayon to lay in a solid tone for the hair on both sides of the face. At the same time, he pulls together and simplifies some of the masses, and establishes the portrait's darkest darks. At this stage, he devotes much attention to the shadows, working into them with large but broken strokes of warm and dark color. The shapes of the shadows are stroked in with some degree of finality, and the lighter areas are as if chopped away from them. This process goes from shadow, to middletone, to light. At the beginning of this step, as he does each* *time he commences a new sitting. He re-evaluates the values, colors, and proportions of the portrait and strives to correctly establish the basic masses of light, middletone and shadow. He paints the darkest shadows first, then the lightest shadows and so on. It's the artist's theory that the darkest shadows, the lightest lights, the sharpest edges, the strongest contrasts, and the warmest colors tend to advance, while the softest edges, the coolest colors, and the least contrasting areas recede. He employs these principles in his portrait accordingly, to attract the viewer's eyes to those areas he seeks to emphasize. He doesn't paint his light areas quite as light as he sees them, in order to leave room for the final decisions concerning the finished portrait.*

Step Six *Now, modeling from dark to light, Greene often works deliberately against the form of the face, in order to maintain a free and spontaneous effect and to avoid a mechanical appearance. He now* paints *rather than* draws *with his crayon, seeking to soften and to modify the edges. He begins to model the planes of the cheek as it turns from the shadow into the light area under the eye. He gives form to the right eye and paints the upper lip. The planes of the cheek as it curves toward the mouth and meets with the dip beneath the lower lip, become more evident. He strokes in the angle of the upper lip and marks in definite highlights on the tops of the inside lower lids. Some sections of the face are now almost completely worked out, but the eyes have been deliberately left unfinished, so that the artist can formulate their final placement and treatment until the last.*

Step Seven *Greene darkens the shadows considerably in the hair, the jawline, the corners of the eye, the nostrils. The planes of the model's face are carefully molded and small anatomical touches have been added to further individualize the portrait. Her mouth is more carefully painted, the jawline has been rounded somewhat. Janice's rather pointed nose is* clearly established. *Greene has shown his sitter's bony, angular face in a series of planes of angles that serve as a counterpoint to each other. The portrait, at this stage, is clearly that* of a *definite someone; in addition to all its artistic values, it has assumed a human, an unmistakably* personal *factor that belongs clearly to its subject.*

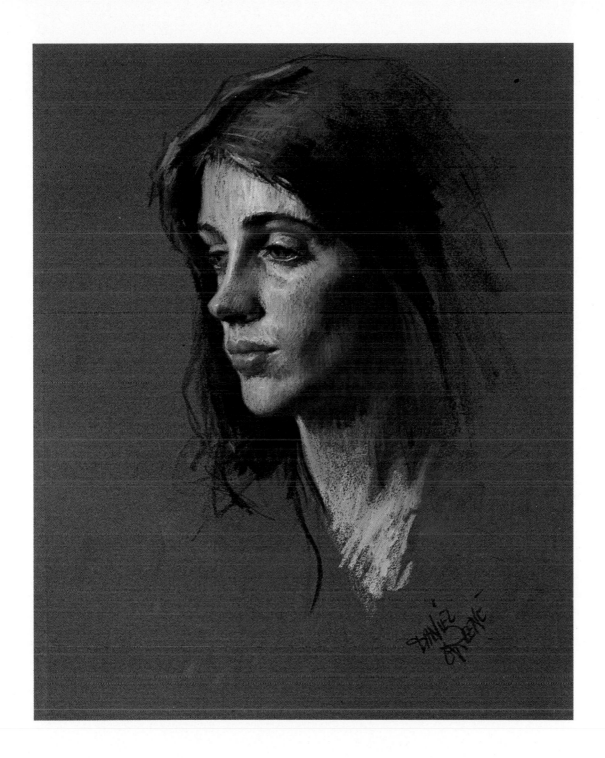

Step Eight *The final stage of the portrait entails placing the significant accents and highlights; to sharpening or softening the appropriate edges; balancing, toning down, or livening up colors; to minimizing and subordinating details; to controlling distracting elements such as reflected lights. He paints the sitter's long neck with broken strokes of light, flesh tone over the green middletone of the paper. He paints in the model's vivid blue eyes, and adds touches of warm reds and pinks to the tip of the nose, the inside of the bridge, and to the nostrils. Warm pink and ochre accents separate the shadow and light areas of the face. The lips are a hot pink-red, and there are other warm touches in the chin, and in the left, top section of the hair. Touches of yellow can be seen in the reflected light above the jawline. The shadows are basically cool and more translucent than in the previous stage. The final strokes are broken, loose, generally vertical. They lend animation and verve to the portrait. There's a feeling of liveliness and spirit in the painting so that we feel that a flesh and blood person, a sensitive and intelligent girl speaks out to us from beneath the pastel impression so skillfully rendered by one of the American master pastellists of our time—Daniel Greene.*

EVERETT RAYMOND KINSTLER PAINTS A PORTRAIT OF S. J. PERELMAN

Everett Raymond Kinstler is a distinguished portrait painter whose works hang in some of the best known homes, institutions, and museums in America, including the Metropolitan Museum of Art, the Smithsonian Institution, the Pentagon, and Yale, Princeton, and Columbia universities.

Kinstler has won prestigious prizes awarded by the American Watercolor Society, the National Arts Club, the Audubon Artists, and the Allied Artists. He teaches life drawing, portraiture, painting, and composition at the Art Students League and is the author of the book *Painting Portraits*.

As a former illustrator, Kinstler approaches painting and art in a refreshingly candid, practical, and intelligent way.

Although Kinstler works primarily in oil with occasional forays into charcoal, acrylic, and watercolor, he was intrigued by the idea of painting a pastel portrait for the book. He chose for his subject the well-known humorist and raconteur S. J. Perelman.

To execute the portrait, the artist selected an assortment of hard pastels and used no more than eight or nine sticks to complete the job. It was painted on a piece of olive-tan board.

Step One *Using an olive green crayon, Kinstler sketches in the general proportions of the head. He works very roughly and merely indicates the big masses, the distribution of lights and shadows, the location of the main areas of interest such as the eye, the ear, the bottom of the nose, the mouth, the jaw, and the upper contour of the skull. In order to provide a true impression of the subject's rather imposing leonine head, Kinstler paints him a trifle bigger than life-size, which Mr. Perelman definitely is. Now, using a stick of burnt sienna,*

Kinstler reinforces the drawing and loosely marks off the places where he'll subsequently be striking in with warm, rich shadows—the nostril and mustache, the eyes and the eyebrows, the shadow beneath the chin, the line of the mouth, the inside of the ear. At all times, Kinstler keeps this preliminary drawing open and free, subject to subsequent changes and corrections. His contour lines aren't completely defined and the drawing remains exactly what it's supposed to be—an outline to guide the artist.

Step Two *In this phase of the portrait, Kinstler works more elaborately with color and begins to build the tones and to establish more definite divisions of light, halftone, and shadow. Still working without a precise outline, and employing a madder pink and a sandalwood, which are two flesh colors, Kinstler strikes in loosely over the middletone areas, varying the strokes and the pressure of the crayon to obtain a broken tone over the general face area. He uses the darker sandalwood shade on the bridge of the nose, to outline the top of and the inside of the ear, under the mouth, under the chin, and behind the ear. With a light Naples yellow, Kinstler then marks some of the lighter areas of the portrait—the side of the* forehead, the top of the cheekbone, the side of the nose, the spot beneath the lower lip, the top of the ear lobe. He then uses a burnt umber to go over some of the shadow areas, thus achieving a nicely balanced blend of warm and cool in the shadows. The areas thus covered include the eyebrows, the nostril and mustache, the slash of the mouth, the shadow under the jaw, and several touches inside the eye socket. He has only indicated that his subject wears glasses. Note that until now, Kinstler has avoided striking in any true highlights, but has kept the painting confined to a limited scale of tones. Nor has he drawn to any degree, but has painted at all times in a loose, a free, a truly bold technique.*

Step Three *At this stage, Kinstler begins to define and further refine the portrait. Using basically the same range of colors except for an additional light blue, a deep ultramarine blue, a gray and a dark green, the artist carries the painting further by filling in areas in the hair, the nose, the cheek, the forehead, and the chin. He strengthens the portrait by drawing a bit more and by painting in the planes of the nose, the ear, the mouth, and the chin. He indicates the subject's gray hair with several vigorous strokes of a blue crayon. He strikes in some highlights on the lenses with a touch of white over* Naples yellow. He reinforces the hairline with blues, browns, and grays. The ear is drawn more carefully and by using tones rather than lines, the artist has marked off the contours of S. J. Perelman's face and skull. A plastic, three-dimensional effect is achieved through the vigorous alignment of the planes and angles of the features, and a striking resemblance emerges from the collection of characteristics that express the subject's distinctive appearance: the bushy brows, the wise, penetrating glance, the heavy, assertive mustache, the big, bony skull, the firm jawline.

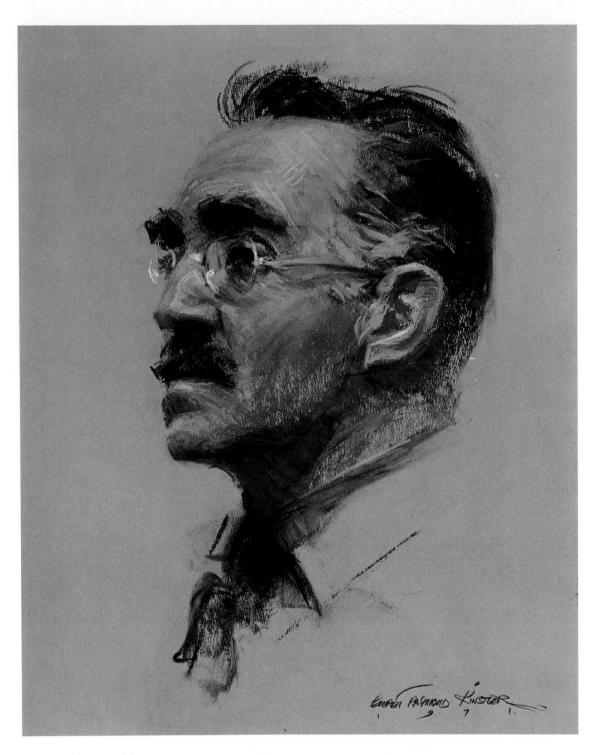

Step Four *At this stage, Kinstler works swiftly to set down the final accents, to further improve the anatomical structure, to extract deeper insights from his subject. He chisels out the planes of the face by stroking boldly with a Naples yellow crayon into the temple, across the forehead, down over the nose, and into the break between the nose and cheek. He marks a highlight on the rather full lower lip. He vigorously highlights the top and the inside fold of the ear, which he selects as one of Mr. Perelman's outstanding characteristics. He indicates the heavy eyelid and the gleam of the eyeglass lenses and frames. He gives a dashing upturn to the guardsman mustache. He boldly strikes in with hot red and violet behind the ear and under the jaw. He draws an independent red line to mark off the hot impression of the jaw shadow,* and runs several parallel lines across the shirt collar, which lend the portrait a snap and a lively, brisk crispness that typify Kinstler's dashing, bravura style of painting. A spot of bright green at the back of the head livens up what would be a dull gray area. The neck is left almost completely unfinished. Kinstler drags an olive and a pink loosely over the cheek, allowing the surface tone to show through and lending luminosity and a kind of textured verity to the side of the face. It looks as if it were scraped by a razor every morning. The shirt and tie are merely indicated, but there's something perky and engaging about the way the tie flips upward and forward. All in all, you sense Mr. Perelman's wit, intellectual brilliance, and forceful, original personality in this masterfully rendered pastel painting.

AARON SHIKLER
PAINTS A PORTRAIT
OF GEOFFREY CLEMENTS

Aaron Shikler is a busy, successful portrait painter, easily one of the best known and the most respected men in the field. He added to his fame by being selected to do the official portraits of the late President John F. Kennedy and of Mrs. John F. Kennedy, which today hang in the White House. Among other prominent persons Shikler has painted are the Duchess of Windsor, Mrs. William Paley, and the families of Paul Newman and of Lauren Bacall.

The artist was recently honored with a show at the Brooklyn Museum. He has exhibited widely and is represented in many important collections including the Metropolitan Museum of Art and the National Academy of Design. He has won the Tiffany Award, the Thomas R. Proctor Prize (twice), the Thomas B. Clarke Prize, and the Ranger Purchase Prize of the National Academy.

Aaron Shikler lives and works in New York City.

Shikler is a master pastellist, one of the finest exponents of the medium. He has delved deeply into its methods and techniques and has fully explored pastel's broad range and potential. He works with various grades of pastel and on various surfaces, from canvas to paper. For his portrait study of the noted photographer Geoffrey Clements, Shikler selected a marble dust board, one of the few remaining from a hoard of this highly desirable material which is no longer manufactured.

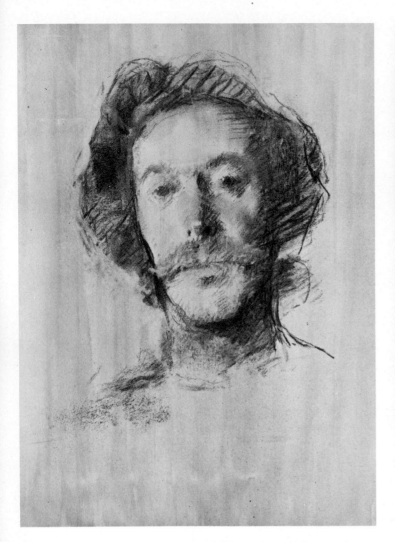

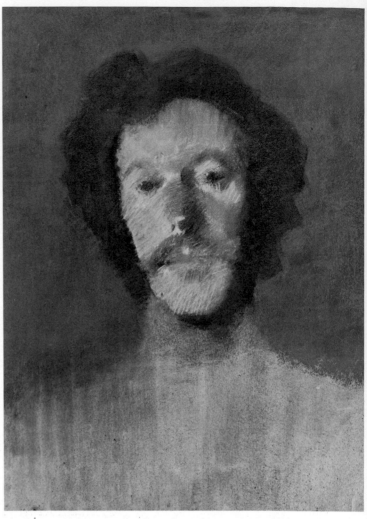

Step One *Shikler toned the board, which was white in its original state, with a green earth color in casein in order to provide a more sympathetic surface upon which to work and to set a color scheme for the portrait. He begins by drawing a fairly comprehensive sketch of the sitter in charcoal, working in tone rather than in line and seeking to establish the general thrust, the angles and proportions of the head and features. Shadows are marked with dark, solid tones and there's a suggestion of the planes of the face. The charcoal drawing is sprayed with fixative to keep it from smearing.*

Step Two *Shikler studies his sitter who is a ruddy-faced, red-haired man, and decides to go to the earth colors for the warm, overall tone that his sitter projects. The artist visualizes the portrait in the Venetian tradition of umbers, siennas, and ochres, with touches of Naples yellow. He employs three sticks of warm earth color to strike in big, covering strokes that run from right to left and that fill in the face and hair nearly completely. Although he obliterates pretty well the charcoal drawing underneath, the artist veers not too far from the original statement, but follows the original outline fairly closely. He fills in the hair as one dark mass, but leaves the neck, shirt, and background alone. The eyes are marked with highlights and there are dark accents at the corner of the mouth, in the nostril, and at the bridge of the nose.*

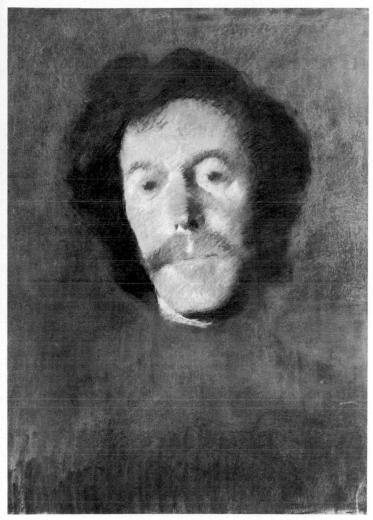

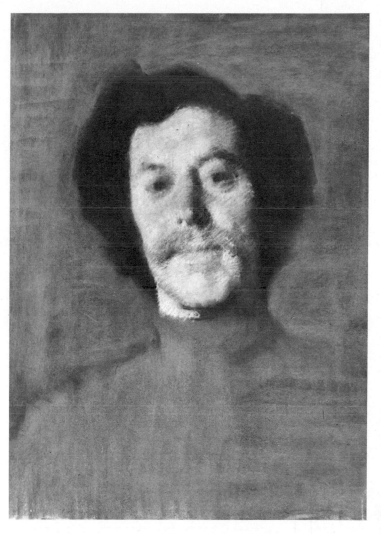

Step Three *The artist begins to pull the painting together by running the various tones of the face into closer harmony, by going over and smoothing out the rougher strokes, by blending the planes together, by finding several edges and by losing several others. He now uses colors that are truer to the so-called "flesh" tone, by toning down some of the rawer hues used in the secondary stage. He redraws the nostrils and establishes the slash of the mouth. He refines the eyes and corrects the drawing by broadening the face somewhat and by shortening up on the chin. By adding more tones to the middle values, he reduces the marked differences between the light, middle, and dark tones of the head. He makes a decision to discard the green background since he feels it will make the face seem too hot, and he determines to use a warm, reddish color in the background as well. He covers in the shirt area with a warm red tone, but doesn't show any details in the overall tone.*

Step Four *At this stage, Shikler decides to completely redraw the portrait. He tilts the head so that the forehead goes farther back and the chin comes more forward. This shortens up on the head, rounds out somewhat the angularity apparent in the previous stages, and broadens the subject's head and face. By stroking over and over with combinations of warm colors, he further refines the portrait and elicits a positive resemblance of Clements. The mouth assumes a tentative smile; the eyebrows acquire an alert, inquisitive expression. For the first time now, the portrait seems to achieve a personal and an individualistic look. He decides to kill the highlight in the pupils in order to remove the focus of attention from the eyes. He seeks the soft, calmly deliberate effect of the Venetian master portraits. Shikler now holds his crayon softly so that it merely feathers the surface. He is glazing, in effect, stroking gently with light colors to build up the surface and to mold the planes around the nose, on the forehead, around the chin, in the lips and mustache. He softens and lightens the shadows so that a reflected shadow becomes apparent on the subject's left cheek and jawline. The nostrils, corner of the mouth, and eyeballs are softer and more muted as Shikler begins to unify and homogenize the planes of the face, seeking a total and an overall balance of hues and values. Only under the chin does he draw in with any degree of hardness. He also indicates lightly the right shoulder and the fold in the turtleneck collar.*

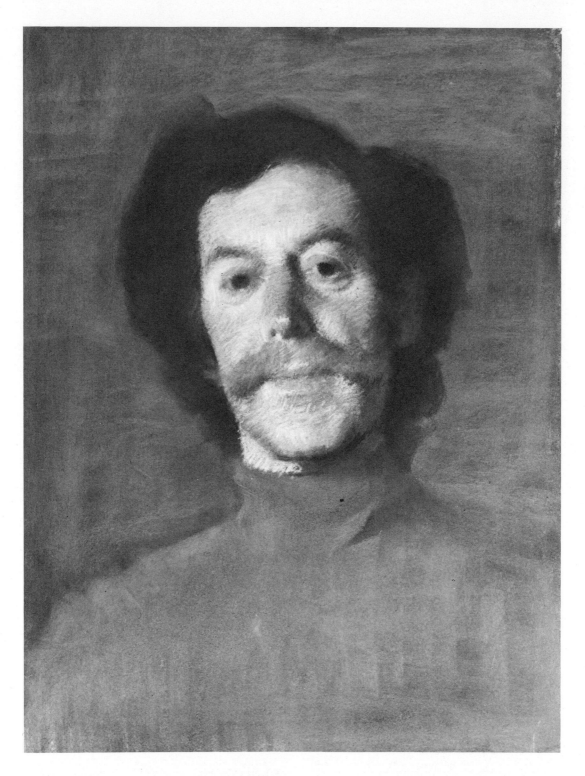

Step Five *Here, Shikler begins to recover some of the lost edges and accents that he has deliberately sacrificed in the previous stage. Still employing only* warm *colors, he darkens and tightens the shadow of Clements' nose and nostrils, the eyebrows, the line of the mouth, the right outline of the face, the left edge of the jaw. The folds under the eyes are now more clearly marked, and for the first time we see the suggestion of the ear. The left upper part of the mustache is more distinctly indicated as is the right tip of the mustache, which extends beyond the face. The highlights over the bridge of the* nose, *on the tip of the nose, above the upper lip, at the corners of the mouth and above the cheekbones come into sharper focus. There's more evident indication that Shikler's strokes are now following the* form *of the facial planes. The upper eyelids are more carefully drawn and the back of the hair on the subject's left side is clearly outlined. The artist has painted the fold under Clements' shirt collar and his left shoulder. We even see such character-delineating touches as the insides of the lower eyelids and the slight droop in the sitter's left eye.*

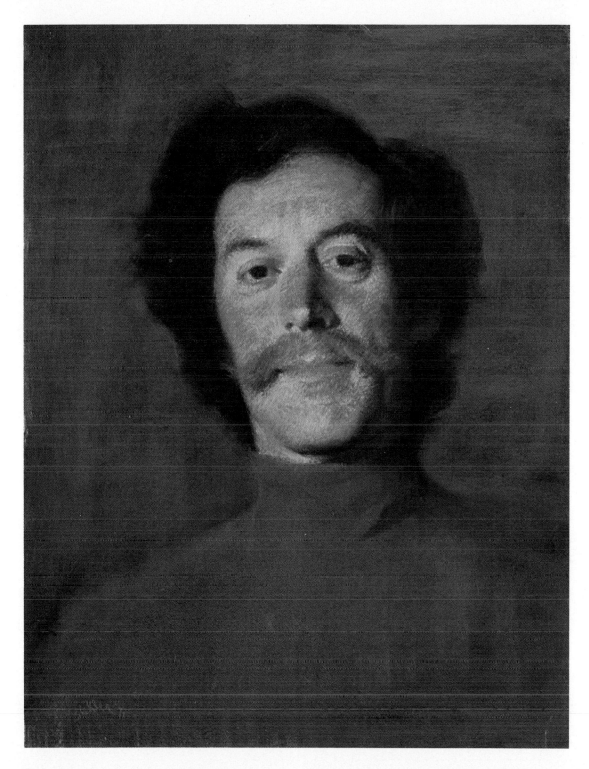

Step Six To complete this portrait of Geoffrey Clements, Shikler adds dark umber to the eyes and for the first time introduces something akin to a cool color—a raw umber which is close to a gray—in the chin, the neck, in the light area separating the right eye from the bridge of the nose, in the corners of the mouth, just above the left eyelid, around the eyes, in the whites of the eyes. Although he follows the shape of the forms, he occasionally counters this direction in order to relieve the monotony, to open up the forms, and give them a bit more "air." He introduces a few lighter accents into the hair at the right side of the face. He tones down the ear, but brings up the left nostril and the top of the left mustache. Details are sharpened; lights are reinforced and brought up higher. The left eyelid is redrawn, the face is broadened some more and the smile on Clements' face becomes more apparent. Shikler closes the eyes a trifle which lends the face a warmer, a more intimate expression. I haven't met Geoffrey Clements, but seeing the appealing face in the finished portrait, I would very much like to. Aaron Shikler has painted a warm, sensitive pastel portrait of a modern man, one that can easily hold its own with the better portraits of the past centuries. A final note: the artist uses a mahlstick to support his drawing hand during the various stages of the portrait. He fixes each intermediary stage, and gives the portrait a light fixing at the end. He blends with stumps, never with his fingers.

Burt Silverman belongs to that growing school of realist painters who have rejected the faddist, mannered caprices that have dominated the art world since the 1920s, and who are determined to paint man and his environment realistically, honestly, and with feeling.

He's a superb craftsman in many painting mediums. Although essentially not a portrait painter, Burt Silverman has completed portrait studies of David Rockefeller, Thomas Hoving, Rudolf Bing, and others for the *New Yorker* magazine. He is represented in the permanent collections of the Philadelphia Museum of Art and the Brooklyn Museum and has won the National Academy's Benjamin Altman Prize, the Thomas Proctor Prize, and the Henry W. Ranger Purchase Prize.

Silverman uses pastel in a broad, loose manner that captures the essence of a subject and lends the head or figure an atmospheric ambience such as in many of Degas' pastels.

He uses soft pastels only in his painterly technique and paints on boards, on toned paper, or on canvas. For this study of his wife, Claire, Burt picked a reddish pastel paper.

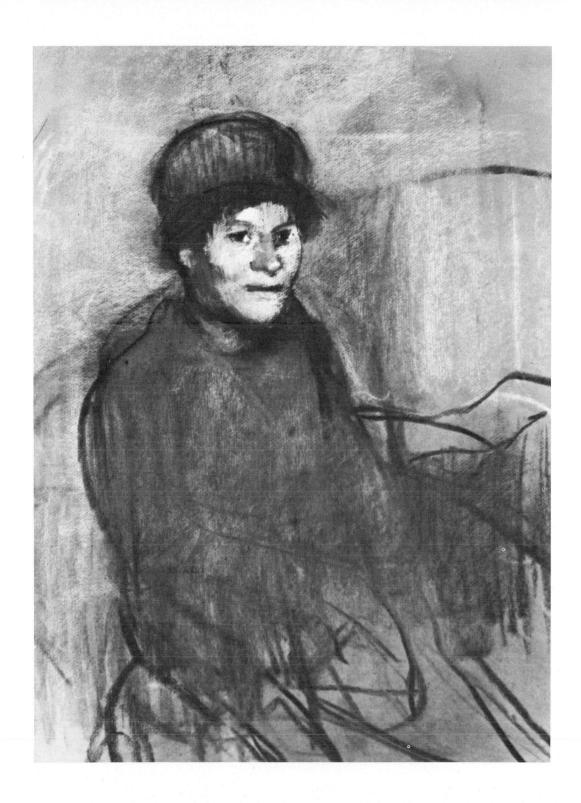

Step One *Before beginning the actual painting, Silverman decided that the portrait necessitated a warm approach, and he selected a palette that matched this concept. In the first stage, he draws in with charcoal, getting down the essential masses and indicating only roughly the thrusts and angles of the head and figure. While the head is fairly accurately placed, the arms and torso are merely touched in here and there for subsequent correction and refinement. Silverman prefers charcoal for this preliminary outline since he likes its soft quality and its facility to work over and correct. Having gotten down this basic outline on paper, he sprays the drawing with fixative. The artist places his figure in such a way as to* *leave lots of air around it in order to lend the portrait a feeling of space. It is his means of focusing the viewer's eye on the subject's head; of forcing the viewer to "dig" well into the painting and to consciously search out the figure that so positively peoples and animates the center of this empty space. At this stage, Silverman uses the greens and ochres in the background, and leaves the dress and cap essentially the color of the rust paper beneath. He also lightly and roughly strikes into the face with an ochre, employing it as the middle-tone of the flesh and leaving the charcoal to serve as the shadow areas. The strokes are rough, broken, and they frequently cross and trespass the preliminary outline.*

Step Two *Here, adding Naples yellow and flesh ochres, Silverman works more carefully in the face, building up the tones and correcting the drawing to great degree. He thins the face, indicates the line of the jaw, narrows and refines the figure, and begins to model the features. The mouth assumes character and there's an indication of the neck and ear. The hair and cap are refined and the eyes are beginning to assume a mildly ironical and an intelligent appearance. Silverman dips in and out of the figure with his chalks, always striving for that lively, rhythmic spontaneity that characterizes all his paintings. He uses greens and umbers in his shadows so that they seem to throb with vibrancy and life. He sprays fixative lightly whenever a certain area seems to go dead, and works with strokes that either follow the form or* consciously work against it. The structure of the sitter's cheek is reworked so that it turns more subtly and delicately. He touches in the first highlights on the tip of the nose, the upper lip, the top of the lower lip, the right cheek and just above the right brow. There's a strong contrast of light at the neck, which seems to project forward the sitter's rather strong, square jaw and chin. The cap is completely redrawn; it's no longer a pillbox but more the floppy, Dutch peasant's cap. The left shoulder is now noticeably higher and the model is sitting more erectly. Silverman darkens the shadow behind the right shoulder so that the figure acquires the kind of conflicting blend of animation and sedateness that characterizes his wife's rather mercurial personality which even in repose bristles with life and nervous energy.*

Step Three *Silverman redraws, this time, broadening again somewhat the face and figure so that it has lost some of the constrained quality it had acquired in the previous stage. He widens the cheeks and fits the cap at a jaunty, playful angle. The eyes now look straight into the viewer's eye, and they seem to smile in a kind of intimate and knowing way. The artist crosshatches with his pastel stick and pulls the planes of the face together. The left outline of the nose is almost obliterated and the pupils have been carefully drawn in. The shadow beneath the right nostril is firmly established and the mouth has been formed with a degree of finality.*

Silverman lightens the ear with a blend of ochres and pale Naples yellow. He fuses the tones of the face closer together and lightens the shadow on the cheekbone. The left contour of the bust and torso has been established and we see for the first time the inside of the right arm as it sweeps down and seemingly out of the picture. The cut of the hair is affirmed with strokes of a black crayon and color is added to the lips. Silverman paints the whites of the eyes in a light tone purposely, so that the pupils would stand out and accurately reveal the sitter's alertness, intellectuality, and animation. Strokes of a brighter color are added to the cap to lend it verve.

Step Four *In the final stage of the portrait, the artist paints flesh tones into the right and left hands. He merely indicates these shapes and has the courage to run the right hand out of the picture. He slashes in with darks to eliminate the graceless bulge on the left contour of the torso and provides his subject with a distinct bust and waistline. A cool middletone provides a turning plane to the left edge of the face and chin. The face now seems to go to and around this vanishing contour. Bright highlights give further sparkle to the dark brown pupils. The shadows of the bridge and nostril are slightly darkened again with umber, green earth, and sienna. The hair is fluffed out a bit and touched with umber at the sides to lend it its curly, snappy character. The cap is further redrawn so that its visor becomes more apparent. Silverman also lightens the shadow around the left shoulder and hand with vertical strokes of yellow. Touches of red and hot brown are introduced into the* left arm and the sofa below it. A suggestion of a yellowish pattern is indicated on the material of the sofa. The shadow behind the right side of the face is floated into the hair to provide the impression of space behind the head. The left cheek is cooled down with some greens so that it does not thrust too aggressively forward and turns back into the edge as it should. A pale green has been run over the right eye and the bridge of the nose, and a flesh ochre has been applied to the right cheek. A spot of hot pink is added to the ear. Silverman decides to completely eliminate the shape of the left arm, and it becomes a shadowy mass since it is the torso that he wants to emphasize. He also touches a bright highlight to the lip to lend it even more accent and prominence. There's a distinct, cool green accent in the shadow between the jaw and ear, and green accents in the right arm and in the bosom, which contrast with the hot rust tones of the dress material.

Bibliography

Birren, Faber, *The History of Color in Painting.* New York and London, Van Nostrand Reinhold, 1965.

Csoka, Stephen, *Pastel Painting: Modern Techniques.* New York, Van Nostrand Reinhold, 1962.

Doerner, Max, *The Materials of the Artist: And Their Use in Painting with Notes on the Techniques of the Old Masters.* New York, Harcourt Brace Jovanovich, 1949; Hart-Davis, London, 1969.

Fabri, Ralph, *Artist's Guide to Composition.* New York, Watson-Guptill Publications, 1970.

Fabri, Ralph, *Color: A Complete Guide for Artists.* New York, Watson-Guptill Publications, 1967.

Haak, Bob, *Rembrandt: His Life, His Work, His Time.* New York, Harry N. Abrams, 1969; Thames & Hudson, London, 1969.

Kinstler, Everett Raymond, *Painting Portraits.* New York, Watson-Guptill Publications, 1971.

Laliberte, Norman, and Mogelon, Alex, *Painting with Crayons: History and Modern Techniques.* New York and London, Van Nostrand Reinhold, 1967.

Mayer, Ralph, *The Artist's Handbook of Materials and Techniques.* New York, Viking, 1970; Faber, London, 1964.

Mayer, Ralph, *The Painter's Craft.* Van Nostrand Reinhold, New York, 1966, London, 1967.

Merriott, Jack, *Drawing and Painting in Pastel.* London, Adam & Charles Black, 1963.

Muybridge, Eadweard, *Animals in Motion.* New York, Dover Publications, 1957.

Ormond, Richard, *John Singer Sargent: Paintings, Drawings, Watercolors.* New York, Harper and Row, 1971; Phaidon Press, London, 1970.

Pluckrose, Henry, *Introducing Crayon Techniques.* New York, Watson-Guptill Publications, 1968; Batsford, London, 1967.

Reinhardt, Ed, and Rogers, Hal, *How to Make Your Own Picture Frames.* New York, Watson-Guptill Publications, 1964.

Rewald, John, *The History of Impressionism.* New York, The Museum of Modern Art, 1969.

Richmond, Leonard, and Littlejohns, J., *Fundamentals of Pastel Painting.* New York, Watson-Guptill Publications, 1970.

Savage, Ernest, *Painting Landscapes in Pastel.* New York, Watson-Guptill Publications, 1971.

Sears, Elinor Lathrop, *Pastel Painting Step-by-Step.* New York, Watson-Guptill Publications, 1968.

Taubes, Frederic, *The Painter's Dictionary of Materials and Methods.* New York, Watson-Guptill Publications, 1971.

Taubes, Frederic, *The Technique of Portrait Painting.* New York, Watson-Guptill Publications, 1967.

Watrous, James, *The Craft of Old Master Drawings.* Madison, Wisconsin, University of Wisconsin Press, 1957.

Werner, Alfred, *Degas Pastels.* New York, Watson-Guptill Publications, 1969; Barrie & Jenkins, London, 1969.

Index

Edited by Donald Holden and Juliana W. Goldman
Designed by James Craig and Robert Fillie
Set in 10 point English by University Graphics, Inc.
Printed by Rochester Polychrome Press, Inc.
Bound by Riverside Book Bindery